TABLE OF CONTENTS

SPRING 2024
VOLUME 4, NUMBER 3

EDITOR
LEON WIESELTIER

MANAGING EDITOR
CELESTE MARCUS

PUBLISHER
BILL REICHBLUM

JOURNAL DESIGN
WILLIAM VAN RODEN

WEB DESIGN
BRICK FACTORY

EDITORIAL ASSISTANT
DYLAN PARTNER

Liberties is a publication of the Liberties Journal Foundation, a nonpartisan 501(c)(3) organization based in Washington, D.C. devoted to educating the general public about the history, current trends, and possibilities of culture and politics. The Foundation seeks to inform today's cultural and political leaders, deepen the understanding of citizens, and inspire the next generation to participate in the democratic process and public service.

Engage
To learn more please go to libertiesjournal.com

Subscribe
To subscribe or with any questions about your subscription, please go to libertiesjournal.com

ISBN 979-8-9854302-4-0
ISSN 2692-3904

EDITORIAL OFFICES
1101 30th Street NW, Suite 310
Washington, DC 20007

FOUNDATION BOARD
ALFRED H. MOSES, *Chair*
PETER BASS
BILL REICHBLUM

DIGITAL
@READLIBERTIES
LIBERTIESJOURNAL.COM

Liberties

CYNTHIA OZICK

Like Peeling Off a Glove

Reflecting on Philip Roth in *Harper's* not long ago, the journalist Hannah Gold observes that few of the novelists she read during her high school years "captured my imagination and became my companion throughout adulthood the way Roth did." It is a moist confession familiar to writers who recall clinging to *Little Women* in faraway childhood with similar ardor. Yet now, in full maturity, Gold sees this transfiguring devotion as touching on "questions of inheritance as a problem of influence." And in pursuit of such spoor — directly as reporter, aslant as skeptic, but chiefly as admittedly recovering Roth addict — she recounts her impressions of "Roth

Unbound," a conference-cum-dramatic-staging-cum-fan-tour dubbed "festival" that unfolded in March of last year at the New Jersey Performance Center in Newark, Roth's native city. Stale though it may be, she calls it, in a rare flash of sinuous phrase, "the physical instantiation of a reigning sensibility."

What remains in doubt is whether her recovery is genuine, and whether she has, in fact, escaped her own early possession by the dominance of a defined sensibility. The latterday Newark events she describes mark the second such ceremonial instantiation. The first was hosted by the Philip Roth Society and the Newark Preservation and Landmarks Department, and by Roth himself, in celebration of his eightieth birthday. Unlike during the previous occasion, the 2023 honoree was now in a nondenominational grave at Bard College, but the proceedings were much the same as ten years before: the bus tour of Rothian sites and its culmination at Roth's boyhood home, the speeches, the critical and theatrical readings, the myriad unsung readers, gawkers, and gossips. With all this behind her — three nights in a "strange bed" in a "charmless" hotel, the snatched meals of chicken parm and shrimp tacos — Gold recalls her fervid homeward ruminations in a car heading back to writer-trendy Brooklyn:

I saw before me this distinguished son of Newark,
his sentences like firm putty in my mind. I wanted to
give them some other form, to claim, resist, and
contaminate them, then release them back into the
world, very much changed. My whole body went warm
just imagining it, turning the words inside out over
themselves the way that someone —maybe you, maybe
me — peels off a glove.

The concluding image echoes an exchange between Mickey Sabbath and a a lover named Drenka, taken from *Sabbath's Theater* and quoted by Gold in a prior paragraph:

"You know what I want when next time you
get a hard-on?"

"I don't know what month that will be. Tell
me now and I'll never remember."

"Well, I want you to stick it all the way up."

"And then what?"

"Turn me inside out all over your cock
like somebody peels off a glove."

But set all that aside — the *esprit d'escalier* dream of usurpation, the playing with Roth's play of the lewd. Despite these contrary evidences and lapses into ambivalence, however pertinent they may be to Gold's uneasy claim to be shed of Roth's nimbus, they are not central to her hope of unriddling the underlying nature of inheritance and influence. A decade hence, will there be still another festival, and another a decade after that? Influence resides in singularity, one enraptured mind at a time, not in generational swarms. Besides, influential writers do not connive with the disciples they inflame, nor are they responsible either for their delusions or their repudiations.

The power both of influence (lastingness apart from temporal celebrity) and inheritance (reputation) lies mainly in the weight, the cadence, the timbre, the graven depth of the prose sentence. To know how a seasoned reputation is assured,

8

look to the complex, intricate, sometimes serpentine virtuosity of Dickens, Nabokov, Pynchon, George Eliot, Borges, Faulkner, Proust, Lampedusa, Updike, Woolf, Charlotte Brontë, Melville, Bellow, Emerson, Flaubert, and innumerable other world masters of the long breath. But what of the scarcer writers who flourish mainly in the idiom of the everyday — in the colloquial? One reason for the multitude of Roth's readership, as exemplified by the tour buses, is too often overlooked: he is *easy to read*. The colloquial is no bar to art, as Mark Twain's Huck Finn ingeniously confirms; and dialogue in fiction collapses if it misses spontaneity. A novel wholly in the first person, and surely a personal essay, demands the most daring elasticity, and welcomes anyone's louche vocabulary. (Gold is partial to "cum.")

Roth's art — he acknowledges this somewhere himself — lacks the lyrical, despite Gold's characterization of it as "sequestered in enchantment," a term steeped in green fields and fairy rings. Elsewhere she speaks of Roth's "lyrical force," but only as it manifests in the context of Sabbath's immersion in Lear; then is it Roth's force, or is it Shakespeare's? Roth's own furies come in flurries of slyness, lust, indirection, misdirection, derision, doppelgangerism, rant. Gusts of rant; rant above all. Gold's desire to "contaminate" Roth's sentences would be hard put to match his own untamed contraries. Nor can she outrun the anxiety of his influence in another sense: she is a clear case of *imitatio dei* — would-be mimicry of her own chosen god, and more than mimicry: an avarice to contain him, to possess him, to inhabit him, to be his glove. It is an aspiration indistinguishable from sentimentality: emotion recollected in agitation. Gold the ostensibly hard-bitten reporter, the wise-guy put-downer, the breezy slinger of slangy apostrophes, is susceptible to self-gratifying — and hubristic — yearnings. "I'd like to possess Roth in ways I'd hope to see more

9

of his readers do as well: to take what creative, licentious force I need, and identify the Lear-ian corners in my own brain." But this is to mistake both Roth and Lear. Lear's frenzies are less licentious than metaphysical. Roth's licentiousness is more grievance-fueled than metaphysical; he is confessedly an enemy of the metaphysical.

Still, the underside of Roth's satiric bite can be its opposite: a leaning toward extravagance of sympathy. The Roth parents in *The Plot Against America*, a relentless and not implausible invention of a fascist United States under a President Lindbergh, are imagined in the vein of an uneasy yet naive and pure-hearted goodness. As they tour the historical landmarks of Washington, the father's instinct for the greatness of America is redolent of a schoolroom's morning recitation of the Pledge of Allegiance. But while the novel is a brainy and wizardly achievement of conjecture clothed in event heaped on fearsome event, it also sounds the beat of allegory's orderly quick-march. In "Writing American Fiction," an essay published in *Commentary* as early as 1961, Roth was already denying contemporary political allusions in his work. Assessing Nixon, his chief *béte noire* at the time, he insisted that "as some novelist's image of a certain kind of human being, he might have seemed believable, but I myself found that on the TV screen, as a real public image, a political fact, my mind balked at taking him in." A decade later, in savaging Nixon in *Our Gang*, Roth's mind, and his fiction, no longer balked. And who can doubt that beneath his fascist Lindbergh lurks a scathing antipathy to George W. Bush and Donald J. Trump?

The heartwarmingly patriotic fictive father whose family is assailed by creeping authoritarianism is not the only Rothian father given to all-American syrup. He emerges again in *American Pastoral*, where the syrup is fully attested

both in the novel's title and in the person of blue-eyed Seymour "Swede" Levov, a successful Jewish glove manufacturer, Vietnam Marine veteran, and idolized athlete, a family man married to a beauty pageant queen — in an era when it was requisite for contestants in their swimsuits to prattle American sentiments as proof that they were more than starlets. This unforgiving caricature implodes when Merry, Levov's daughter, is revealed to be a revolutionary bomber in the style of the 1960s Weathermen.

Close kin to Levov is Bucky Cantor of *Nemesis*, another accomplished Rothian athlete, and a devoted playground director and teacher during the polio epidemic of the 1940s, when it was known as "infantile paralysis" and had no countering vaccine. He, like the dutiful Roth parents, is one more conscious avatar of spotless good will. His fiancée, a counselor at a children's summer camp, persuades him to join her there to escape the devastating spread of polio he sees on the playground. And it is by means of this tender exchange, which takes place during an idyllic island holiday, that nemesis arrives, as it must, in the form of the unforeseen. Afflicted as an adult by the crippling disease, and festering guilt over the likelihood that it is he who carried polio from the playground into the camp, Bucky is a man broken forever. He will never again throw a javelin. He will never marry. But it is just here, in the lovers' island murmurings, that syrup overtakes not merely the novel but Roth himself. Tenderness is his verbal Achilles heel: an unaccustomed flatness of prose, passages of dialogue that might have been lifted from a romance novelette. Gone is the Rothian irritability, the notion of the commonplace overturned, the undermining wit. In the absence of excess, in the absence of diatribe and rage, the sentences wither. Triteness is caricature's twin.

As for self-caricature: asked in an interview at Stanford University in 2014 whether he accepted the term "American Jewish writer," Roth grumbled,

> I flow or I don't flow in American English. I get it
> right or I get it wrong in American English. Even
> if I wrote in Hebrew or in Yiddish I would not be
> a Jewish writer. I would be a Hebrew writer or a
> Yiddish writer. The American republic is 238 years
> old. My family has been here 120 years, or for more
> than half of America's existence. They arrived during
> the second term of President Grover Cleveland, only
> seventeen years after the end of Reconstruction.
> Civil War veterans were in their fifties. Mark Twain
> was alive. Henry Adams was alive. Walt Whitman
> was dead just two years. Babe Ruth hadn't been born.
> If I don't measure up as an American writer, just
> leave me to my delusions.

What might Henry Adams say to that? Or Gore Vidal?

And to reinforce his home-grown American convictions, Roth went on (but now in an unmistakably long breath) to invoke the density of the extensive histories that engrossed him: "the consequences of the Depressions of 1783 and 1893, the final driving out of the Indians, American expansionism, land speculation, white Anglo-Saxon racism, Armour and Smith, the Haymarket riot and the making of Chicago, the no-holds-barred triumph of capitalism, the burgeoning defiance of labor," and on and on, a recitation of the nineteenth century from Dred Scott to John D. Rockefeller. "My mind is full of *then*," he said.

But was it? In Roth's assemblage of family members,

fictional and otherwise, his foreign-born grandmother is curiously, and notably, mostly absent. "She spoke Yiddish, I spoke English," he once remarked, as if this explained her irrelevance. Was this insatiable student of history unaware of, or simply indifferent to, her experiences, the political and economic circumstances that compelled her immigration, the enduring civilization that she personified, the modernist Yiddish literary culture that was proliferating all around him in scores of vibrant publications in midcentury New York? Was he altogether inattentive to the presence of I. B. Singer, especially after Bellow's groundbreaking translation of "Gimpel the Fool," which introduced Yiddish as a Nobel-worthy facet of American literature? It cannot be true that writers in Hebrew or Yiddish (in most cases both, plus the vernacular), however secular they might be in outlook or practice, escaped his notice — as Eastern European writers, many of them Jews, whose various languages were also closed to him, did not. Speculation about the private, intimate, hidden apprehensions of Roth-the-Fearless may be illicit, but what are we to make of his dismissal of the generation whose flight from some Russian or Polish or Ukrainian pinpoint village had catapulted him into the pinpoint Weequahic section of Newark, New Jersey? Was it the purported proximity of Grover Cleveland, or the near-at-hand Yiddish-speaking grandmother, who had made him the American he was?

13

Had Roth lived only a few years more, he might have discovered a vulnerability that, like the Roth family under President Lindbergh, he might have been unprepared to anticipate. Never mind that as the author of *Portnoy's Complaint* and the short stories "Defender of the Faith" and "The Conversion of the Jews" he was himself once charged with antisemitism. Married to the British actor Claire Bloom

and living in London, he experienced firsthand what he saw as societally pervasive antisemitism. But this, he concluded, was England; at home in America such outrages were sparse. One unequivocal instance was that of poet and playwright Amiri Baraka, né LeRoy Jones, the New Jersey Poet Laureate whose notorious 2002 ditty asked, "Who knew the World Trade Center was gonna get bombed / who told the 4000 Israelis at the Twin Towers / to stay away that day / why did Sharon stay away" — implying that the Jewish state had planned the massacre. Responding to protests, New Jersey removed Baraka by abolishing the post of Laureate. Roth, incensed by a writers' public letter in support of Baraka, excoriated him as "a ranting, demogogic, antisemitic liar and a ridiculously untalented poet to boot." So much for one offender a quarter of a century ago; but would proximity to Grover Cleveland serve to admonish the thousands of students across countless American campuses seething with inflammatory banners and riotous placards who traffic in similar canards today?

And here in the shadow of what-is-to-come crouches the crux of the posthumous meaning of Philip Roth. No one alive can predict the tastes, passions, and politics of the future. No critical luminary can guarantee the stature of any writer, no matter how eminent — not even the late Harold Bloom, whose rhapsodic anointment of Roth named him one of the three grandees of the modern American novel. Inexorably, the definitive arbiter, the ultimate winnower, comes dressed as threadbare cliché: posterity.

Some have already — prematurely? — disposed of any viable posterity for Roth, and for Bellow as well, "a pair of writers who strong-armed the culture" and whose hatred and contempt for women (an innate trait of the Jewish male writer?) dooms them, as Vivian Gornick suggests, to the crash

of their renown. Yet the charge of misogyny diminishes and simplifies Roth to a one-dimensional figure, as if his work had no other value. Demand that a writer be in thrall to the current prescriptive policies of women's (and gender) studies departments, and tyranny rules; every consensual relationship deserves punitive monitoring. And must rascally Isaac Babel, a bigamist, also be consigned to eclipse, or was his execution in Stalin's Lubyanka Prison penalty enough? What of Dickens, who attempted to shut up his discarded wife in a lunatic asylum? Should *David Copperfield* be proscribed?

No writer can be expected to be a paragon; writers are many-cornered polygons. Gold, unlike Gornick, is more forgiving of Roth's depiction of female characters. "I have no desire," she affirms, "to expunge charismatic sexism from the page," and asks that it "be read as libidinal drive, and a creative force in its own right, without being reduced to righteousness or piety." But the eventual status of Philip Roth under the aegis of futurity will likely depend neither on sullen antipathies nor on greedy panegyrics. Posterity itself differs from era to era. Is there some universal criterion of lastingness — some signal of ultimate meaning — that can defy the tides of time, change, history?

Roth found it in mortality. It came after the hijinks, the antic fury, the vilifications of this or that passing political villain, the urge to startle and offend and deride, the floods of social ironies, the gargantuan will to procreate sentences. It came late, when mortality came for him. And so the writer who commanded that no kaddish be permitted to blemish his obsequies ends, after all, in the grip of his most-eluded nemesis — and the most metaphysically acute.

LINDA KINSTLER

The Olive Branch of Oblivion

To run out of memory, in the language of computing, is to have too much of it and also not enough. Such is our current situation: we once again find ourselves in a crisis of memory, this time marked not by dearth but by surplus. Simply put, we are running out of space. There is no longer enough room to store all of our data, our terabytes of history, our ever-accumulating archival detritus. As I type, my computer labors to log and compress my words, to convert each letter into a byte, each byte into a hexadecimal "memory address." This procedure is called "memory allocation," a process of sifting, sorting, and erasing without which our devices would cease to

function. For new bytes to be remembered, older ones must be "freed" — which is to say, emptied but not destroyed — so as to prevent what are called "memory leaks." Leaks are to be avoided because, wherever they occur, blocks of precious computing memory are forever fated to remember the same stubborn information, and therefore rendered useless. For memory allocation to function smoothly, the start and finish of each memory block must be definitively marked. "In order to free memory, we need to keep better track of memory," one developer advises. Operating systems, unlike the humans for whom they were designed, are built to tolerate little ambiguity about where memory begins and where it ought to end.

The machinic lexicon is both a site of and a guide to the current memory crisis. We are living through the tail-end of the "memory boom," immersed in the memory-soaked culture that it coaxed into being, a culture now saturated with information, helplessly consumed by the unrelenting labor of data retrieval, recovery, and storage. Even the computers are confused, for deletion does not mean what it used to: when profiles, usernames, or files are erased they are often replaced by what are called "ghost" or "tombstone" versions of their former selves, and these empty markers of bygone selves haunt and clutter our hard drives. Fifty years ago, memory became a "best-seller in consumer society," as the great historian Jacques Le Goff lamented. The new prestige of memory, its special authority for us, was evident before the digital era, in culture and history and politics; but today, with the colossus of digital memory added, I suspect that we are watching as memory's hulking mass begins to collapse under its own weight.

It is a physical crisis as well as a philosophical one: the overdue reckoning with corrosive memorials — with the contemporary ideal and imperative of memorialization — has

not been answered with a reappraisal of what memorials are for and what they can do, but rather with a rapid profusion of new ones. We all belong to the contemporary "cult of apology," in the words of the architect and scholar Valentina Rozas-Krause, who has observed that we have come perilously close to relying upon the built environment to speak on our behalf, to atone for our sins, to signal our moral transformation. Of course the cult of apology disfigures also our personal and social and political relations. "The more we commemorate what we did, the more we transform ourselves into people who did not do it," warns the novelist and historian Eelco Runia. A superabundance of bad memories has been answered only with more memory.

Our spatial coordinates are no longer primarily defined by our relation to physical memorials, municipal boundaries, and national borders, but ultimately by our proximity to data centers and "latency zones," geographical regions with sufficient power and water to keep us connected to the cloud, to track our live locations and feed our phones directions. (The cloud may be the controlling symbol of our time.) In the United States, the Commonwealth of Virginia is the site of the largest concentration of data centers: these bastions of memory are being built over Civil War battlefields, gravesites, and coal mines, next to schools and suburban cul-de-sacs, beside reservoirs and state parks. In Singapore, the proliferation of data centers led the government to impose a three-year moratorium on further construction. (The ban was imposed in 2019 and lifted in 2022; new data centers are subject to stricter sustainability rules.) In Ireland, which together with the Netherlands stores most of the European continent's data, similar measures are under consideration. Augustine described memory as a "spreading limitless room,"

an undefined space to which memories, things, people, and events are consigned for the sake of preservation, and we have made his theoretical fantasy all too real. These unforgetting archives suck up the water, energy, air, and silence; their server fields buzz, warm, and whir through the night. It is an unsustainable and ugly situation to which a bewildering solution has already been found: by 2030, virtual data will be stored in strands of synthetic DNA.

How did we get here? We are swimming in memory — sinking in it, really — devotees of what has become a secular religion of remembrance, consumed by the unyielding labor of excavating, archiving, recording, memorializing, prosecuting, processing, and reckoning with conflicting memories. We cannot keep going in this manner, for it is ecologically, politically, and morally unsustainable. There is no need to deploy metaphors here, for we are quite literally smothering the earth under the weight of all our memory.

What happened is that we forgot how to forget. Along the way, we also forgot why we remember — the invention of one-click data recovery, searchable histories, and all-knowing archives made our already accelerating powers of recollection reflexive, automatic, unthinking, foolproof. I am belaboring these contemporary technological mechanisms of recall because not only have they ensured that remembering has become the default setting of everyday life, but they have also tricked us into believing we can lay claim to a certain kind of forensic knowledge of the past — an illusion of perfect completeness and clarity. It is a dangerous posture, for it is one thing to say, as everyone well knows, that what's past is always present, and quite another to insist upon experiencing the present as if it is the past, and to attempt to understand the past in the language of the present.

The Olive Branch of Oblivion

Our commitment to remembrance at all costs is a historical anomaly: ever since there have been written records and rulers to endorse them, societies have sustained themselves on the basis of cyclical forgetting. Over the past two decades, as memory has become the primary stage upon which politics, culture, and personal life is played out, a handful of voices have attempted to call attention to this aberration. In 2004, the late French anthropologist Marc Augé declared: "I shall risk setting up a formula. Tell me what you forget and I will tell you who you are." In 2016, David Rieff asked, in a fine book called *In Praise of Forgetting*, on the political consequences of the cult of memory: "Is it not conceivable that were our societies to expend even a fraction of the energy on forgetting that they now do on remembering... peace in some of the worst places in the world might actually be a step closer?" He understood all too well that "everything must end, including the work of mourning," for "otherwise the blood never dries, the end of a great love becomes the end of love itself." In 2019, Lewis Hyde suggested that our inability to forget has crippled our capacity to sufficiently grieve. Reading Hesiod's *Theogony*, he observes that Mnemosyne, the mother of the Muses, ushers in both memory and forgetting in the service of imagination and preservation. "What drops into oblivion under the bardic spell is fatigue, wretchedness, and anxiety of the present moment, its unrefined particularity," Hyde writes, "and what rises into consciousness is knowledge of the better world that lies hidden beyond this one." A dose of forgetfulness allows us to put aside, if only temporarily, the sheer volume of all that we must mourn, to break the cycle of vengeance, to see through the fog of fury in moments of the most profound loss.

Prior to any of these pleas for forgetting, the French scholar Nicole Loraux demanded that we look back to the

Greek world to rediscover the political power of oblivion. Her interest in the subject, she explains, began when she read of a simple question that an Athenian citizen posed to his warring neighbors after surviving the decisive battle of the civil war that ended the reign of the Thirty Tyrants. The man had sided with the vanquished oligarchs and followed them into exile: he had chosen the side of unfreedom. Facing defeat, he confronted the winning democratic army and asked, "You who share the city with us, why do you kill us?"

It was an "anachronistically familiar" question for Loraux in 2001 and remains so for us today. How to make the killing cease? How to quell the desire for vengeance? How to relinquish the resentments of old? How to reunite a riven family, city, or nation? Loraux pondered the Greek experience, which has become the paradigmatic example of political oblivion, a collective "founding forgetting" that diplomats and lawmakers would attempt to replicate for centuries to come. For once the Athenian democrats won the war and reclaimed their city, they did not seek to exact vengeance upon everyone who had supported the tyrannical reign, but rather only tried and expelled the Thirty themselves and their closest advisors. All of the Greeks, no matter what side they took in the war, swore an oath of forgetting, promising not to recall the wrongs of a war within the family, a civil war that had led its citizens to kill and jail and disenfranchise one another. They swore never to remember: to not think of, recollect, remind themselves of evils. Oblivion became an institution of peace: it amounted to a ban on public utterances, a prohibition against vindictive lawsuits and accusations over what occurred before and during the fighting. "After your return from Piraeus you resolved to let bygones be bygones, in spite of the opportunity for revenge," Andocides writes of

21

this moment. An offering is said to have been made before the altar of Lethe, or oblivion, on the Acropolis; erasures cascaded across Athens as records of the civil war were destroyed, chiseled out, whitewashed. Memory was materially circumscribed, and democracy was re-founded upon the premise of negation. The Athenian approach, Loraux argues, "defined politics as the practice of forgetting." It ensured that from that moment onwards, *"Politikos* is the name of one who knows how to agree to oblivion."

Oblivion: it is tempting to read the word as a mere synonym for "forgetting," "erasure," or "amnesty." In practice, however, it has always been a far more complex commitment. When the Athenians swore never to remember, they were also swearing to always remember that which they had promised to forget. The Athenian example illustrates that the "unforgettable" — the civil war, or *stasis,* and the ensuing tyranny — is that "which must remain always possible in the city, yet which nonetheless must not be remembered through trials and resentments," as Giorgio Agamben observed in 2015. The terms of the peace agreement compelled its subjects to behave "as if" a given crime, transgression, or conflict never occurred, but also to always remember that it *did* occur and *may* occur again. It was a paradoxical promise to never remember and to always remember. The beauty of oblivion is that it reinforces the memory of the loss while prohibiting it from calcifying into resentment; it sanctions certain acts of vengeance, but also imposes strict formal and temporal limitations upon them, so that recrimination does not go on forever. In short, it mandates forgetting in service of the future. This is the upside of oblivion, and this is why, in our hyper-historicist moment, we must labor to remember its powers in the present, which for us is not easily done.

22

Doing so requires excavating the long-forgotten techniques of oblivion that, for centuries, regulated private and public life. A mutual commitment to oblivion was once the premise upon which all peacemaking was conducted, between states as well as between spouses. ("It is undoubtedly the general rule that marriage operates as an oblivion of all that has previously passed," the New York Supreme Court's Appellate Division ruled in 1896.) Today, the contemporary "right to be forgotten", which is practiced in a number of countries but not in the United States, is one of oblivion's most prominent, and promising, contemporary incarnations, providing the grace of forgottenness to those who long ago made full penance for past crimes. It is a testament to oblivion's power to combat cynicism and stubbornness and vindictiveness, to embrace the evolution of individual identity and belonging. Abiding by its rules, we acknowledge that who we have been is not the same as who we are, or who we may yet become.

"The only thing left is the remedy of forgetting and of abolition of injuries and offenses suffered on both sides, to erase everything as soon as possible, and proceed in such a way that nothing remains in the minds of men on either side, not to talk it, and never to think about it." So spoke the French jurist Antoine Loisel in 1582 in his "Discourse on Oblivion," a document that has itself been almost entirely swallowed up by time. Loisel reminded his audience of the example of Cicero, who appears to have been the first to translate the Greek ban on forgetting into the Latin prescription for "oblivion," from *ob-lēvis,* meaning "to smooth over, efface, ground down." To erode, to erase. It is likely to Cicero that we owe the

reconfiguration of the Athenian reconciliation agreement into a grand "Act of Oblivion." Tasked with reconstituting Rome after the assassination of Caesar, Cicero appears to have studied the terms of the Athenian agreement as a model for reconciling the republic:

> I have laid the foundation for peace and renewed the
> ancient example of the Athenians, even appropriating
> the Greek word which that city used in settling disputes,
> and so I have determined that all memory of our
> quarrels must be erased with an eternal oblivion.

Cicero recasts the terms of the Athenian reconciliation, and the attendant promise not to recall, as an *oblivione sempiterna*, an eternal oblivion. The Romans look to the Greeks to find a model for political reconciliation which they adapt to suit their own ends. The oblivion is what erases "all memory" of Rome's quarrels and allows for the settling of disputes. Oblivion is an instrument of truce and amnesty.

Cicero turns oblivion into a legislative undertaking: "The senate passed acts of oblivion for what was past, and took measures to reconcile all parties," Plutarch reports. (Another translation reads: "The senate, too, trying to make a general amnesty and reconciliation, voted to give Caesar divine honors.") As a result, Brutus and his allies were protected from vengeful reprisals: oblivion becomes a legal, legislative mechanism for forgetting, amnestying, and reconciling. The Roman adoption of the Greek practice suggests that oblivion was not understood as a blanket amnesty, nor as an absolute commandment to forget, but rather something in between, a somewhat ambiguous legal, moral, and material commitment that enabled political communities to come back together

while at the same time preserving — memorializing by means of a mandate to forget — the memory of what tore them apart.

Generations of statesmen, Loisel among them, have since followed Cicero's example of looking back to the Greek example and recasting its "unending oblivion" for their own ends. In 1689, for example, Russia and China signed the Treaty of Nerchinsk, in which Russia gave up part of its northeastern territory in exchange for expanded trade access to the Chinese mainland. The text of the treaty was inscribed upon stones laid along the new boundary line. The third clause of the Latin version of the treaty promises that "everything which has hitherto occurred is to be buried in eternal oblivion." (Interestingly, this clause does not appear in the Russian or Chinese versions of the treaty; the discrepancies between the different translations were one reason the treaty ultimately had to be revised.) During the early modern period, oblivion was a fixture of diplomatic speech: all over the world, powers swore to consign the grievances of wars and territorial disputes to "eternal oblivion." Russian rulers swore to *vechnoye zabveniye,* Germans to *ewige Vergessenheit,* French to an *oubli général.* So too did Chinese, Ottoman, and African rulers in treaties with Western powers. The Arabic phrase *mazâ-mâ-mazâ,* "let bygones be bygones," appears in Ottoman diplomatic correspondence dating from the thirteenth century as an element of customary law, and persists well into the nineteenth century in Ottoman and Western European diplomatic peace treaties. Oblivion was circulated, translated, and proclaimed as part of the ordinary business of statecraft. Rulers agreed to bury past wrongs as a way of signaling that their states belonged to the family of nations; forgetting the ills that members visited upon one another was a prerequisite for belonging to the family.

25

Modern states owe their foundations to the pragmatic promise of oblivion. When the newly installed Republican government of Oliver Cromwell sought to erase the English people's memory of the bloody civil war in 1651, his parliament passed an act to ensure "that all rancour and evil will, occasioned by the late differences, may be buried in perpetual oblivion." And when, nine years later, King Charles II sought to coax his subjects into forgetting the reign of Cromwell, he too declared an oblivion, forgiving everyone for their prior allegiances to the English Commonwealth except the men who beheaded his father, Charles I. (They were tried for treason and killed.) In France, policies of *oubliance* were widespread in the sixteenth and seventeenth centuries, and the Bourbon restoration of 1814 was marked by a new public law ending investigations into "opinions and votes given prior to the restoration" and stipulating that "the same oblivion is required from the tribunals and from citizens." In territories that would become the United States and Canada, European powers swore to oblivion in treaties with indigenous peoples as part of the project of imperial expansion. Diplomatic exchanges between indigenous leaders and European emissaries did not merely make mention of "burying the hatchet" or burying wrongs in oblivion — they were centered around these cyclical rituals of forgetfulness. French and English diplomats appealed to past oblivions whenever they desired to solidify an alliance with indigenous peoples, securing their support against the encroachment of other white settler groups.

In the Revolutionary period, oblivions proliferated in the colonies, as the legal scholar Bernadette Meyler has documented. The Continental Congress invoked oblivion in its efforts to resolve a boundary dispute between Vermont and New Hampshire; North Carolina deployed one in 1783

to bring a cadre of seditionist residents back into the fold. Massachusetts passed one in 1766, Delaware in 1778. In 1784, Judge Aedaenus Burke, a member of the South Carolina General assembly, made one of the more forceful arguments for oblivion in American history when he delivered his pseudonymous "Address to the Freemen of the State of South Carolina." He wrote of how, during the Revolutionary War, he watched as a man walked over the "dead and the dying" bodies of "his former neighbors and old acquaintances, and as he saw signs of life in any of them, he ran his sword through and dispatched them. Those already dead, he stabbed again." The nature of the violence, he argued, far exceeded the capacity of law. And so a general clemency was the only way forward, for Burke, simply because "so many crimes had been committed that fewer than a thousand men in the state, he thought, could 'escape the Gallows.'" He declared that "the experience of all countries has shewn, that where a community splits into a faction, and has recourse to arms, and one finally gets the better, a law to bury in *oblivion* past transactions is absolutely necessary to restore tranquility." Oblivion was the only way that those who had been royalists could possibly still share the same ground with the revolutionaries they had fought: "Every part of Europe has had its share of affliction and usurpation or civil war, as we have had lately. But every one of them considered an act of oblivion as the first step on their return to peace and order."

Almost a century later, President Andrew Johnson marshalled similar language in his attempt to restore peace in the aftermath of the Civil War. In his first annual message after Lincoln's assassination, he advocated for a "spirit of mutual conciliation" among the people, explaining why he had invited the formerly rebellious states to participate in amending the

27

Constitution. "It is not too much to ask," he argued, "in the name of the whole people, that on the one side the plan of restoration shall proceed in conformity with a willingness to cast the disorders of the past into oblivion, and that on the other the evidence of sincerity in the future maintenance of the Union shall be put beyond any doubt by the ratification of the proposed amendment to the Constitution, which provides for the abolition of slavery forever within the limits of our country." His speech casts the re-writing of the Constitution and the ratification of the Thirteenth Amendment as itself an Act of Oblivion, a way to "efface" the grounds upon which slavery had been legally sanctioned and defended.

And yet we live in the ruins of past peace treaties. We do not need to ask whether all these measures of imposed forgetting "worked," because we know that neither the oblivions nor the ceasefires nor the reconciliations that they were supposed to inaugurate ever held up for long (often for very good reasons). The more interesting question is why oblivion proliferated in the first place, and where the desire that is continuously revealed by the fact of its repetition originates. "Oblivion brings us back to the present, even if it is conjugated in every tense: in the future, to live the beginning; in the present, to live the moment; in the past, to live the return; in every case, in order not to be repeated," Marc Augé writes. The recursive calls for oblivion — pleas for a workable kind of forgetfulness, both legal and moral — can be found wherever people have quarreled, battled, and betrayed one another, only to subsequently discover that, even after all is said and done, they must share the same earth.

On September 19, 1946, as part of a world tour following the end of his first term at 10 Downing Street, Winston Churchill arrived at the University of Zurich and called for "an act of faith in the European family and an act of oblivion against all the crimes and follies of the past." Standing upon a dais set up outside the university building, he faced thousands of people gathered on the square before him and said:

> We all know that the two World Wars through which we have passed arose out of the vain passion of Germany to play a dominating part in the world. In this last struggle crimes and massacres have been committed for which there is no parallel since the Mongol invasion of the 13th century, no equal at any time in human history. The guilty must be punished. Germany must be deprived of the power to rearm and make another aggressive war. But when all this has been done, as it will be done, as it is being done, there must be an end to retribution. There must be what Mr. Gladstone many years ago called 'a blessed act of oblivion.'

As he spoke, the guilty were indeed on their way to being punished in occupied Germany, in Japan, and in the Soviet Union, where prosecutors had not waited for the battles to end to begin trying and sentencing German prisoners of war. The International Military Tribunal at Nuremberg was preparing for its 218th day in session, and in Tokyo the prosecution was still making its case. Much was still unknown about the nature and volume of German atrocities. Churchill acknowledged the unprecedented character of the crimes in question and underscored the imperative of punishing their perpetrators. He also established that everyone in the audience, having

lived through the horrible years of war, was all too familiar with its nature, and that this familiarity was a kind of shared knowledge among them. Much was still to be discovered, unearthed, proven, and punished, yet everyone who had lived through the war in Europe, who had been proximate to its force, "knew" how it came to be — even those who had profited from it, and those who looked away. Otherwise, he feared that memory might be wielded to perpetuate the absence of peace.

Churchill did not shy away from retribution (he had once supported the creation of a "kill list" of high-ranking Nazis), but he also saw its limitations. He understood that the desire for vengeance could not be allowed to fester forever because it risked preventing Europeans from imagining a shared future together:

> We cannot afford to drag forward across the years to come hatreds and revenges which have sprung from the injuries of the past. If Europe is to be saved from infinite misery, and indeed from final doom, there must be this act of faith in the European family, this act of oblivion against all crimes and follies of the past. Can the peoples of Europe rise to the heights of the soul and of the instinct and spirit of man? If they could, the wrongs and injuries which have been inflicted would have been washed away on all sides by the miseries which have been endured. Is there any need for further floods of agony? Is the only lesson of history to be that mankind is unteachable? Let there be justice, mercy and freedom. The peoples have only to will it and all will achieve their heart's desire.

The stakes were high: letting the ills of the past "drag forward" was something that Europeans could not "afford" to do because that would mean "infinite misery" and "final doom" for the already imperiled and destroyed continent. The indefinite continuation of exercises in vengeance and recrimination would spell certain death not only for "Europe," as Churchill saw it, but also for the project of a "United States of Europe" that his speech called for. If the defeat of the Nazis had saved the continent from entering a new "Dark Age," then the practice of perpetual vengeance, he argued, threatened to bring it there anyway. A "United States of Europe," he argued, would return the continent to prosperity. But before that could occur, something else had to take place. "In order that this may be accomplished there must be an act of faith in which the millions of families speaking many languages must consciously take part," Churchill said. That "act of faith" was not a religious or spiritual rite but a political one: an act of oblivion.

The "Mr. Gladstone" to whom Churchill referred was the liberal politician William Gladstone, who served twelve non-consecutive years as British prime minister between 1868 and 1894. In 1886, Gladstone called for a "blessed oblivion of the past" to bury the memory of British Home Rule in Ireland and restore peaceful relations between England and Ireland. "Gladstone urged the MPs to grant the Irish a 'blessed oblivion' and permit them to forget about a tradition of hatred," the historian Judith Pollman writes. Calling for oblivion, Gladstone implicitly referred back to the Act of Oblivion that had restored the British monarchy under Charles II. He was suggesting that the same tool that restored the British monarch in 1660 could serve quite the opposite purpose two centuries later, marking the erasure and forgetting of British rule in Ireland.

Oblivion in the aftermath of war and conflict is emotionally very exacting, and Churchill's remarks were at first poorly received. *The Manchester Guardian* called it an "ill-timed speech," and others thought that it was insensitive to the still-fresh wounds of war. (The paper did not argue that the speech insulted the memory of the slaughtered Jews of Europe, but rather to the French, whom Churchill had dared ask to reconcile with the Germans.) Today, however, the speech is regarded as one of the first calls for the creation of the contemporary European Union, and Churchill is celebrated as one of its founding fathers. He called for a new collective commitment to oblivion, yet the half-century that followed was defined not by oblivion but by its opposite. The Nuremberg trials delivered partial justice for a select group of perpetrators, as did proceedings in the Soviet Union, Poland, Israel, Germany, France, Italy, Japan, and elsewhere. Retribution came in fits and starts, and it is still ongoing today. Memorials were erected all over the formerly occupied territories, part of an effort to ensure that passersby would always remember what had occurred there. But memorials also have an odd way of sanctioning forgetfulness: the more statues we build, the more we fortify the supposedly unbreachable gap between past and present. Is this not its own kind of oblivion?

In a moment of profound rupture, Churchill called for yet another repetition of the Greek model, for a new adaptation of the founding forgetting that supposedly bound the Athenians back together, if only for a short time. His call for an end to memory was far too premature. But his suggestion that, at some point, memory must cede ground to mercy — and, we might add, to the memories of other and not necessarily more recent crimes — is one that we are only now beginning to take up. The "United States of Europe" was ultimately founded not

upon an Act of Oblivion but rather upon the myth that its constituent nations were bound together by a commitment to repudiate and remember the past, and to ensure that the atrocities of World War II would "never again" occur. We all know how that went. To consider the possibilities of oblivion requires accepting that there are some forms of memory production — prosecution, memorialization, truth and reconciliation, processing — that may effectively prolong and even exacerbate the wrongs they were intended to make right.

Oblivion is not a refusal of these efforts but rather a radical recognition of their limitations. It is an invitation not to endlessly participate in the "global theater of reconciliation," in the instrumentalization of survivor testimony, in what the literary scholar Marc Nichanian has called the "manipulation of mourning." It provides an opening through which we might attend to the moral ruptures that preceded the acts of wrongdoing; it creates space to engage in the kind of "unhinged mourning," that Nichanian locates "prior to any politics, prior to any foundation or restoration of democracy, prior to every accord, every contract, every pact and every reconciliation." Oblivion never speaks of forgiveness; indeed, it is the alternative to forgiveness. To forget a transgression is a distinct moral act that liberates its subject from the dueling imperatives to either avenge the wrong or to forgive it. It is, in this sense, an important rejection of the language of reconciliation, of loving one's enemy. It offers a path forward where this kind of "love" is unimaginable, if not impossible. Oblivion embeds the memory of the crime in the hearts of those whom it forbids from speaking about it. "This," Nichanian argues, "is what the Greeks, in their obsession, called *álaston penthos,* mourning that does not pass which nothing could make one forget."

33

Some years ago, I came across a scientific paper announcing that a group of computer scientists in Germany and New Zealand had come up with a "universal framework" that they called *Oblivion*. Its function was rather straightforward: it could identify and de-index links from online search engines at extreme speed, handling two hundred and seventy-eight removal requests per second. They promised nothing less than to make forgetting "scalable," as seamless and widespread as possible, and their citations refer to similar programs, including one called "Vanish" that makes "self-destructing data" and another, called the "ephemerizer" which also promised to make "data disappear." All of these efforts were designed in response to the inauguration, in 2011, of the European Right to Be Forgotten, or as it is officially called, the "Right to Erasure." This new European right affords individuals the ability to demand "data erasure," to require criminal databases and online sources to remove any personal data that is no longer "relevant" or in the "public interest."

The law is composed of two distinct but related ideas: first, that we have a "right to delete" the data that we leave behind as we move about the digital world, and second, that we also have a "right to oblivion" that endows us with what the scholar Meg Leta Ambrose calls "informational self-determination" – the right to control what everyone else is able to learn about us without our consent. Minor offenses, arrests, and dropped charges from the past may be deleted from internet articles and websites if they fit these criteria, such as in cases where criminal records have been sealed or expunged, and the penalties long ago fulfilled (or where no crime was found to have been committed in the first place). As Jeffrey Rosen has

noted, the law derives from the French "'*droit à l'oubli*' — or the 'right of oblivion' — a right that allows a convicted criminal who has served his time and been rehabilitated to object to the publication of the facts of his conviction and incarceration."

The adoption of these new rights marks the most recent transfiguration of the ancient idea of oblivion. The Right to Be Forgotten is both a privacy protection and a rehabilitative mechanism, one which, like the Athenian oath, helps to restore individual membership to the civic family. It gives us the freedom to become someone else, to escape the unhappy past, provided that certain criteria are met. This new right extends far beyond the legal realm. For several years, European nations have been expanding the Right to Be Forgotten such that it protects cancer survivors and those with other chronic illnesses from facing penalties from insurance companies, banks, adoption agencies, and more because of their health troubles. It is a commitment to rehabilitation in the most comprehensive sense, a pledge to ensure that no one should be defined by their worst moments or their greatest misfortunes. You could call it a kind of grace. (The Russian word for these kinds of measures is *pomilovaniye,* derived from the word *milyy,* meaning "dear," "darling," "good." We wash away wrongs and choose to see only the best in ourselves, and in others.) To honor the right to oblivion is to submit to a particular performance of citizenship, one that may seem strange at first glance, and ubiquitous the next: for who among us cannot be said to be engaged in some studied act of forgetfulness, forgetting unhappy episodes from the past in order to prevent them from overtaking the future?

Like the oblivions of old, the right to be forgotten has a paradoxically memorial function: those who ask for erasure have not yet forgotten their offenses, and their digital

rehabilitation cannot alter the facts of their transgressions. I am thinking in particular here of a Belgium man named Olivier G., who killed two people in a drunk driving accident in 1994. In 2006, he was "rehabilitated" under Belgian law after serving out his conviction on multiple charges. In 2008, he sued a French paper for continuing to maintain records of his role in the accident online, and the European Court of Human Rights ultimately ruled that the paper had to delete his name from its past articles and replace it with the letter "X." Owing to the press coverage of the case, we all know very well that he is "X." And he himself is unlikely to forget it.

Yet his case still raises the inevitable question: what does oblivion mean for historical knowledge? By embracing its possibilities, do we also open ourselves up to the erasure of records, of historical truth? In *The Interpretation of History*, in 1909, Max Nordau lamented the "almost organic indifference of mankind to the past," and writes of the "stern law of oblivion" that limits the transmission of memory to no more than three generations. "It is in records, and not in the consciousness of man, that the historical part is preserved," he observed. And yet, as Nietzsche warned, an over-reliance upon record-keeping, upon archiving, preserving, and documenting — the features of his "superhistorical" person — can also snuff out our will to live in the present, our ability to see the world clearly before us. Every archivist knows that doing the job right requires a balance of preservation and destruction, that it is irresponsible and even unjust to save everything from obliteration. This is especially true in instances where penance has been paid, vengeance taken, time served, justice achieved so fully that it has begun to undermine its own wise and measured conclusions. "For with a certain excess of history, living crumbles away and degenerates," Nietzsche admonished.

36

"Moreover, history itself also degenerates through this decay."

It is a mistake to understand history as operating in opposition to forgetting. Ernest Renan made this error when, in 1882, he famously observed that "the act of forgetting, I would even say, historical error, is an essential factor in the creation of a nation, which is why progress in historical studies often constitutes a danger for nationality." In fact, history is as much a vehicle for forgetting as it is for remembering: when we remind ourselves that histories are written by the victors, this is what we mean. History is always edited, and oblivion acts a kind of editorial force on the historical record, though of course history may be edited according to many criteria of significance and some historians may prefer one oblivion to another. To embrace the idea of oblivion, however, is to try to redirect the inevitable erasures of the historical record toward the pursuit of a more just and liberated future – to take moral advantage of the room, and the freedom, that we are granted by forgetfulness.

Besides, every act of forgetting, as Loraux reminds us, "leaves traces." There can be no absolute forgetting, just as there is no possibility of total memory. Every time I encounter a new Act of Oblivion in the archive, I take it as a marker that someone, somewhere, wanted its historical world to be forgotten. And yet there it is, staring back at me on the table. Almost always, whatever conflict prompted the oblivion in the first place is recounted in fine detail alongside the agreement to let bygones be bygones.

Where oblivion was once deployed to reconcile states with themselves and one another, today it is most often invoked in order to restore people to full political citizenship, to repair the relation between subject and sovereign. Oblivion has become individualized. To some extent, it always has been

individualized. Every oath of forgetting required people to look past the transgressions of their neighbors, but not to forget them completely. Nichanian argues that this amounts only to a mere pragmatic performance of reconciliation, which should not be mistaken for absolution. "One should know with whom one is 'reconciling.' One should not confuse friendship and reconciliation," he cautions. "One should be capable of carrying out a 'politics of friendship' instead and in lieu of a 'politics of reconciliation'...one must in any case know what will never be reconciled within reconciliation."

One must never forget with whom one is reconciling; one must forget what came before the reconciliation. These are the contradictory claims that the oath levied upon its swearers. It aimed to obliterate one form of memory while at the same time consecrating another. "I wonder," Loraux asks, "what if banning memory had no other consequences than to accentuate a hyperbolized, though fixed, memory?" The people are reconciled, but they see one another for who they were, and what they did, during the period of tyranny. Nothing is forgotten, and much is owed by one side to the other. This relation, Nichanian writes, is "the irony of being-together, the sole surviving language." What else is there? Oblivion is when one person says to another: I know who you have been, and what you have done, but I will pretend not to remember, and I offer you my friendship, and we will live amicably together. Call it pragmatism, call it decency, call it politics. (Call it quaint.) In the absence of forgiveness, which usually never comes, it may be our only hope.

MICHAEL IGNATIEFF

The History of My Privileges

Is it possible to be a historian of your own life? To see yourself as a figure in the crowd, as a member of a generation who shared the same slice of time? We cannot help thinking of our own lives as uniquely our own, but if we look more closely, we begin to see how much we shared with strangers of our own age and situation. If we could forget for a moment what was singular about our lives and concentrate instead on what we experienced with everyone else, would it be possible to see ourselves in a new light, less self-dramatizing but possibly more truthful? What happens when I stop using "I" and start using "we"?

What "we" are we talking about here? Which "we" is my "we"?

An old joke comes to mind. The Lone Ranger and Tonto are surrounded by Indian warriors. The situation looks bad. The Lone Ranger turns to Tonto. "What do we do now?" Tonto replies, "What do you mean 'we', white man?" The "we" to which I refer and belong were the white middle-class of my generation, born between 1945 and 1960, and my theme is what we made of our privileges, and once we understand them as such, what we did to defend them.

We were, for a time, really something. We were the biggest birth cohort in history. We made up more than half the population and we held all the power, grabbed as much of the wealth as we could, wrote the novels that people read, made the movies that people talked about, decided the political fate of peoples. Now it's all nearly over. Every year more of us vanish. We have shrunk down to a quarter of the total population, and power is slipping from our hands, though two of us, both presidents, are squaring up for a final battle. It will be a last hurrah for them, but for us as well, a symbol of how ruthlessly we clung on, even when our time was up.

The oldest among us were born when Harry Truman was in the White House, Charles de Gaulle in the Elysee Palace, Konrad Adenauer in the Chancery in Bonn, George VI on the throne at Buckingham Palace, and Joseph Stalin in the Kremlin. We were the happy issue of a tidal wave of love and lust, hopes and dreams that swept over a ruined world after a decade of depression and war. My parents, both born during the First World War, met in London during the Second, two Canadians who had war work there, my father at the Canadian High Commission, my mother in British military intelligence. They had gone through the Blitz and the V-2's, fallen for other people, and at war's end decided to return to Canada and get married.

I once made the mistake of saying to my mother that I envied their wartime experience. It had tragedy in it, and tragedy, to a child, seems glamorous. She cut me short. It wasn't like that, she said gently, I hadn't understood. She knew what desolation and loss felt like, and she wanted to spare my brother and me as much as she could. I see now that her reticence was characteristic of a whole generation — for example, the rubble women in Berlin, Hamburg, Dresden, and other German cities, who cleared debris away with their bare hands and never talked about being raped by Russian soldiers; the survivors of the death camps who concealed the tattoo on their forearm; the women who went to the Gare de l'Est in Paris in the summer of 1945, waiting, often in vain, to greet emaciated lovers and husbands returning from deportation. My mother was one of those who waited for a man who never made it back. He was a silent presence in the house throughout my childhood, the man she would have married had he not died in Buchenwald. She kept her sorrow to herself and found someone else — my father — and they brought new life into the world.

I am the child of their hope, and I have carried their hopefulness with me all my life. Beside hope, they also gave us the houses and apartments we took our first steps in, the schools and universities that educated us, the highway systems we drive to this day, the international system — UN, NATO, and nuclear weapons — that still keeps us out of another world war, the mass air travel that shrank the world, the moon landing that made us dream of life beyond our planet, and the government investments in computing in the 1940s and 1950s that eventually led in the 1990s, to the laptop, the internet, and the digital equivalent of the Library of Alexandria on our phones. The digital pioneers of my generation — Jobs, Wozniak, Gates, Ellison, Berners-Lee, and so on — built

41

our digital world on the public investments made by the previous generation.

Thanks to the hospitals and the clinics that our parents built, the medical breakthroughs that converted mortal illnesses into manageable conditions, together with our fastidious diets and cult of exercise, our not smoking or drinking the way they did, we will live longer than any generation so far. I take pills that did not exist when my father was alive and would have kept him going longer if they had. Medicine may be the last place where we still truly believe in progress. Ninety, so our fitness coaches promise us, will be the new seventy. Fine and good, but that leaves me wondering, what will it be like to go on and on and on?

Our time began with the light of a thousand suns over Alamogordo, New Mexico in July 1945. It is drawing to a close in an era so violent and chaotic that our predictions about the shape of the future seem meaningless. But it would be a loss of nerve to be alarmed about this now. We have lived with disruptive change so long that for us it has become a banality.

My first summer job was in a newsroom echoing to the sound of typewriters and wire-service machines clattering away at full tilt, next door to a press room where the lead type flowed off the compositor's machine down a chute to the typesetting room, where the hands of the typesetters who put the pages together were black with carbon, grease, and ink. Sitting now in a clean room at home, all these decades later, staring into the pale light of a computer screen, it is easy to feel cranky about how much has changed.

But what did not change in our time, what remained stubbornly the same, may be just as important as what did. The New York Times recently reported that in America our age-group, now feeling the first intimations of mortality, is

in the process of transferring trillions of dollars of real estate, stocks, bonds, beach houses, furniture, pictures, jewels, you name it, to our children and grandchildren — "the greatest wealth transfer in history", the paper called it. We are drafting wills to transfer the bourgeois stability that we enjoyed to the next generation. This is a theme as old as the novels of Thackeray and Balzac. The fact that we can transfer such a staggering sum — eighty-four trillion dollars! — tells us that the real history of our generation may be the story of our property. It is the deep unseen continuity of our lives.

Our cardinal privilege was our wealth, and our tenacious defense of it may be the true story of white people in my generation. I say tenacious because it would be facile to assume that it was effortless or universal. From our childhood into our early twenties, we were wafted along by the greatest economic boom in the history of the world. We grew up, as Thomas Piketty has shown, in a period when income disparities, due to the Depression and wartime taxation, were sharply compressed. We had blithe, unguarded childhoods that we find hard to explain to our children: suburban afternoons when we ran in and out of our friend's houses, and all the houses felt the same, and nobody locked their doors. When we hit adulthood, we thought we had it made, and then suddenly the climb became steeper. The post-war boom ground to a halt with the oil shock in the early 1970s, leaving us struggling against a backdrop of rising inflation and stagnant real wages. Only a small number of us — Bezos, Gates, and the others — did astonishingly well from the new technologies just then coming on stream.

Many of the rest of us who didn't become billionaires dug ourselves into salaried professions: law, medicine, journalism, media, academe, and government. We invested in real estate.

43

Those houses and apartments that we bought when we were starting out ended up delivering impressive returns. The modest three-bedroom house that my parents bought in a leafy street in Toronto in the 1980s, which my brother and I sold in the early 2000s, had multiplied in value by a factor of three. He lived on the proceeds until he died, and what's left will go to my children.

Real estate helped us keep up appearances, but so, strangely enough, did feminism. When women flooded into the labor market, they helped their families to ride out the great stagflation that set in during the 1970s. Thanks to them, there were now two incomes flowing into our households. We also had fewer children than our parents and we had them later. Birth control and feminism together with hard work kept us afloat. None of this was easy. Tears were shed. Our marriages collapsed more frequently than our parents' marriages, and so we had to invent a whole new set of arrangements — single parenting, gay families, partnering and cohabitating without marriage — whose effect on our happiness may have been ambiguous, but most of the time helped us to maintain a middle-class standard of living.

Of course, there was a darker side — failure, debt, spousal abuse, drug and alcohol addiction, and suicide. The great novelists of our era — Updike, Didion, Ford, Bellow, and Cheever— all made art out of our episodes of disarray and disillusion. What was distinctive was how we understood our own failure. When we were young, in the 1960s, many of us drew up a bill of indictment against "the system," though most of us were its beneficiaries. As we got older, we let go of abstract and ideological excuses. Those who failed, who fell off the ladder and slid downwards, took the blame for it, while those of us lucky enough to be successful thought we had earned it.

So, as our great novelists understood, the true history of our generation can be told as the history of our property, our self-congratulation at its acquisition, our self-castigation when we lost it, the family saga that played out in all our dwellings, from urban walk-ups to suburban ranch houses, the cars in our driveways, the tchotchkes that we lined up on our shelves and the pictures that we hung on our walls, the luxuriant variety of erotic lives that we lived inside those dwellings, and the wealth that we hope to transmit to our children.

I am aware that such an account of my generation leaves out a great deal, outrageously so. There was a lot more history between 1945 and now, but for the rest of it — the epochal decolonization of Africa and Asia, the formation of new states, the bloody battles for self-determination, the collapse of the European empires, the astonishing rise of China — the true imperial privilege of those lucky enough to be born in North America and Western Europe was that we could remain spectators of the whole grand and violent spectacle. Out there in the big wide world, the storm of History was swirling up the dust, raising and dashing human hopes, sweeping away borders, toppling tyrants, installing new ones, and destroying millions of innocents, but none of it touched us. We must not confuse ourselves with the people whose misfortune provoked our sympathies. For us, history was a spectator sport we could watch on the nightly news and later on our smartphones. The history out there gave us plenty of opportunity to have opinions, offer analyses, sell our deep thoughts for a living, but none of it threatened us or absolutely forced us to commit or make a stand. For we were safe.

The History of My Privileges

Safety made some of us restless and we longed to get closer to the action. I was one of those who ventured out to witness History, in the Balkans, in Afghanistan, in Darfur. We made films, wrote articles and books, sought to rouse consciences back home and change policies in world capitals. We prided ourselves on getting close to the action. Hadn't Robert Capa, the great photographer who was killed when he stepped on a landmine in Vietnam, famously remarked that if your photographs aren't any good, it's because you aren't close enough? So we got close. We even got ourselves shot at.

In the 1990s, I went out and made six films for the BBC about the new nationalism then redrawing the maps of the world in the wake of the collapse of the Soviet Union. I can report that nothing was more exciting. A Serb paramilitary, whom I had interviewed in the ruins of Vukovar in eastern Croatia in February 1992, took a random couple of shots at the crew van as we were driving away, and later another group of drunken combatants grabbed the keys out of the van and brought us to a juddering halt and an uneasy hour of interrogation, broken up by the arrival of UN soldiers well enough armed to brook no argument. I had other adventures in Rwanda and Afghanistan, but the Balkans were as close as I ever came to experiencing History as the vast majority of human beings experience it — vulnerably. These episodes of peril were brief. We all had round trip tickets out of the danger zone. If History got too close for comfort, we could climb into our Toyota Land Cruisers and get the hell out. I can't feel guilty about my impunity. It was built into the nature of our generation's relation to History.

Anybody who ventured out into the zones of danger in the 1990s knew there was something wrong with Francis Fukuyama's fairy tale that history had ended in the final

victory of liberal democracy. It certainly didn't look that way in Srebrenica or Sarajevo. History was not over. It never stopped. *It never does.* In fact, it took us to the edge of the abyss several times: in the Cuban missile crisis; when King and the Kennedys were shot; in those early hours after September 11; and most recently during the insurrection of January 6, 2021, when wild violence put the American republic in danger. Those were moments when we experienced History as vertigo.

The rest of the time, we thought we were safe inside "the liberal rules-based international order." After 1989, you could believe that we were building such a thing: with human rights NGO's, international criminal tribunals, and transitions to democracies in so many places, South Africa most hopefully of all. Actually, in most of the world, there were precious few rules and little order, but this didn't stop those of us in the liberal democratic West from believing that we could spread the impunity that we enjoyed to others. We were invested in this supposed order, enforced by American power, because it had granted us a lifetime's dispensation from history's cruelty and chaos, and because it was morally and politically more attractive than the alternatives. Now my generation beholds the collapse of this illusion, and we entertain a guilty thought: it will be good to be gone.

Smoke haze from forest fires in Canada is drifting over our cities. Whole regions of the world — the olive groves of southern Spain, the American southwest, the Australian outback, the Sahel regions of Africa — are becoming too hot to sustain life. The coral reefs of Australia, once an underwater wonder of color, are now dead grey. There is a floating mass of plastic bottles out in the Pacific as big as the wide Sargasso Sea. My generation cannot do much about this anymore, but we

know that we owe the wealth that we are handing over to our children to high life in the high noon of fossil fuels.

At least, we like to say, our generation woke up before it was too late. We read *Silent Spring* and banned DDT. We created Earth Day in 1970 and took as our talisman that incredible photo of the green-blue earth, taken by the astronaut William Anders floating in space. We discovered the hole in the ozone layer and passed the Montreal protocol that banned the chemicals causing it. We began the recycling industry and passed legislation that reduced pollution from our stacks and tailpipes; we pioneered green energy and new battery technologies. Our generation changed the vocabulary of politics and mainstreamed the environment as a political concern. Concepts such as the ecosphere and the greenhouse gas effect were unknown when we were our kids' age. Almost the entirety of modern climate science came into being on our watch. With knowledge came some action, including those vast lumbering UN climate conferences.

Look, we say hopefully, the energy transition is underway. Look at all those windmills, those solar farms. Look at all the electric cars. They're something, aren't they? But we are like defendants entering a plea in mitigation. The climate crisis is more than a reproach to our generation's history of property and consumption. It is also an accusation directed at our penchant for radical virtue-signaling followed by nothing more than timid incrementalism. The environmental activists sticking themselves to the roads to stop traffic and smearing art treasures with ketchup are as tired of our excuses as we are of their gestural politics.

Our children blame us for the damaged world that we will leave them, and they reproach us for the privileges that they will inherit. My daughter tells me that in her twelve

48

years of working life as a theater producer in London, she has interviewed for jobs so many times she has lost count. In fifty years of a working life, I interviewed only a handful of times. The competitive slog that her generation takes for granted is foreign to me. The entitlement, dumb luck, and patronage I took for granted is a world away from the grind that her cohort accepts as normal. She said to me recently: you left us your expectations, but not your opportunities.

Like many of her generation, she grew up between parents who split when she was little. Like other fathers of my generation, I believed that divorce was a choice between harms: either stay in a marriage that had become hollow and loveless or find happiness in new love and try, as best you could, to share it with the kids. My children even say that it was for the best, but I cannot forget their frightened and tearful faces when I told them I was leaving. These personal matters that should otherwise stay private belong in the history of a generation that experienced the sexual revolution of the 1960s and took from that episode a good deal of self-justifying rhetoric about the need to be authentic, to follow your true feelings, and above all to be free.

Our children are reckoning with us, just as we reckoned with our parents. Back then, we demanded that our parents explain how they had allowed the military-industrial complex to drag us into Vietnam. We marched against the war because we thought it betrayed American ideals, and even a Canadian felt that those ideals were his, too. Those further to the left ridiculed our innocence. Didn't we understand that "Amerika" never had any ideals to lose? There were times, especially after the shooting of students at Kent State, when I almost agreed with them.

I was a graduate student at Harvard when we bussed down to Washington in January 1973 for a demonstration against

Nixon's second inauguration. It was a huge demonstration and it changed nothing. Afterwards some of us took shelter at the Lincoln Monument. Righteous anger collapsed into tired disillusion. I can still remember the hopelessness that we felt as we sat at Lincoln's feet. Two and half years later, though, the helicopters were lifting the last stragglers off the roof of the American embassy in Saigon, so we did achieve something.

Vietnam veterans came home damaged in soul and body, while radicals I marched with ended up with good jobs in the Ivy League. Does that make Vietnam the moment when the empire began to crack apart? The idea that Vietnam began the end of "the American century" remains a narrative that our generation uses to understand our place in history. Behold what we accomplished! It is a convention of sage commentary to this day, but really, who knows?

The colossus still bestrides the world. The leading digital technologies of our time are still owned by Americans; Silicon Valley retains its commanding position on the frontiers of innovation. The United States spends eight hundred-billion dollars on defense, two and half times its European allies and China. America's allies still will not take a significant step on their own until they have cleared it with Washington. Nobody out there loves America the way they did in the heyday of Louis Armstrong, Ella Fitzgerald, Walt Disney, and Elvis Presley; the universal domination of American popular music, mainly in the form of rap and hip hop, no longer makes America many friends. Yet the United States still has the power to attract allies and to deter enemies. It is no longer the world's sole hegemon, and it cannot get its way the way it used to, but that may be no bad thing. The stories of American decline give us the illusion that we know which way time will unfold, and encourage us in a certain acquiescence. Fatalism is relaxing.

The truth is that we have no idea at all. The truth is that we still have choices to make.

American hegemony endures, but the domestic crisis of race, class, gender, and region that first came to a head when we were in our twenties polarizes our politics to this day. As the 1960s turned into the 1970s, there were times, in the States but in Europe too, when the left hoped that revolution was imminent and the right dug in to defend its vanishing verities. The assassinations of Martin Luther King, Jr. and Robert Kennedy, followed by the police violence at the Chicago Democratic Convention in August 1968, led some of my generation — Kathy Boudin, Bernadine Dohrn, Bill Ayers, the names may not mean much anymore — to transition from liberal civil rights and anti-Vietnam protest to full-time revolutionary politics. What followed was a downward spiral of bombings, armed robberies, shoot-outs that killed policemen, and long jail-time for the perpetrators. Decades later I met Bernadine Dohrn at Northwestern Law School, still radical, still trailing behind her the lurid allure of a revolutionary past, but now an elegant law professor. Her itinerary, from revolution to tenure, was a journey taken by many, and not just in America. In Germany, the generation that confronted their parents about their Nazi past spawned a revolutionary cadre — the Baader-Meinhof gang and the Red Army Faction— who ended dead or in jail or in academe. In Italy, my generation's confrontation with their parents ended with "the decade of lead," bombings, political assassination, jail, and once again, post-revolutionary life in academe.

Those of us who lived through these violent times got ourselves a job and a family and settled down to bourgeois life, and now we resemble the characters at the end of Flaubert's *Sentimental Education,* wondering what a failed revolution did

to us. For some, the 1960s gave us the values that we espouse to this day, while for others it was the moment when America lost its way. We are still arguing, but both sides carry on the shouting match within secure professions and full-time jobs. Nobody, at least until the Proud Boys came around, wants an upheaval anymore. What changed us, fundamentally, is that in the 1970s we scared ourselves.

And so we settled for stability instead of revolution, though we should give ourselves some credit for ending an unjustified war and wrenching the political system out of the collusive consensus of the 1950s. My generation of liberal whites also likes to take credit for civil rights, but the truth is that most of us watched the drama on television, while black people did most of the fighting and the dying. All the same, we take pride that in our time, in 1965, America took a long-resisted step towards becoming a democracy for all Americans. Our pride is vicarious, and that may mean it isn't quite sincere. Our other mistake was in taking yes for an answer too soon. We believed that the civil rights revolution in our time was the end of the story of racial justice in America, when in fact it was just the beginning.

The reckoning with race became the leitmotiv of the rest of our lives. I grew up in a Toronto that was overwhelmingly white. What we thought of as diversity were neighborhoods inhabited by Portuguese, Italian, Greek, or Ukrainian immigrants. The demographers now say that, if I live long enough, I will soon be in a minority in my city of birth. Fine by me, but it's made me realize that I never grasped how much of my privilege depended on my race. My teenage friends and I never thought of ourselves as white, since whiteness was all we knew. Now, fifty years later, we are hyper-sensitively aware of our whiteness, but we still live in a mostly white world.

At the same time, the authority of that world has been placed in question as never before, defended as a last redoubt of security by frightened conservatives, and apologized for, without end, by liberals and progressives.

Some white people, faced with these challenges to our authority, are apt to speak up for empathy, to claim that race is not the limit of our capacity for solidarity, while other white people say to hell with empathy and vote instead to make America great again. Liberals are correct to insist that racial identity must not be a prison, but claims to empathy are also a way to hold on to our privileges while pretending we can still understand lives that race has made different from our own. While I do not regard the color of my skin as the limit of my world, or as the most significant of my traits, I can see why some other people might.

Nor has whiteness been my only privilege, or even the source of all the others. An inventory of my advantages, some earned, most inherited, would include being male, hetero-sexual, educated, and well housed, pensioned and provided for, with a wife who cares about me, children who still want to see me, parents who loved me and left me in a secure position. I am the citizen of a prosperous and stable country, I am a native speaker of the lingua franca of the world, and I am in good health.

I used to think that these facts made me special. Privileges do that to you. Now I see how much of my privilege was shared with those of my class and my race. I am not so special after all. I also see now that, while privileges conferred advantages, some of them unjust, they also came with liabilities. They blinded me to other people's experience, to the facts of their shame and suffering. My generation's privileges also make it difficult for me to see where History may be moving.

The History of My Privileges

My frame of relevant experience omits most of the planet outside the North Atlantic at precisely the moment when History may be moving its capital to East Asia forever, leaving behind a culture, in Europe where I live, of museums, recrimination, and decline. There is plenty here that I cherish, but I cannot escape a feeling of twilight, and I wonder whether the great caravan may be moving on, beyond my sight, into the distance.

Everybody comes to self-consciousness too late. This new awareness of privilege, however late it may be, is perhaps the most important of all the changes that History has worked upon my generation. What we took for granted, as ours by inheritance or by right, is now a set of circumstances that we must understand, apologize for, or defend. And defend it we do. We moralized our institutions—universities, hospitals, law firms—as meritocracies, when they were too often only reserves for people like us. When challenged, we opened up our professions to make them more diverse and inclusive, and this makes us feel better about our privileges, because we extended them to others. "Inclusion" is fine, as long as it is not an alibi for all the exclusions that remain.

As white persons like me edge reluctantly into retirement, our privileges remain intact. Our portion of that money — the eighty-four trillion dollars — that we are going to hand over to the next generation tells us that we have preserved the privilege that matters most of all: transmitting power to our kith and kin. Closing time is nigh and raging against the dying of the light is a waste of time. What matters now is a graceful exit combined with prudent estate planning.

Not all privileges are captured by the categories of wealth, race, class, or citizenship. I have been saving the most important of my privileges for last.

This one is hidden deep in my earliest memory. I am three years old, in shorts and a T-shirt, on P Street in Georgetown, in Washington, D.C. P Street was where my parents rented a house when my father worked as a young diplomat at the Canadian Embassy. It is a spring day, with magnolias in bloom, bright sunshine, and a breeze causing the new leaves to flutter. I walk up a brick sidewalk towards a white house set back from the street and shaded by trees. I walk through the open door into the house, with my mother at my side. We are standing just inside the door, looking out across a vast room, or so it seems from a child's-eye view, with high ceilings, white walls, and another door open on the other side to a shaded garden.

The large light-filled room is empty. I don't know why we are here, but now I think it was because my mother was pregnant with my little brother, and she was looking the place over as a possible rental for a family about to grow from three to four. We stand for an instant in silence, surveying the scene. Suddenly the front door slams violently behind us. Before our astonished eyes, the whole ceiling collapses onto the floor, in a cloud of dust and plaster. I look up, the raw woodwork slats that held the ceiling plaster are all exposed, like the ribs on the carcass of some decayed animal. The dust settles. We stand there amazed, picking debris out of our hair.

I don't know what happened next, except that we didn't rent the house.

It is a good place to end, on a Washington street in 1950, at the height of the Korean War, in the middle of Senator McCarthy's persecutions, that bullying populism which is never absent from democracy for long and which had all

55

my father's and mother's American friends indignant, but also afraid of Senate hearings, loss of security clearances, and dismissal. I knew nothing of this context, of course. This memory, if it is one at all—it could be a story I was told later — is about a child's first encounter with disaster. I begin in safety, walking up a brick path, in dappled sunlight. I open a door and the roof falls in. Disaster strikes, but I am safe.

At the very center of this memory is this certainty: I am holding my mother's hand. I can feel its warmth this very minute. Nothing can harm me. I am secure. I am immune. I have clung to this privilege ever since. It makes me a spectator to the sorrows that happen to others. Of all my privileges, in a century where history has inflicted so much fear, terror, and loss on so many fellow human beings, this sense of immunity, conferred by the love of my parents, her hand in mine, is the privilege which, in order to understand what happens to others, I had to work hardest to overcome.

But overcome it I did. I was well into a fine middle age before life itself snapped me awake. When, thirty-seven years after that scene in Washington, I brought my infant son to meet my mother, in a country place that she had loved, and she turned to me and whispered, who is this child? recognizing neither me nor her first grandchild, nor where she was, I understood then, in that moment, as one must, that all the privileges I enjoyed, including a mother's unstinting love, cannot protect any of us from what life — cruel and beautiful life — has in store, when the light begins to fade on the road ahead.

TIMOTHY NOAH

A Prayer for the Administrative State

In February 2017, Steve Bannon, then senior counselor and chief strategist to President Donald Trump, pledged to a gathering of the Conservative Political Action Conference (CPAC; initiates pronounce it "See-Pack") that the Trump administration would bring about "the deconstruction of the administrative state." Bannon's choice of the word "deconstruction" raises some possibility that he had in mind a textual interrogation in the style of Derrida. Laugh if you want, but Bannon claims an eclectic variety of intellectual influences, and the anti-regulatory movement that Bannon embraced did begin, in the 1940s, as a quixotic rejection of that same empiricism against

which Derrida famously rebelled (*"Il n'y a pas de hors-texte"*). More likely, though, Bannon was using the word "deconstruction" as would a real estate tycoon such as his boss, to mean dismantlement and demolition. The "progressive left," Bannon told See-Pack, when it can't pass a law, "they're just going to put in some sort of regulation in an agency. That's all going to be deconstructed and I think that that's why this regulatory thing is so important." Kaboom!

Already the wrecking ball was swinging. Reactionary federal judges had for decades been undermining federal agencies, egged on by conservative scholars such as Philip Hamburger of Columbia Law School, the author in 2014 of the treatise, *Is Administrative Law Unlawful?* Anti-regulation legal theorists are legatees of the "nine old men" of the Supreme Court who, through much of the 1930s, resisted President Franklin Roosevelt's efforts to bring regulation up to date with the previous half-century of industrialization. The high court made its peace with the New Deal in 1937 after Roosevelt threatened to expand its membership to fifteen. Today's warriors against the administrative state see this as one of history's tragic wrong turns.

As president, Trump attacked the administrative state not to satisfy any ideology (Trump possesses none) but to pacify a business constituency alarmed by Trump's protectionism, his Muslim-baiting, his white-nationalist-coddling, and all the rest. "Every business leader we've had in is saying not just taxes, but it is also the regulation," Bannon told CPAC. But does the war against the administrative state hold appeal for ordinary Republican voters? The rank and file don't especially hate government regulation of corporations except insofar as they hate government in general (especially when Democrats are in charge). They certainly don't wish to succor the S&P

500, which, as Comrade Bannon made clear, is what the war on the administrative state is all about. Between August 2019 and October 2022, a Pew survey found, the proportion of Republicans and Republican leaners willing to say large corporations had a positive effect on America plummeted from fifty-four percent to twenty-six percent. Bannon's vilification of the administrative state would therefore appear to run in a direction opposite that of Trump voters. The *nomenklatura* loved it at CPAC, but the words "administrative state" make normal people's eyes glaze over.

During his four years in office, Trump achieved only limited success dethroning the administrative state. On the one hand, he gummed up the works to prevent new regulations from coming out. The conservative American Action Forum calculated that during Trump's presidency the administrative state imposed about one-tenth the regulatory costs imposed under President Obama. But on the other hand, Trump struggled to fulfill Bannon's pledge to wipe out existing regulations. Trump's political appointees were too ignorant about how the federal bureaucracy worked to wreak anywhere near the quantity of deconstruction that Trump sought.

To eliminate a regulation requires that you follow, with some care, certain administrative procedures; otherwise a federal judge will rule against you. The bumbling camp followers that Trump put in charge of the Cabinet and the independent agencies lacked sufficient patience to get this right, and the civil servants working under them lacked sufficient motive to help them. According to New York University's Institute for Policy Integrity, the Trump administration prevailed in legal challenges to its deregulatory actions only twenty-two percent of the time. Granted, in many instances where Trump lost, as the Brookings Institution's

Philip A. Wallach and Kelly Kennedy observed, he "still succeeded in weakening, if not erasing, Obama administration policy." But after Biden came in, the new president set about reversing as many of Trump's deregulatory actions as possible, lending a Sisyphean cast to the deconstruction of the administrative state. Just in Biden's first year, the American Action Forum bemoaned that he imposed regulatory costs at twice the annual pace set by Obama.

Clearly the only way Republicans can win this game is to gum up the regulatory works during both Republican and Democratic administrations. Distressingly, Trump will likely take a long stride toward achieving that goal in the current Supreme Court term. The vehicle of this particular act of deconstruction is a challenge to something called *Chevron* deference, by which the courts are obliged to grant leeway to the necessary and routine interpretation of statutes by regulatory agencies. The Supreme Court heard two *Chevron* cases in January and is expected to hand down an opinion in the spring. At oral argument, two of Trump's three appointees to the high court, Neil Gorsuch and Brett Kavanaugh, were more than ready to overturn *Chevron*, along with Clarence Thomas and Samuel Alito. Chief Justice John Roberts, though more circumspect, appeared likely to join them, furnishing the necessary fifth vote. In killing off *Chevron* deference, the right hopes not only to prevent new regulations from being issued, but also to prevent old ones from being enforced. This is the closest the business lobby has gotten in eighty-seven years to realizing its dream to repeal the New Deal.

60

The administrative state is often described as a twentieth-century invention, but in 1996, in his book *The People's Welfare: Law and Regulation in 19th Century America*, William J. Novak, a legal historian at the University of Michigan, showed that local governments were delegating police powers to local boards of health as far back as the 1790s, largely to impose quarantines during outbreaks of smallpox, typhoid, and other deadly diseases. In 1813 a fire code in New York City empowered constables to compel bystanders to help extinguish fires; bucket brigades were not voluntary but a type of conscription. The same law contained two pages restricting the storage and transport of gunpowder, and forbade any discharge of firearms in a populated area of the city. These rules were accepted by the public as necessary to protect health and safety.

In 1872, Benjamin Van Keuren, the unelected street commissioner of Jersey City, received complaints about "noxious and unwholesome smells" from a factory that boiled blood and offal from the city's stockyard, and mixed it with various chemicals, and cooked it, and then ground it into fertilizer. The Manhattan Fertilizing Company ignored Van Keuren's demand that it cease befouling the air, so Van Keuren showed up with twenty-five policemen, disabled the machinery, and confiscated assorted parts of it. The fertilizing company then sued Van Keuren for unreasonable search and seizure and the taking of property without due process or just compensation. But the street commissioner was carrying out a duty to address public nuisances that had been delegated to him by the city's board of aldermen, and the judge ruled in Van Keuren's favor.

As the latter example illustrates, government regulation grew organically alongside industrialism's multiplying impositions on the general welfare. As with industrialism itself, this mostly began with the railroads. Thomas McCraw,

61

in *Prophets of Regulation*, in 1984, identified as America's first regulatory agency the Rhode Island Commission, created in 1839 to coax competing railroad companies into standardizing schedules and fees. Railroads themselves only barely existed; the very first in the United States, which were in Baltimore and Ohio, had begun operations a mere nine years earlier. At the federal level, the first regulatory agency, the Interstate Commerce Commission, was invented in 1887 likewise to regulate railroads.

From the beginning, the railroads' vast economic power was seen as a threat to public order. In 1869, Charles Francis Adams, Jr. — great-grandson to John Adams and brother to Henry Adams — complained that the Erie Railway, which possessed "an artery of commerce [Jersey City to Chicago] more important than ever was the Appian Way," charged prices sufficiently extortionate to invite comparisons to the Barbary pirates. "They no longer live in terror of the rope, skulking in the hiding-place of thieves," Adams wrote, "but flaunt themselves in the resorts of trade and fashion, and, disdaining such titles as once satisfied Ancient Pistol or Captain Macheath, they are even recognized as President This or Colonel That." Railroads represented the industrial economy's first obvious challenge to the Constitution's quaint presumption that commerce would forever occur chiefly within rather than between the states, and therefore lie mostly outside the purview of Congress. By the early twentieth-century, interstate commerce was becoming the rule rather than the exception.

A parallel development was the passage, in 1883, of the Pendleton Civil Service Act. After the Civil War, an unchecked "spoils system" of political patronage corrupted the federal government, making bribery and the hiring of incompetents

the norm. A delusional and famously disappointed office-seeker named Charles Guiteau closed this chapter by assassinating President James Garfield. Guiteau had expected, despite zero encouragement, that he would be appointed consul to Vienna or Paris. He went to the gallows believing that he had saved the spoils system — a martyr in the cause of corruption! — but instead he had discredited it. The Pendleton Act left it up to the president and his Cabinet to determine what proportion of the federal workforce would be hired based on merit as part of a new civil service. As a result, civil servants rose rapidly from an initial ten percent of federal workers in 1884 to about forty percent in 1900 to nearly eighty percent in 1920. Today about ninety percent of the federal civilian workforce consists of civil servants.

With the establishment of a civil service, it quickly became evident that government administration was becoming a professional discipline requiring its own expertise. In 1886, in an influential essay called "The Study of Administration," Woodrow Wilson (then a newly minted PhD in history and government) argued that it lay "outside the proper sphere of politics." Democratic governance, Wilson wrote,

> does not consist in having a hand in everything, any
> more than housekeeping necessarily consists in cooking
> dinner with one's own hands. The cook must be trusted
> with a large discretion as to the management of the fires
> and the ovens.

If Wilson's analogy strikes you as aristocratic, recall that he was writing at a time when it wasn't exceptional for a middle-class family to employ a full-time cook. If Wilson were writing today, he would more likely say that you don't need to be an

auto mechanic to drive your car. His point was that elected officials lacked sufficient expertise to address the granular details of modern government administration. "The trouble in early times," Wilson explained,

> was almost altogether about the constitution of government; and consequently that was what engrossed men's thoughts. There was little or no trouble about administration, — at least little that was heeded by administrators. The functions of government were simple, because life itself was simple. [But] there is scarcely a single duty of government which was once simple which is not now complex; government once had but a few masters; it now has scores of masters. Majorities formerly only underwent government; they now conduct government. Where government once might follow the whims of a court, it must now follow the views of a nation. And those views are steadily widening to new conceptions of state duty; so that, at the same time that the functions of government are every day becoming more complex and difficult, they are also vastly multiplying in number. Administration is everywhere putting its hands to new undertakings.

Government required assistance from unelected officials who possessed expertise, and a new type of training would be required to prepare them. In 1924, Syracuse University answered the call by opening the Maxwell School, the first academic institution in America to offer a graduate degree in public administration.

All this took place before the advent of the Progressive Era, the historical moment when, conservatives often complain,

Jeffersonian democracy died. In fact, as Novak argues persuasively in his recent book *New Democracy: The Creation of the Modern American State*, Congress had been expanding its so-called "police power" (i.e., regulatory power) since the end of the Civil War. The Progressive Era spawned only two new federal regulatory agencies, the Food and Drug Administration in 1906 and the Federal Trade Commission. What most distinguishes the Progressive Era is that its leading thinkers—among them Woodrow Wilson, Herbert Croly (the founding editor of *The New Republic*), and John Dewey — articulated more fully than before the rationale for an expanded federal government. Surveying America's industrial transformation, they concluded that state houses would never possess sufficient means to check the power of corporations. "The less the state government have to do with private corporations whose income is greater than their own," Croly observed tartly, "the better it will be for their morals." It remains true today that state and local government officials are much easier for businesses to buy off or bully than their counterparts in Washington. That is the practical reality behind conservative pieties about the virtues of federalism and small government.

What Croly said of state government could be applied equally to the judiciary. Through the first half of the nineteenth century, if a farm or small business engaged in activity that caused social harm, redress would typically be sought in the courts. Since damages weren't likely very large, the Harvard economists Edward L. Glaeser and Andrei Shleifer have explained, the offending party had little motive — and, given its small scale, little ability — to "subvert justice," that is, to bribe a judge. As the offending firms got bigger in size and wealth, "the social costs of harm grew roughly proportionately, but the costs of subverting justice did not." To a railroad

baron or a garment merchant, judges could (and often were) bought with pocket change. Wilson noted the problem during his campaign for president in 1912: "There have been courts in the United States which were controlled by the private interests…. There have been corrupt judges; there have been judges who acted as other men's servants and not as servants of the public. Ah, there are some shameful chapters in the story!"

It took the catastrophe of the Great Depression to establish the countervailing federal power necessary to make rich corporations behave. President Franklin Roosevelt and Congress created more than forty so-called "alphabet agencies." Most of these no longer exist, but many remain, including the Federal Communication Commission (FCC), the Federal Deposit Insurance Corporation (FDIC), and the National Labor Relations Board (NLRB). During Roosevelt's first four years in office the Supreme Court limited the creation of such agencies, following three decades of anti-regulatory precedent that sharply restricted federal power under the Commerce Clause. This is commonly known as the "*Lochner* era," but that is slightly misleading because *Lochner v. New York*, a 1905 ruling against a regulation establishing maximum work hours for bakers, addressed power at the state level, where the Commerce Clause does not directly apply. In truth, *Lochner*-era justices didn't like regulation, period, and found reasons to limit it in Washington and state capitals alike.

For Roosevelt, matters came to a head in February 1937. Fresh from re-election and miffed that the Supreme Court had struck down the National Industrial Recovery Act, the Agricultural Adjustment Act, and assorted lesser New Deal programs,

Roosevelt introduced a bill to pack the Supreme Court with six additional judges. The legislation went nowhere, but the mere threat was apparently sufficient to liberalize the high court's view of the Commerce Clause, starting with *NLRB v. Jones & Laughlin Steel Corp.* (1937), which gave Congress jurisdiction over commerce that had only an indirect impact on interstate commerce. A legal scholar would explain this shift in terms of subtle jurisprudential currents, but I find the simpler and more vulgar explanation—Roosevelt's application of brute force—more than sufficient. After *NLRB v. Jones & Laughlin Steel Corp.*, fifty-eight years passed before the Supreme Court sided with any Commerce Clause challenge, and the few instances where it did so were fairly inconsequential.

With that battle lost, conservative criticism of the administrative state shifted away from the broad question of whether Congress possessed vast powers to regulate business to the narrower one of whether it could or should delegate those powers to executive-branch agencies. The critique's broad outlines were laid down by Dwight Waldo, a young political scientist with New Deal experience working in the Office of Price Administration and the Bureau of the Budget. It was Waldo who popularized the phrase "the administrative state" in 1948 in a book of that name. *The Administrative State* is an attack on empiricism — or more precisely, the positivism of Auguste Comte, the French social thinker who from 1830 to 1842 published in six volumes his *Cours de Philosophie Positive,* which inspired Comtean movements of bureaucratic reason around the world.

The Progressive Era had articulated a need for apolitical experts to weigh business interests against those of the public on narrow questions that required some expertise. The New Deal had committed the federal government to applying

such expertise on a large scale, creating for the first time a kind of American technocracy. Waldo did not believe that narrow regulatory questions could be resolved objectively. He surrounded the phrase *scientific method* with quotation marks. He complained that writers on public administration showed a bias toward urbanization (when really it was the American public that showed this bias, starting in the 1920s, by situating themselves more in cities than in rural places). He questioned the notion of progress and scorned what he called "the gospel of efficiency." To Waldo, it was "amazing what a position of dominance 'efficiency' assumed, how it waxed until it had assimilated or overshadowed other values, how men and events came to be degraded or exalted according to what was assumed to be its dictate." Waldo deplored the influence of Comte. Like positivists, he complained, public administrators "seek to eliminate metaphysic and to substitute measurement."

Unlike most critics of the administrative state, Waldo is fun to read, and he was even right up to a point. Public policy is not as value-free as cooking a meal or repairing an automobile. "Metaphysic," meaning a larger philosophical framework, may have a role to play; there are more things in heaven and earth, etc. But a lot depends on what sort of problem it is that we are trying to solve. The question of how much water should flow through your toilet doesn't rise to the metaphysical. Waldo's anti-positivism created the template that industry later adopted against every conceivable regulation: sow doubt about scientific certainty and exploit that doubt to argue either that a given problem's causes or a proposed solution's efficacy is unproveable. Shout down the gospel of efficiency with a gospel of uncertainty. Do cigarettes cause heart disease or cancer? Hard to say. Does industrial activity cause climate change? We can't assume so. Hankering for "metaphysic" can

68

be used self-interestedly to reopen questions already settled to a reasonable degree by science.

Ironically, though, Waldo's loudest complaint about the administrative state was that its methods too closely resembled those of that same business world that otherwise embraced his critique. To the latter-day corporate blowhard who demands that government be run more like a business, Waldo would say: God forbid! Waldo was especially repelled by Frederick W. Taylor's theories of scientific management and their influence on public administration. Taylor (1856–1915) famously evangelized for improvements in industrial efficiency based on time-motion studies of workers that were sometimes criticized as dehumanizing. (Charlie Chaplin's *Modern Times* is a satire of Taylorism.) "The pioneers," Waldo protested, "began with inquiries into the proper speed of cutting tools and the optimum height for garbage trucks; their followers seek to place large segments of social life — or even the whole of it — upon a scientific basis." Waldo likened the displacement of elected officials by government experts to the displacement of shareholders by managers in what James Burnham, seven years earlier, had termed the "managerial revolution", and what John Kenneth Galbraith, a decade later, would more approvingly call "the new industrial state." To Waldo, it was all social engineering.

Today, of course, the managerial revolution is long dead. The shareholder, or anyway the Wall Street banks, hedge funds, and private equity funds that purport to represent him, holds the whip hand over managers, employees, and consumers. The shareholder value revolution of the 1980s came dressed up with

69

a lot of populist-sounding rhetoric about democratic account-ability, but even at the time nobody seriously believed this accountability would serve anyone but the rich. Its results were beggared investment, proliferating stock buybacks (largely illegal in 1982), and a reduction in labor's share of national income. Conservative warriors against the administrative state similarly seek to serve the rich by minimizing any restraints that society might impose on their capital. As they push to return as much regulatory power as possible to Congress, they, too, farcically apply the rhetoric of democratic accountability.

You think the administrative state came into being as a logical response to the growing power of industry? Nonsense, argued Hamburger in *The Administrative Threat* in 2017, a pamphlet intended to bring his legal analysis to a larger audience. Regulatory agencies arose to check the spread of *voting rights*! The Interstate Commerce Commis-sion was founded seventeen years after the Fifteenth Amendment enfranchised African Americans. The New Deal's alphabet agencies were created a decade after the Nineteenth Amendment enfranchised women. The Environmental Protection Agency, the Consumer Protection Safety Commis-sion, and the Occupational Health and Safety Commission were created a decade after Congress passed the Voting Rights Act. "Worried about the rough-and-tumble character of representative politics," Hamburger writes, "many Americans have sought what they consider a more elevated mode of governance." That would be rule by experts and the cultural elite — the people whom the neoconservatives labelled "the new class." Hamburger uses the milder term "knowledge class", but, as with the old neocons and today's MAGA shock troops, the intent is to denigrate expertise. Never mind that the newly freed slaves were too focused on racial discrimination to spare

70

much thought for rail-rate discrimination, or that Depression-era women were too focused on putting food on the table to fret much about utility public holding companies.

Hamburger's argument leaned heavily on Woodrow Wilson's well-known — and obviously repellent — affinity for eugenics. But even Wilson had to know that the great mass of the knowledge class possessed no greater understanding of how to keep *Escherichia coli* out of canned goods than an unschooled Tennessee sharecropper or an Irish barman. The staggering complexities of industrial and post-industrial society render *all* of us ignoramuses. That is why we must rely on unelected government experts. Too many of the most urgent policy questions facing us — financial reform, climate change, health care — are just too complicated and detailed and arcane for ordinary citizens to master, and it is not an elitist insult to these ordinary citizens to say so.

Equally absurd is the notion that the administrative state is unaccountable. Every regulation that a federal agency issues is grounded in a federal statute enacted by a democratically elected Congress. A regulation is nothing more than the government's practical plan to do something its legislature ordered it to do already. To put out a significant regulation (i.e., one expected to impose economic costs of at least two hundred million dollars), a government agency will usually start by publishing, in the *Federal Register*, an Advance Notice of Proposed Rulemaking. (This and most of what follows is required under the Administrative Procedure Act of 1946.) The advance notice invites all parties (in practice, usually business) either to write the agency or meet with agency officials to discuss the matter. The agency then sets to work crafting a proposed rule, incorporating therein an analysis of the rule's costs and benefits.

It is amply documented that regulatory cost-benefit analyses, which necessarily rely on information from affected businesses, almost always overstate costs by a wide margin. This is not a new phenomenon, or even an especially partisan one. In 1976, for example, the Occupational Health and Safety Administration, under President Gerald Ford, estimated that a rule limiting workers' exposure to cotton dust would cost manufacturers seven hundred million dollars per year. But when a slightly modified version of the rule was implemented in 1978, under President Jimmy Carter, it actually cost manufacturers only two hundred and five million dollars per year. That is a significant difference. In 1982, the Reagan administration, opposed philosophically to regulation as a betrayal of capitalism, and convinced that this particular regulation was too burdensome, called for a review. This time, the cost to manufacturers was found to be an even lower eighty-three million dollars per year.

After the agency in question has (over)estimated the cost of its proposed rule, it submits a draft to the White House Office of Information & Regulatory Affairs (OIRA). Here the draft is subjected to independent analysis, though sometimes that analysis is informed by political pressure applied to the president or his staff by the affected industry. OIRA may then modify the draft. The proposed rule is then published in the *Federal Register*. The public is given sixty days to submit comment on the proposal. The agency then spends about a year readying a final regulation, which is resubmitted to OIRA and perhaps modified or moderated further. Then the final rule is published in the *Federal Register*.

At this point the affected industry, recoiling from limits (real or imagined) that the rule will impose on its profit-seeking, will take the agency to court to block or modify it.

Congress also has, under the Congressional Review Act (CRA) of 1996, the option, for a limited time, to eliminate the regulation under an expedited procedure. That seldom occurs except at the start of a new administration, because a president will veto any resolution of disapproval against a regulation produced by his own executive branch. If the president's successor is of the same party, he will also likely veto any such resolution. If, on the other hand, the president is from the opposite party and virulently against regulation — say, Donald Trump — he may go to town on any and all regulations still eligible for cancellation. Trump used the CRA to kill fifteen Obama-era regulations.

Getting a federal agency to issue a regulation is more complicated and more time-consuming even than getting Congress to pass a law. This is because a regulation gets into the weeds in a way that legislators, who must address a great variety of problems, truly cannot, even in much saner political times than these. There is always the risk of "regulatory capture," wherein regulators adopt too much of a regulated industry's point of view, possibly in anticipation of a job. But civil servants and political appointees receive much fewer financial inducements from industry than members of Congress, on whom Hamburger wishes to bestow most if not all regulatory functions. Senators and representatives collect money from the industries they oversee — in the form of campaign contributions — *while they are still in government*, and nearly two-thirds become lobbyists once they leave Congress, according to a study in 2019 by Public Citizen, a Nader-founded nonprofit. Government-wide revolving-door data for agency officials is less readily available, but about one-third of political appointees to the Department of Health and Human Services between 2004 and 2020 ended up working for industry, according to

73

a study recently published in the journal *Health Affairs*. The proportion of civil servants who pass through the revolving door is likely smaller still because, unlike political appointees, civil servants don't work on a time-limited basis. Congress, then, is at least twice as easy to buy off as regulators. *That* is the real reason administrative-state critics want to increase congressional control over regulation.

For the past four decades the judiciary, under the Supreme Court's *Chevron* decision in 1984, has deferred to the expertise of administrative agencies in interpreting statutes. It was inclined to do that anyway, but *Chevron* formalized that arrangement. After *Chevron*, the courts could still block regulations, but only in exceptional cases, because jeez, like Woodrow Wilson said, these guys are the experts.

Industry loathes *Chevron*, and is bent on overturning it. This is ironic, because when it was handed down *Chevron* was considered pro-business. The *New York Times* headline was "Court Upholds Reagan On Air Standard." The case concerned an easing of air pollution controls by the industry-friendly Environmental Protection Agency administrator Ann Gorsuch (who in 1983 re-married and became Ann Burford). *Chevron* turned on whether the word "source" (of pollution) in the text of the Clean Air Act referred to an entire factory or merely to a part of that factory. In his decision, Justice John Paul Stevens concluded that this was not a matter for a judge to decide. It was the EPA's job, informed by the duly elected chief executive — even granting (Stevens might have added) that the president in question was on record stating that "eighty percent of air pollution comes from plants and trees."

Conservatives cheered *Chevron* because it gave Reagan a blank check to ease the regulatory burden on business without being second-guessed by some liberal judge. But as the judges got less liberal and Democrats returned to the White House, enemies of the administrative state lost their interest in judicial restraint. Starting in 2000, an ever-more-conservative Supreme Court limited the application of *Chevron* deference in various ways — for instance, by requiring more formal administrative proceedings. One of the *Chevron* decision's fiercest critics, interestingly, is Ann Gorsuch's own son. *Chevron*, Neil Gorsuch wrote in a dissent in November 2022, "deserves a tombstone no one can miss." In Gorsuch's view, *Chevron* is a cop-out for judges. "Rather than say what the law is," Gorsuch wrote, "we tell all those who come before us to go ask a bureaucrat."

Bureaucrat. To opponents of the administrative state, that is the worst thing you can be. Even liberals, when they talk about bureaucracy, speak mostly about bypassing it. Granted, bureaucracies can be exasperating — cautious to a fault, obstructionist for no evident reason. But if government bureaucracy were defined only by its vices, we would have jettisoned it a long time ago. Bureaucracy is also, as Max Weber pointed out in *The Theory of Social and Economic Organization* in 1920,

> the most rational known means of carrying out imperative control over human beings. It is superior to any other form in precision, in stability, in the stringency of its discipline, and in its reliability.... The choice is only that between bureaucracy and dilettantism in the field of administration.

On this last point, the presidency of Donald Trump is amply illustrative. Trumpian dilettantism collided with bureaucratic resistance again and again, and it was bureaucracy that (thank God) kept the Trump administration from spinning completely out of control. Most crucially, it was Justice Department bureaucrats who, when Trump disputed the 2020 election, threatened to resign en masse if Trump replaced Acting Attorney General Jeffrey Rosen with Jeffrey Clark, a MAGA sycophant eager to file whatever lawsuit the president desired to hang on to power. The lifers' threat worked, and Trump backed down. Trump is now plotting his revenge with a scheme to strip career federal employees in "policy-related positions" of all civil service job protections, reviving Charles Guiteau's fever dream of an unmolested spoils system. ""We need to make it much easier," Trump said in July 2022, "to fire rogue bureaucrats who are deliberately undermining democracy." In this instance, "undermining democracy" means upholding the rule of law.

Overturning *Chevron* is every bit as important to the business lobby as overturning *Roe* was to evangelicals. Even more than tax cuts, the possibility of repealing *Chevron* and the regulatory burden — which could also be called the regulatory duty — that it represents was why corporate chiefs held their noses and voted for Trump in 2016. To reduce or eliminate the administrative state's ability to interpret statutes is to reduce or eliminate regulation, because what is regulation if not the interpretation of statutes? As Justice Antonin Scalia wrote in 1989 (before he, too, changed his mind about *Chevron*),

> Broad delegation to the Executive is the hallmark of
> the modern administrative state; agency rulemaking
> powers are the rule rather than, as they once were, the

exception; and as the sheer number of departments and agencies suggests, we are awash in agency "expertise." To tell the truth, the search for the "genuine" legislative intent is probably a wild goose chase.

I would quarrel only with Scalia's placement of snide quotation marks around the word *expertise* — was he himself not an expert? — and with his idealized notion of a recent past in which regulators seldom regulated. Four decades ago, conservatives such as Scalia accepted the administrative state as legitimate and necessary because they expected to control it. Now they realize that often they do not control it, so they want to kill it.

The conservative lie about regulation is that it is an anti-democratic conspiracy to smother capitalism. In truth, the administrative state came into being to allow capitalism to flourish in the industrial and post-industrial eras without trampling democracy. Today we sometimes hear it said that American democracy is in peril, but with six of the world's ten biggest companies headquartered in the United States (ranked by *Forbes* according to a combination of sales, profits, assets, and market value) not even conservatives bother to argue that American capitalism is in peril. The war on the administrative state is not a sign that American business is too weak. It is a sign that American business is too strong — so strong that the business lobby, abetted by fanciful legal theories and mythologized history, is tempted to break free of the rules democracy imposes on it.

In a pluralistic society, it is natural for any constituency — even business — to strive for greater power. But it would be immoral and self-destructive for the broader public, acting through its government, to grant such power. Capitalists

live and thrive not in isolation but within a society, among people whom they are obliged not to harm. The damage they can do is complex enough to require scrutiny from government bureaucrats. One blessing of a functioning democracy is that we citizens (up to a point) can take for granted that our government will perform this necessary work. That assurance lets the rest of us pursue happiness and get on with our lives. It may soon be imperiled by the Supreme Court and, God forbid, a second Trump term. And so we must pray that we avert such perils, and apply all available tools in our democracy to preserve and protect the administrative state. Long may it rule.

SOHRAB AHMARI

The Poverty of Catholic Intellectual Life

1

In the middle of August in 1818, some three thousand five hundred Methodists descended on a farm in Washington County, Maryland, for days of prayer and fellowship. Their lush surroundings seemed to quiver in the swelter of a mid-Atlantic summer, to which the believers added the fever of faith. Men and women, white and black, freedmen and slaves, they were united by gospel zeal. There was only one hiccup: the scheduled preacher was ill-disposed and nowhere to be found.

The anxious crowd turned to the presiding elder, a convert to Methodism from Pennsylvania Dutch country named Jacob Gruber, who accepted the impromptu preaching gig as

a matter of ecclesial duty. His sermon began, in the customary style, with a reading from Scripture: "Righteousness exalteth a nation, but sin is a reproach to any people" (Proverbs 14:34). After explaining this verse from a theological perspective, Gruber ventured to apply it to the moral conditions of the American republic at the dawn of the nineteenth century. How did the United States measure up against this biblical standard?

Not very well at all. America, Gruber charged, was guilty of "intemperance" and "profaneness." But worst of all was the "national sin" of "slavery and oppression." Americans espoused "self-evident truths, that all men are created equal, and have unalienable rights," even as they also kept men, women, and children in bondage. "Is it not a reproach to a man," asked Gruber, "to hold articles of liberty and independence in one hand and a bloody whip in the other?" There were slaves as well as white opponents of slavery at the camp that day, and we may assume that they were fired up by Gruber's jeremiad.

But there were also slaveholders among his hearers. This last group was not amused. Following their complaints, he was charged with inciting rebellion and insurrection. Luckily for Gruber, he had the benefit of one of the ablest attorneys in Maryland, a forty-one-year-old former state lawmaker who also served as local counsel to an activist group that helped rescue Northern freedmen who were kidnapped and sold as slaves in the South. The case was tried before a jury in Frederick that included slaveholders and was presided over by judges who were all likewise slaveholders. Even so, Gruber's lawyer offered a forceful defense of his client's right to publicly voice revulsion at slavery. In his opening statement, the lawyer declared that

there is no law which forbids us to speak of slavery as we think of it. . . . Mr. Gruber did quote the language of our great act of national independence, and insisted on the principles contained in that venerated instrument. He did rebuke those masters who, in the exercise of power, are deaf to the calls of humanity; and he warned of the evils they might bring upon themselves. He did speak of those reptiles who live by trading in human flesh and enrich themselves by tearing the husband from the wife and the infant from the bosom of the mother.

The lawyer went on to identify himself with the sentiments expressed in the sermon. "So far is [Gruber] from being an object of punishment," that the lawyer himself would be "prepared to maintain the same principles and to use, if necessary, the same language here in the temple of justice." The statement concluded with an unmistakable echo of Gruber's sermon: that so long as slavery persisted in the United States, it remained a "blot on our national character." Only if and when the detestable institution was abolished could Americans "point without a blush to the language held in the Declaration of Independence."

Gruber was acquitted of all charges. His triumphant lawyer was none other than Roger Brooke Taney: radical Jacksonian, successor to John Marshall as chief justice of the Supreme Court, and author of the decisive opinion in *Dred Scott v. Sandford.* Alongside fellow Jacksonian Orestes Brownson, Taney was the most influential Catholic in American public life during the pre-Civil War period. In *Dred Scott*, he rendered an opinion defined by an unblinking legal originalism — the notion that the judge's role is strictly limited to upholding the intentions of constitutional framers and lawmakers, heedless

of larger moral concerns. Applying originalist methods, Taney discovered that Congress lacked the power to ban slavery under the Missouri Compromise and that African-Americans could not be recognized as citizens under the federal Constitution. His reasoning prompted his abolitionist critics to "go originalist" themselves, countering that the Constitution had to be decoded using the seeing stone of the declaration. Put another way, Taney set in train a dynamic in American jurisprudence that persists to this day.

What do American Catholics make of Taney today? What does he represent to us? For most, Taney is occluded by the fog of historical amnesia that afflicts Americans of every creed. If he is remembered at all, it is as the notorious author of *Dred Scott* — one of those figures whose name and face are fast being removed from the public square amid our ongoing racial reckoning. Many of the chief justice's contemporaries would have approved of this fate for "The Unjust Judge" (the title of an anonymous Republican pamphlet, published upon his death, that condemned Taney as a second Pilate). Taney ended his life and career attempting to foist slavery on the whole nation, prompting fears that markets for bondsmen would soon crop up in Northern cities. His evil decision sealed the inevitability of the Civil War and hastened the conflict's arrival. "History," concluded one abolitionist paper, "will expose him to eternal scorn in the pillory she has set up for infamous judges." Speaking against a measure to install a bust of the late chief justice at the Supreme Court, Senator Charles Sumner of Massachusetts fumed that "the name of Taney is to be hooted down the page of history." An abolitionist ally of Sumner's, Benjamin Wade of Ohio, said he would sooner spend two thousand dollars to hang Taney's effigy than appropriate half that amount from the public fisc for a bust of the man.

Modern American institutions should be excused for declining to memorialize a figure like Taney. What is inexcusable is the contemptuous indifference and incuriosity of much of the orthodox Catholic intellectual class not just toward Taney and figures like him, but almost to the entirety of the American tradition, in all its glories and all its flaws: the great struggle to preserve authentic human freedom and dignity under industrial conditions; to promote harmony in a culturally and religiously divided nation; to balance competing and sometimes conflicted regional, sectional, and class interests; and to uphold the common good — all, crucially, within a democratic frame.

This profound alienation is, in part, an understandable reaction against the progressive extremism of recent years, which has left orthodox and traditionalist Catholics feeling like "strangers in a strange land." But it is also a consequence of an anti-historical and deeply un-Catholic temptation to treat anything flowing from modernity as *a priori* suspect. The one has given rise to the other: a pitiless mode of progressivism, hellbent on marginalizing the public claims of all traditional religion and the Church's especially, has triggered a sort of intellectual gag reflex. I have certainly felt it, and sometimes vented it. Anyone who knows his way around the traditionalist Catholic lifeworld knows the reflex: *Who cares, really, what American political actors, Catholic or otherwise, have done through the ages? The whole order, the whole regime, is corrupt and broken.*

Whatever the sources, the results are tragic: highbrow Catholic periodicals in which you will not find a single reference to Lincoln, let alone Taney; boutique Catholic colleges that resemble nothing so much as Hindu Kush madrassas, where the students can mechanically regurgitate

83

this or that section of the *Summa* but could not tell you the first thing about, say, the Catholic meaning of the New Deal; a saccharine aesthetic sensibility, part Tolkien and part Norman Rockwell, that yearns for the ephemeral forms of the past rather than grappling with the present in the light of the eternal; worst, a romantic politics that, owing to an obsession with purity, can neither meaningfully contribute to democratic reform nor help renew what Arthur Schlesinger Jr. felicitously called the "vital center" of American society: the quest for a decent order in a vast and continental nation, uniting diverse groups not in spite of, but because of, their differences.

All this, just when a dangerously polarized nation could desperately use that intellectual capaciousness and historical awareness, that spirit of universality, for which the Catholic tradition is justly renowned.

The whole order, the whole regime, is corrupt. The Catholic critique of modern politics is formidable. It cannot be reduced, as Michael Walzer did in these pages not too long ago, to a fanatical yearning for a repressive society bereft of "individual choice, legal and social equality, critical thinking, free speech, vigorous argument, [and] meaningful political engagement." As if these ideals were not instantiated in various modes and circumstances under preliberal regimes; or as if actually existing liberal democracies have always and everywhere upheld them, heedless of other concerns, such as solidarity, social cohesion, or simple wartime necessity.

The tension arises also at a much deeper level: namely, the metaphysical. The classical and Christian tradition holds

that every agent acts for an end (or range of ends). It is the examination of the ends or final causes of things that renders the world truly legible to us. Most things in nature, from the lowliest shrub to astronomical objects, act for their respective ends unconsciously. But human beings' final end — to live in happiness — is subject to our own choices. Those choices are, in turn, conditioned by the political communities we naturally form. It follows that a good government is one that uses its coercive authority to habituate good citizens, whose choices fulfill our social nature, rather than derail us, unhappily, toward antisocial ends.

Government, in this telling, is not a necessary evil, but an expression of our social and political nature. Government is what we naturally do for the sake of those goods that only the whole community can secure, and that are not diminished by being shared: common goods. Justice, peace, and a decent public order are among the bedrock common goods, though these days, protection of the natural environment — our common home — supplies a more concrete example, not to mention an urgent priority. And just as government is not a tragedy, the common good is not a "collectivist" imposition on the individual. Rather, it comprehends and transcends the good of each individual as an individual. We become more social, more fully human, the more we partake in and contribute to the common good of the whole.

The Church took up this classical account of politics as its own, giving birth to what might be called a Catholic political rationality. In doing so, sages such as Augustine and Aquinas made explicit its spiritual implications. If there be an unmoved mover or absolute perfection in which all others participate, as the unaided reason of the Greek metaphysicians had deduced, then true happiness lies in communion with this ultimate

85

wellspring of reality — with the God who has definitively revealed himself, first at Sinai and then even more intimately in Jesus of Nazareth.

The eternal happiness of the immortal soul is thus the final common good of individuals and of the community. It is the *summum bonum*, the highest good. Men and women's status as rational, ensouled creatures thus cannot be partitioned off from how we organize our politics. To even attempt to do so is itself to stake a spiritual claim, one with profound ramifications, since politics is architectonic with respect to all other human activities (to repeat the well-known Aristotelian formula), and since the law never ceases to teach, for good or ill.

This final step in the argument is where things get hairy, since it turns on revealed truths to which Catholics give their assent and adherents of other belief systems do not. The ideal — of properly ordering, or "integrating" if you will, the temporal and spiritual spheres — has never been abrogated by the Church, not even by the Second Vatican Council in the 1960s. Yet what this proper ordering should look like as a matter of policy has clearly shifted in the mind of the Church since the council and in the teaching of recent popes. A reversion to the specific legal forms and practices of, say, King Louis IX or even Pope Pius IX is unimaginable. It would be unimaginably cruel. "This Vatican Council declares that the human person has a right to religious freedom." It is among the most unequivocal statements ever to be etched in a Holy See document (*Dignitatis Humanae*). True, religious freedom, like all rights, must be circumscribed by the common good. And a "confessional state," under the right circumstances and with due respect for religious freedom, is not ruled out. But if the Roman pontiff isn't running around demanding confessional states in the twenty-first century, then a lay Catholic

writer such as yours truly would be wise similarly to demur.

As vexing as disagreements over the scope of the Church's public authority have been, the basic metaphysical rupture is of far greater practical import today. The revolt against final causes unsettled the whole classical picture of an orderly cosmos whose deepest moral structures are discernible to human reason; and whose elements, from the lowest ball of lint to the angels in heaven, are rationally linked together "like a rosary with its *Paters*," to borrow an image from the French Thomist philosopher A.G. Sertillanges. The anti-metaphysical revolt lies at the root of orthodox Catholics' alienation from modern polities, and American order especially, which has lately reached a crisis point.

As Walzer correctly hints, the revolt against metaphysics was launched by Luther & Co. for reasons that had nothing to do with political liberalism. Rather, the Reformers accused Rome of having polluted the faith of the Bible by deploying pagan categories to explain it. (In this sense, the Reformation was a special instance of the fundamentalist "biblicism" that had already erupted as early as the thirteenth century in the violent reaction of some Latins to the Muslim recovery of Aristotle.) Still, it was Hobbes and his progeny who brought the revolt to a stark conclusion, ushering in the modern. "There is no *finis ultimis*," Hobbes declared in *Leviathan*, "nor *summum bonum* as is spoken of in the books of the old moral philosophers."

Ditch the highest good, and you also sweep away the common good, classically understood. The whole analogical edifice crumbles. What are human beings? Little more than selfish brutes, thrown into a brutish world and naturally at war with their fellows. Why do we form communities? Because we fear each other to death. The best politics can achieve is

to let everyone maximize his self-interest, and hope that the public good emerges "spontaneously" out of this ceaseless clash of human atoms. Self-interest comes to dominate the moral horizon of the modern community; selfishness, once a vice, now supplies what one thinker has called its "low but solid ground." Yet practices such as commercial surrogacy and suicide-by-doctor, not to mention the more humdrum tyrannies of the neoliberal model, leave us wondering just how low the ground can go and how solid it really is. Invoking natural law in response, Catholics find that our philosophical premises, which like all serious thinking in terms of natural law appeals to reason and not to revelation, are treated like nothing more than an expression of subjectivity and a private "faith-based" bias.

Historic Christianity had taught that "order is heaven's first law," as Sertillanges put it, that even angels govern each other in harmonious fashion. The new politics insisted that order was a fragile imposition on brute nature; that if men were angels, they would have no need of government. Over the years, I have heard liberals of various stripes earnestly profess that the classical account of politics is nothing more or less than a recipe for authoritarianism, even "totalitarianism." This is madness. As George Will wrote in a wonderful little book published in 1983, the classical account of politics formed for millennia the "core consensus" of Western civilization, and not only Western civilization.

Aristotle, Cicero, Augustine, and Aquinas believed that governments exist to promote the common good, not least by habituating citizens to be naturally social rather than unnaturally selfish. The great Jewish and Muslim sages agreed, even as they differed with their medieval Christian counterparts on many details. Confucius grasped at the same ideas. To frame

these all as dark theorists of repression is no less silly and ahistorical than when *The New York Times* claims that preserving slavery was the primary object of the American Revolution.

The *reductio ad absurdum* of all this is treating all of past history as a sort of dystopia: a benighted land populated exclusively by tyrannical Catholic kings, vicious inquisitors, corrupt feudal lords, and other proto-totalitarians. Under this dispensation, as progressives discover ever more repressed subjects to emancipate, history-as-dystopia swallows even the relatively recent past, and former progressive heroes are condemned for having failed to anticipate later developments in progressive doctrine. The dawn of enlightened time must be shifted forward, closer and closer to our own day.

The whole order, the whole regime, is corrupt and broken. That about sums up the purist moral instinct, the phobia of contamination, at the heart of, say, The 1619 Project or the precepts of Ibram X. Kendi. It is the instinct of a young liberal academic with a big public profile who once told me with a straight face that he thinks Aristotle was a "totalitarian." But it is also, I worry, the instinct that increasingly animates the champions of Catholic political rationality, driving them to flights of intellectual fancy and various forms of escapism, and away from the vital center of American life.

The temptation — faced by the orthodox Catholic lifeworld as a whole, not just this or that faction — is to ignore the concrete development of the common good within American democracy. We face, in other words, a mirror image of the ahistorical tendency to frame the past as a dystopia. Only here, it is modernity, and American modernity in particular,

that is all benighted. Meanwhile, the very real shortcomings of the classical worldview — not least, its comfort with slavery and "natural hierarchies" that could only be overcome by the democratic revolutions of the eighteenth and nineteenth centuries — are gently glossed over, if not elided entirely.

There is a better way. It begins with taking notice that American democracy has, at its best, offered a decent approximation of Catholic political rationality: the drive to make men and women more fully social; to reconcile conflicting class interests by countervailing elite power from below; and to subject private activity, especially economic activity, to the political imperatives of the whole community. To overcome our misplaced Catholic alienation, then, we need to recover American Catholicism's tactile sense for the warp and weft of American history: to detect patterns of reform and the common good that lead us beyond the dead-end of the current culture war.

Doing so would liberate us from the phantoms of romantic politics, be it the fantasy of a retreat to some twee artificial Hobbiton or the dream of a heroically virtuous aristocracy. (Today that latter dream could only legitimate the predations of Silicon Valley tycoons, private-equity and hedge-fund oligarchs, and the like.) It may even begin to shorten the distance between orthodox Catholicism and the American center, to the mutual enrichment of both.

To be clear, I have no brief here for the theory, often called "Whig Thomism" in Catholic circles, according to which modern liberal democracy and the American founding represent a natural blossoming of the classical and Christian tradition as embodied by Aquinas, improbably recast by proponents as the first Whig. There clearly *was* a rupture, and the philosophy and theology of *Federalist 51* cannot easily

be reconciled with Catholic political rationality. Nor am I suggesting that we chant the optimistic mantra, first voiced by American bishops in the early nineteenth century, that the Founders "built better than they knew": meaning that the framers of the Constitution somehow (perhaps providentially) transcended their late-eighteenth century intellectual limitations to generate a sound government; or that American order ended up working much better in practice than its theoretical underpinnings might have suggested. "Better than they knew" is a backhanded compliment where patriotism and reason demand sincere reverence for the Founders' genius for practical statesmanship and constitution-building. This, even as we can critique how their bourgeois and planter-class interests warped their conceptions of liberty and justice — a task progressive historiography has carried out admirably, and exhaustively, since the days of Charles and Mary Beard and the early Richard Hofstadter.

Such debates, over how Catholic or un-Catholic the Founding was, are finally as staid and unproductive as Founders-ism itself. Even the extreme anti-Founding side is engaged in Founders-ism (albeit of a negative variety): the attempt to reduce the American experience to the republic's first statesmen, who fiercely disagreed among themselves on all sorts of issues, making it difficult to distill a single, univocal "American Idea" out of their sayings and doings.

So what am I proposing? Simply this: that American Catholics must not lose sight of their own first premise, inscribed right there in the opening of the *Nichomachean Ethics,* that people naturally seek after the good — after happiness — even if they sometimes misapprehend what the genuine article entails. Widened to a social scale, it means that the quest for the common good didn't grind to a halt with the

publication of this or that book by Hobbes or Locke, nor with the rise of the modern liberal state and the American republic.

Whether or not it was called the common good, the American democratic tradition — especially in its Jacksonian, Progressive, and New Deal strains — has set out to make the republic more social and solidaristic, and less subject to self-interested and private (including its literal sense of "idiotic") passions. The protagonists of this story have acted within the concrete limits of any given historical conjuncture, not to mention their own limits as fallen human beings. The whole project demands from the Catholic intellectual what used to be called "critical patriotism": a fiercely critical love, but a love all the same.

Such a Catholic inquiry must begin with a consideration of the concrete fact of American actors, Catholic and otherwise, striving for the common good via the practice of democracy, especially economic democracy.

2

Consider Roger Brooke Taney. In addition to being a world-historic bad guy, he was an economic reformer. At crucial moments as a member of Jackson's Cabinet and later as the nation's chief judicial officer, he insisted that government is responsible for ensuring the flourishing of the whole community, as opposed to the maximal autonomy of private corporate actors. In this aspect, his story is illustrative of how democratic contestation functions as the locus of the American common good, drawing the best energies of even figures whom we otherwise (rightly) condemn for their failings.

He was born in 1777, in Calvert County, in southern Maryland. Six generations earlier, the Taneys had arrived in the region as indentured servants. They had won their

freedom through seven years of hard toil. Freed of bondage, the first Taney in Calvert became prosperous, even getting himself appointed county high sheriff. In short time, his descendants joined the local gentry. To ease their way socially, they converted to Catholicism, the area's predominant faith. Yet the colony was soon overrun by migrating Puritans, who barred Catholics from holding public office, establishing their own schools, and celebrating the Mass outside their homes.

The Taneys had supported the revolution in 1776, not least in the hope that it might bring them greater religious liberty. The birth of the new republic otherwise barely touched them, at least initially. They continued to occupy the commanding heights in the area, from a majestic estate that overlooked the Patuxent River to the west, while to the south flowed Battle Creek — named after the English birthplace of the wife of the first colonial "commander," Robert Brooke, another convert to Catholicism. It was a measure of the Taneys' social rise, from their humble origins to the Maryland planter semi-aristocracy, that Roger's father, Michael, had married a Brooke. Having begun their journey in the New World as indentured servants, the Taneys now owned seven hundred and twenty-eight acres of land, ten slaves, twenty-six cattle, and ten horses.

93

Michael Taney, Roger's father, belonged to the establishment party, the Federalists, but he broke with them on important questions. He opposed property qualifications for voting, while favoring monetary easing to rescue struggling debtors. These stances were more befitting a follower of Jefferson than a disciple of Hamilton. Michael Taney, then, was a slave-holding democrat — a contradictory posture that we find replicated, a few decades later, in Jacksonian democracy, of which his infamous son was both a leader and a supreme exemplar.

Under the rules of inheritance that in those days governed the fate of male children, Taney's older brother was to take over the estate, while a younger son was expected to find his own way in the world as a professional, if he was the book-learning type. This was his good fortune, for the business of the estate soon soured: the Napoleonic Wars wrecked the international tobacco trade, and Maryland's climate was ill-suited to other crops, such as wheat, cotton, and indigo, that dominated slave economies further south and west. The revolution had been a great spur to commercial boom, and that meant urbanization. In Maryland, the center of gravity shifted to towns such as Baltimore, while places such as Calvert County fell behind. It was for those urban power centers that Taney was destined. He graduated valedictorian at Dickinson College in Pennsylvania and went on to study law in Annapolis under a judge of the state Court of Appeals, and soon rose to the top of the Maryland bar, eventually becoming attorney general, with a stint in the state legislature as a Federalist before the party imploded.

The post-revolutionary commercial boom decisively gave the upper hand to what might be called "market people": coastal merchants and financiers, technologically empowered manufacturers, large Southern planters, and enterprising urban mechanics in the North who mastered the division of labor to proletarianize their fellows. Their rise came at the expense of "land people": the numerical majority, the relatively equal yeomanry that formed the nation's sturdy republican stock, Jefferson's "chosen people of God." The disaffection of the latter set the stage for a ferocious democratic backlash and the birth of American class politics.

As he won entrée to the urban professional bourgeoisie, Taney didn't leave behind his emotional commitment to the

"land people" from whose ranks he thought he hailed. I say thought, because in reality the Taneys belonged to the rarefied planter-capitalist class of the Upper South, even if their fortunes had begun to wane. Still, as a result of this subjective sense of class dislocation, the future Taney would remain acutely aware of the topsy-turvy, and the misery, to which Americans could be exposed in market society. It was predictable that he would rally to Andrew Jackson's battle cry against finance capital generally and particularly against the Second Bank of the United States.

Congressionally chartered, the Bank of the United functioned simultaneously as a depository for federal funds, a pseudo-central bank, and a profiteering private actor in the money market. Its biggest beneficiaries were market people, those who held "the money power," in the coinage of Jackson's senatorial ally and one-time pub-brawl belligerent Thomas Hart Benton. In the 1820s, Taney became a Democrat, and declared himself for "Jacksonism" and nothing else. Soon he found his way into Jackson's Cabinet as attorney general in the heat of the Bank War.

In 1832, Jackson issued the most famous presidential veto of all time, barring the Bank's charter from being renewed on the grounds that it made "the rich richer," while oppressing "farmers, mechanics and laborers." Taney was a principal drafter of the message, alongside the Kentucky publicist and Kitchen Cabinet stalwart Amos Kendall. The BUS counterpunched by tightening credit in an attempt to bring the Jackson administration to its knees. In response, Old Hickory tapped Taney — "the one who is with me in all points" — to oversee the removal of American taxpayer funds from the Bank's coffers. It was Taney who, at the behest of a Baltimore crony named Thomas Ellicott, improvised the so-called

pet-banking "experiment," in which the federal deposits were gradually placed with select state banks.

The Bank War was a lousy reform at best, and emblematic of American populism's enduring flaws. Jackson had not contemplated an alternative to the BUS before restructuring the nation's credit system on the fly; state banking was the gimcrack alternative improvised as a result of this lack of planning. As the unimpeachably scrupulous Taney was later to learn, to his utter mortification, his Quaker friend Ellicott was a fraudster who had dreamed up state banking as a way to rescue his own bank, which had been engaged in reckless speculation, and to fund further gambling of the kind.

The local and the parochial, it turned out, were no more immune to corruption than the large Northeastern institution; indeed, local cronyism was in some ways worse, since its baleful effects could more easily remain hidden. What followed was a depression, an orgy of wildcat banking, and decades of banking crises that comparable developed nations with more centralized banking systems would be spared. As Hofstadter noted, what had been needed was better regulation of the Bank. Jackson, however, only knew how to wallop and smash.

96

What matters for our purposes, however, are less the policy details than the overarching concept. Taney was a sincere reformer, keenly aware of what the insurgent democracy was all about. At stake in the struggle, he declared at one point, had been nothing less than the preservation of popular sovereignty against a "moneyed power" that had contended "openly for the possession of the government." This was about as crisp a definition of the Bank War's meaning as any offered by those who prosecuted it.

Jacksonian opponents of the Bank considered it an abomination for self-government that there should be a

private market actor that not only circumvented the imperatives of public authorities, but also used its immense resources to shape political outcomes to its designs. With the Bank defeated, no longer could a profiteering institution wield "its corrupting influence . . . its patronage greater than that of the Government — its power to embarrass the operations of the Government — and to influence elections," as Taney had written in the heat of the war. Whatever else might be said about the Jacksonians, they had scored a decisive victory for the primacy of politics over capitalism. Politics, democracy, the well-being of the whole had to circumscribe and discipline economic forces. The Bank War, in sum, had been all about the common good.

Taney believed that market exchanges, especially where markets were created by state action, should be subject to the political give-and-take that characterized Americans' other public endeavors; subject, too, to the imperatives of the political community. It was a principle that Taney would champion even more explicitly in some of his best rulings as chief justice of the U.S. Supreme Court, especially in 1837 in the Boston Bridges case. As Hofstadter commented, although the outcome of the Bank War was on the whole "negative," the "struggle against corporate privileges which it symbolized was waged on a much wider front," most notably the Charles River Bridge case.

The facts of the case are more arcane than a brief summary will permit, but the upshot was that a private corporation — the Harvard corporation, as it happens — had been granted a charter to operate a bridge across the Charles River dividing Boston and Charlestown. Could the state legislature later grant

a license to another corporation to build and operate a second bridge, to relieve traffic congestion on the first? Harvard argued that this was a violation of the exclusive contractual concessions that the state had made to it. The second charter, Harvard insisted, trespassed the constitutional prohibition against state laws abridging pre-existing contractual rights — one of the Hamiltonian system's main defenses against the danger of democracy interfering with the market. Chief Justice Taney, writing for a Jacksonian majority, disagreed with Harvard. Again, the principles that underlay his thinking are more important, for our purposes, than its immediate practical import for corporation law. "Any ambiguity" in contractual terms, Taney wrote in a famous passage,

> must operate against the adventurers and in favour of the public.... [This is because] the object and end of all government is to promote the happiness and prosperity of the community by which it is established.... A state ought never to be presumed to surrender this power, because, like the taxing power, the whole community have an interest in preserving it undiminished.... While the rights of private property are sacredly guarded, we must not forget that the community also have rights, and the happiness and well-being of every citizen depends on their faithful preservation.

That is, the preservation of the state's prerogative to act for the common good, even if that at times means derogating private-property rights. Those are genuinely marvelous sentences. There are scarcely any more crystalline expressions of the classical account of politics in the entire American tradition. It is notable, too, that Taney went on to reason that

no lawmaking body could possibly bind its own power to act for the common good in granting a privilege to a private actor at some earlier point in history.

In the shadow cast by *Dred Scott*, praising Taney's economic jurisprudence can feel a little like the old joke about whether Mrs. Lincoln enjoyed the play. But in fact the tragedy of *Dred Scott* lay in Taney's violation of the principle that he had himself articulated in the course of the Bank War and again in the Boston Bridges case. *Dred Scott* represented a moral catastrophe of epic proportions. It was also a failure to uphold common-good democracy: indeed, Taney's common-good reasoning in the Charles River case could have served as a dissenting opinion in *Dred Scott*.

Taney — the lawyer who had once called slavery "a blot on our national character," who had stated that the Declaration of Independence would be a source of shame until slavery was abolished, and who early in life had manumitted his own bondsmen — ruled that Congress had lacked the authority to ban slavery in parts of the Northwest Territory under the Missouri Compromise. He reasoned that Congress's power under the Property Clause of the Constitution to make rules for all territories only applied to American lands at the time of ratification, in 1787, and not to territories subsequently acquired, such as through war or the Louisiana Purchase. In the Charles River case, he had insisted that a lawmaking body cannot possibly shackle itself at a particular moment in history in such a way that subsequent generations of lawmakers would be unable to act for the common good of the whole. In declaring the Missouri Compromise unconstitutional, however, he imposed just such a limitation on Congress.

But Taney went further than that. In also passing judgment on Dred Scott's standing to bring suit as a citizen

of the United States, he denied the primacy of morality and political rationality that had characterized his reasoning in the Bank War and his Jacksonian rulings on economics. Men at the time of ratification, he pointed out, did not believe that black people were endowed with any rights that whites were obliged to respect. To be sure, the abolitionist press seized on that one sentence to suggest that Taney was expressing his own opinion regarding the moral status of black Americans. Yet the full quotation and reasoning do little to exculpate Taney for attempting to write into the Constitution, in perpetuity, the racist biases of the eighteenth and nineteenth centuries — prejudice that even enlightened slaveholders in the eighteenth century acknowledged to be just that.

Taney ended his life an authentic villain, fully deserving his ignominious reputation, a fact made all the more painful by his brilliance and doggedness in defense of the economically downtrodden in other contexts. "The Unjust Judge," the pamphlet anonymously published to celebrate Taney's death, noted that "in religion, the Chief Justice was Roman Catholic." And his own Pope Leo X had "declared that 'not the Christian religion only, but nature herself, cries out against the state of slavery.'" (Never have the words of a Roman pontiff been deployed to such devastating effect against the moral legacy of an American Catholic jurist.)

Removing the "blot on our national character" and correcting Taney's hideous error in *Dred Scott* would require the shedding of democratic blood. And future generations of democrats, including the Progressives and especially the New Dealers, would enact far more effective reforms than Taney's cohort achieved, even as they drew inspiration from the Jacksonian example. Those looking for a Catholic exemplar — for a figure who confidently advanced Catholic political

rationality within the American democratic tradition — need look no further than the Reverend James A. Ryan. The moral theologian and activist came to be known as "Monsignor New Deal" for his advocacy for a "living wage" (the phrase was the title, in 1906, of the first of his many books), health insurance for the indigent, the abolition of child labor, and stronger consumer laws, among other causes. In 1936 he vehemently challenged the racist and anti-Semitic populist Father Charles Coughlin and endorsed Franklin Delano Roosevelt for president. In 1942, he published a book called *Distributive Justice,* in which he insisted that economic policies must not be detached from ethical values and championed the right of workers to a larger share of the national wealth. He was both an originator and a popularizer of New Deal ideas, prompting Roosevelt to serenade him in 1939 for promoting "the cause of social justice and the right of the individual to happiness through economic security." In 1945, he delivered the benediction at Roosevelt's last inauguration.

What distinguished Ryan's public presence was a humane realism about modern life that is sorely lacking among many of today's "trads." As the historian Arthur S. Meyer has noted, for example, Ryan in theory gave preference to Catholicism's patriarchal conception of the living wage. But recognizing that economic necessity forced many American women, especially poor and working-class women, to enter the labor force, he didn't pine for a romantic restoration of the patriarchal ideal. Instead, he called for the extension of living-wage and labor-union protections to working women. At a more fundamental level, he understood that under modern industrial conditions, social justice and class reconciliation could not be accomplished by means of mere exhortations to virtue targeted at the elites, but by means of power exerted

from below and bolstered by state action — in a word, by means of democracy.

To advance the common good today, to act (in the words of Matthew) as salt and light, the American Catholic intellectual must enter this drama, wrestling with its contradictions, sincerely celebrating its achievements, and, yes, scrutinizing its shortcomings in the light of the moral absolutes that we believe are inscribed in the hearts of all men and women. This, as opposed to striking a dogmatic ahistorical posture and rendering judgment from a position of extreme idealism giving rise to an unhealthy and philosophically indefensible revulsion for the nation and its traditions. Critical patriotism and a return to the American center — the vital center *redux* — should be our watchwords, and this implies, first and foremost, a recognition that American democracy is itself a most precious common good.

CAMILLE RALPHS

Wessobrunn Prayer

Once, there were neither bottled-up fields
 nor bluebottled breeze;
nor trill of pollen, tree nor hill to die on was there there
 (there, there):
not yet our unseated adjustment of dust; no striking star,
 nor stroke of sun;
nor did the moon light, like the grey, scaled nodule nodding
off the dead end of a cigarette;
 nor was sea seen.
No, nothing: neither loose nor bitter ends.
Yet there was something sizing up that endlessness,
 some agency
which advertised the heavens' opening: our ice floes' flow,
 our black and smeary snow above
 the alps of steel production plants,
 our rivers' scalp of fat;
and which said, "Before you were, I am."

Like that last phrase, you run, like blinding colors through
 the eyeless world
and when the mind forgets itself, you're there — where what
 is left to know is left to live.
Fine, hold me in your Holocene: give me a kicking;
 and the goods,
the martyrs with their hopscotch blood and nails as fragrant
 in their palms as cloves —

a coat of your arms to weather the flustering,
 clusterbomb wind, which changes,
and the tide of time which draws us from ourself and —
 as it takes time to keep time; it takes
 one to know one; it takes —
 and which draws itself out.

104

Job 3:11–26

To me moans came for food, my roars poured forth like drink.
— John Berryman, "Job"

"So why did my umbilicus, umbrella of the belly,
 not asphyxiate and fix me at my birth
 and make my due my expiration date?
Why was I lapped in aprons, and not limbo's fair-welled,
 farewell wave;
 why was I milk-fed, milk-toothed, given weight?
Better end here unborn: then I'd shut the hell up;
 then I would snooze all my alarm
at all the hedge-funds who so priveted and so deprived
 the world,
 who drilled a black yet golden heaven from
 the deadened graves,
and all the highnesses who built a pyramid of
 buried complexes
 on pyramids of schemes.
Or why was I not canned like laughter or an unexpected baby,
 my metaphysic offal cured in sewage?
There the stranded heartbeat of the world's unquickened
 by desiring,
 the tired sleep in forever.
There the mountains range, the sundials of wild granite,
 and sun sets like a dodgy jelly.
And the thimble and the Brunelleschi dome alike are there, alike,
 and corners are the only cornered things.

Why is a light given to who is darkness,
 life to whose long life seems lifeless,
who, meeting the business end of time, if it returned
 his holy texts,
 would see in definition things defined,
 or finitude;
who dances on his own life's line, his own grave's square,
 in a garden teething white with plastic chairs?
Why is enlightenment a thing, when we are walled up
 in this faceless space
 where blindness is a kindness?
My daily bread and I are toast,
 and hormones pip from the eyes as tears
 drip-drip from ice caps.
My agoraphobia gores me, my claustrophobia closes in,
 and when I'm being oh-so-careful, the piano
 drops from nowhere on my head.
I'm not a laugh, but nor am I the strong and silent type.
 I take no painkillers; how can I — I, who make
 a living of my pain?"

Job 42:10-17

Yesterday P. asked: "Do you think the children
from Job's second chance could actually be happy?"
— *Anna Kamieńska,* A Nest of Quiet: A notebook,
translated by Clare Cavanagh

But then amid the helplessness of Lives and corrugated
sewage, underneath the heavens'
 cold and hatchbacked tabernacle, absolute, at night
 and then in the tubercular dawn, the Man who had
 been locked in Place, shocked by his loss of Face and
 Family, was loosed: and then the World donated to
 him twice what had been gone.
His Children (whom he'd seen the fired pyres stripping of
their nakedness and every woolly
 talisman) came back, came bringing groceries: and
 they said, this is what a bad trip feels like, we were
 never dead, you only thought we were: and though he
 had mislaid his Face in tumuli of boils, had dropped his
 Eyes in lozenge-bottles crouched behind the ziggurats
 of shipping boxes at the docks, screamed at Life's fair
 unfairness, they beatified him, decorated him with
 Reassurances that tugged like ugly gold hoops at his
 ears.
So in the End he was more blessed (which in some Tongues
translates as wounded) than in
 the Beginning: but he cried I said, I said, I know you're
 as dead as the oxen the asses the camels the sheep that
 the Mesopotamians carried away, in that Book.

＇ And he blessed the World in turn because he feared to curse it.
Blessed the mad black flowers crackling hotly in the Planet's
gradients of heart, the bed-mud
 of the Mersey their grey, gradual becoming; blessed
 the Bodies fished like banknotes from the throats of
 archways; blessed the Names that passed like pills or
 golem spells under the drawbridge of his Tongue, and
 his roarings that poured like the waters; blessed his
 Eye trapped now inside another cranky orbit, and the
 broken hug of him ungrasping child and fatherless.
And any liberal, and always liberally worded, Words they said
were only words: he still
 missed what they said had not gone missing.
After This is After That, he said, and if this were a bad trip I
would know it. And did not
 escape the Feeling, angry as a tennis racquet, of his
being made to serve.
You're dead, you're dead, he said, watching his children
reproduce; and soon they too grew
 to believe it.

108

after Margaret Cropper

Genesis, behold your progeny:
inventor, behold your inventory:

protagonist, behold your agony:
window, the wind is in your eye:

Capuchin, here's your cappuccino:
tragedy, I've got your goat:

and here I come
O deathless mortgage, O unmanageable manifesto.
Ready or not.

after St Francis of Assisi

Here goes; and there it went. It might *stay* gone.
What next? Play faster with the quick and dead, with the tight-
ened fist play looser:
amplify the beggar in the chooser.

Cursed are we who lop the tops off trees to find heat's name is
written in the wood;
cursed are we who know it's hard to save the world from
everyone
who wants to save the world. You do have to be good.

YAROSLAV HRYTSAK

The War in Ukraine and The Fate of Liberal Nationalism

1

If nationalism sounds like a dirty word, then Ukrainian nationalism has sounded even worse. In the imaginations of many, it is associated with extreme xenophobic violence. Even those who sympathize with Ukraine are not free from this image. Michael Ignatieff, for example, an eminent Western liberal intellectual, wrote shortly after visiting independent Ukraine: "I have reasons to take Ukraine seriously indeed. But, to be honest, I'm having trouble. Ukrainian independence conjures up images of embroidered peasant shirts, the nasal whine of ethnic instruments, phony Cossacks in cloaks and boots, nasty anti-Semites." This stereotype is not totally groundless, and it

has various roots. Indeed, xenophobic overtones can be found in one of the earliest formulations of Ukrainian identity, in an early modern Ukrainian folk song:

There is nothing greater,
no nothing better,
than life in Ukraine!
No Poles, no Jews,
No Uniates either.

The funny thing is that a few hundred years later Ukrainians and Poles have managed to reconcile, and Ukraine ranks among the leaders of pro-Israeli sympathizers, and Uniates — present-day Greek Catholics living mostly in western Ukraine — display the highest level of Ukrainian patriotism.

The song makes no mention of Russians. At the time, in the early modern centuries, Russian ethnicity was not widely familiar to Ukrainians. And even later, when it was, for a long time it did not feature in the common inventory of Ukraine's historical enemies. That list comprised Poles, Jews, and Crimean Tatars. Now former enemies have turned into allies, and Russians are the ones who have launched a full-scale war on Ukraine.

This radical transformation in Ukrainian identity can also be illustrated by a video taken in Kyiv during the first days of the Russian-Ukrainian war. It depicts Volodymyr Zelensky and his men standing in the courtyard of the presidential office in Kyiv. They were delivering a message to Ukraine and to the world: "All of us here are protecting the independence of our country." Of the five people there, only two — Dmytro Shmyhall, the Prime Minister, and Mykhailo Podoliak, an advisor to the preisent's office — are ethnic Ukrainians. The other two, Zelensky and Andriy Yermak, the head of his office,

are of Jewish origin, and the fifth one, David Arakhamia, is Georgian. One person missing from the photo is Defense Minister Oleksii Reznikov. Like Zelensky and Yermak, he is also of Jewish origin. In September 2023, he was replaced by Rustem Umerov, a Crimean Tatar. Regardless of their different ethnic origins, all of them identify as Ukrainian. In short, they represent what is known as civic nationalism.

We are living in a golden age of illiberal nationalism. We see it in countries as historically and geographically diverse as Hungary, India, Brazil, and others. Ukraine, however, seems to run against this lamentable global trend. In this sense, the Ukrainian situation, for all its hardships, is a source of good news. Its rejection of tribal and exclusivist nationalism in favor of an ethnically inclusive kind, the civic nationalism for which it is now fighting, is a remarkable development in an increasingly anti-democratic world. But to what extent is the Ukrainian case unique? And does it convey any hope for the future?

In and of itself, nationalism is neither good nor bad. It is just another "ism" that emerged in the nineteenth century. According-ing to the twentieth-century philosopher Ernest Gellner, who thought long and hard about the nature of nationalism, "nationalism is primarily a political principle, which holds that the political and the national unit should be congruent." Or, as the nineteenth-century Italian nationalist Giuseppe Mazzini declared, "Every nation a state, only one state for the entire nation." In other words, nationalism claims that a national state should be considered a constitutive norm in modern politics. And indeed it is: the main international institution today is called the United Nations, not the United Empires.

Nationalism, of course, can take a wide array of forms. One of the most frequently debated questions is whether nationalism is compatible with liberalism. Hans Kohn, a German-Jewish historian and philosopher displaced to America who was one of the founders of the scholarly study of nationalism, claimed that "liberal nationalism" is not at all an oxymoron, and with other historians he documented the early alliance of national feelings with liberal principles, notably in the case of Mazzini. But he located liberal nationalism only within the Western civic traditions. Eastern Europe, in his opinion, was a domain of illiberal ethnic nationalism.

The study of nationalism has advanced since Kohn's day, and nowadays there is a consensus among historians that the dichotomy of "civic" versus "ethnic" nations is analytically inadequate. With few exceptions, ethnic nations contain within themselves numerous minorities, and civic nations are built around an ethnic core. So the correct question to ask is not whether to be a civic nation or an ethnic nation, but rather this: what are the values around which a civic nation is built?

Since the very beginning, Ukrainian nationalism combined both ethnic and civic elements. Ukrainian identity is based on the Ukrainian Cossack myth. The Ukrainian national anthem claims that Ukrainians "are of Cossack kin." Initially, there was nothing "national" about Cossackdom. It was a typical military organization that emerged on the frontier between the settled agrarian territories and the Eurasian steppes. The transformation of Ukrainian Cossacks into a core symbol of Ukrainian identity occurred in the sixteenth and seventeenth centuries within the realm of the Polish-Lithuanian Commonwealth. Though we are accustomed to viewing Ukrainian history in the shadow of Russia, this formulation is anachronistic: historically speaking, Poland's impact on Ukraine started earlier and lasted

114

longer. It began with the annexation of western Ukrainian lands by Polish kings in 1349, and was extended to almost all the Ukrainian settled territories after the emergence of the Polish-Lithuanian Commonwealth in 1569, and remained strong even after the collapse of that state in 1772–1795.

On the map of early modern Europe, the Polish-Lithuanian Commonwealth looks like an anomaly. In the first place, it was known for its extreme religious diversity. The Polish-Lithuanian Commonwealth was the only state where Western Christians and Eastern Christians lived together as two large religious communities. It was as a consequence of their intense encounters that the Ukrainian identity emerged. Also many Jews, expelled from the Catholic countries of Europe, found refuge in the Polish-Lithuanian Commonwealth. They were under the protection of the Polish king, and he engaged them in the colonization of the rich Ukrainian lands on the southeastern frontier known as the Wild Fields.

Moreover, the power of the king was very limited. As the proverb goes, he governed but did not rule. The king was elected by local nobles (*szlachta*). Their exceedingly high numbers — this aristocracy comprised five to eight percent of the population, compared to one to two percent in other states — along with the scope of their privileges and their multiethnic composition, constitute yet another anomaly of that state. By and large, the Polish-Lithuanian Commonwealth was an early (and limited) model of the civic nation — if we understand the concept of the nation in the context of those times: a nation of nobility whose rights and privileges did not extend to other social groups.

The nobles legitimized their privileged status by serving the Polish-Lithuanian Commonwealth with the sword. But the Ukrainian Cossacks did the same. They fought in the

military campaigns of the Polish-Lithuanian Commonwealth and defended its borders from Tatars and Turks. By this token, the Cossacks could claim equal status in the polity. But the gentry jealously guarded their privileges. They viewed the Cossacks as a rebellious rabble who could not lay claim to equal dignity. Then, from the 1590s through the 1630s, the Commonwealth was rocked by uprisings sparked by the Cossacks' dissatisfaction with their status. Their rebellions fell on favorable ground. The Commonwealth, after all, was known as "heaven for the nobles, paradise for the Jews, purgatory for the townspeople, hell for the peasants." The situation of the peasants was particularly deplorable. The emergence of the Commonwealth coincided with the institution of mass serfdom, as the local gentry aimed to maximize profits from the production of Ukrainian bread for European markets. Guillaume Levasseur de Beauplan, the author of *A Description of Ukraine*, from 1651, claimed that the situation of the local peasants was worse than that of Turkish galley slaves.

Alongside the rise of serfdom, religious tolerance began to wane. The local Orthodox church was under pressure to convert to Catholicism. To protect themselves, the hierarchy agreed to a union with Rome. For most of the Orthodox flock this was an act of treason, so they turned to the Cossacks. And as the Cossacks offered support and protection to the Orthodox Church, the Church offered the Cossacks a sense of a national mission. The result was an emergence of a new national identity — Ukraine, with "no Poles, no Jews, no Uniates." This formula was implemented in the early modern Ukrainian Cossack state. It came into being as a result of the victorious Cossack revolution under Bohdan Khmelnytsky. The rebellion was spectacularly violent. As a Cossack chronicler

wrote, blood "flowed like a river and rare was the person who had not dipped their hands in that blood," and Jews and Poles were the main victims of the Cossack massacres. The Hebrew chronicles of 1648 concur with the Cossack ones about the magnitude of the savagery.

Even though the Cossacks rebelled against the Polish-Lithuanian Commonwealth, they also emulated its practices: like the Polish kings, the leaders of the Cossack state — they were known as hetmans — were elected by Cossacks, and Cossack officers saw themselves as equivalent to the Polish nobility. In a sense, the Cossack state was a mixture of civic and ethnic elements. It was civic insofar as the Cossacks saw themselves as citizens, not subjects; the Cossack ruler was elected and his power was limited. It was ethnic insofar as its core was made of Orthodox Ukrainians. It reflected the common European principle of *cuius regio eius religio*, he who governs the territory decides its religion. This principle emerged from the ferocious and protracted religious wars between Catholics and Protestants in Europe in the sixteenth and seventeenth centuries. Tellingly, the Cossack revolution started the same year that the Thirty Years' War — one of the bloodiest wars in European history — ended.

In the long run, this religious dimension played a bad joke on the new Ukrainian identity. As a petty noble with no royal blood, Khmelnytsky had no legitimate claim to become an independent ruler. He thus sought a monarch who would allow him to preserve his autonomy. Finally he chose the Tsar in distant Moscow, who, like the Cossacks, was of the same Orthodox faith. This choice was ruinous for the Cossack state. Under Russian imperial rule the Cossack autonomy was gradually abolished, and the Cossack state finally dissolved in 1764.

117

Around the same time, the Russian Empire, together with the Austrian and the Prussian empires, annexed the lands of the Polish-Lithuanian Commonwealth. The Russian Empire thus gained control over most of Ukrainian ethnic territory, and only a small western part went to the Austrian Empire. In this new setting it seemed like the fate of early modern Ukrainian identity was sealed. The offspring of the Cossack officers made their way into the Russian imperial elites. Russia was a large but backward empire. It desperately needed an educated elite to govern its vast expanses. That elite was most abundant on its western margins. The Ukrainian Cossack nobility, although not as educated as the Baltic German barons and not as numerous as the Polish gentry, had one advantage: they were of the same faith as the Russians. In the eighteenth century, Ukrainians made up almost half of the Russian imperial intelligentsia. In the nineteenth century the Ukrainian influence became hard to trace, because most of them had already been assimilated into Russian culture.

Like the Scots in the British Empire, Ukrainians paved the way for the Russian Empire to become a global power because many of them thought of it as *their* empire. Ironically, they started out like the Scots but finished like the Irish. Those Ukrainians who moved out of Ukraine to make their careers in the imperial metropoles of St. Petersburg and Moscow became a success story. The ones left behind were less fortunate. Under Russian imperial rule, they were increasingly impoverished, progressively ousted from the administration, and steadily deprived of their liberties. The Ukrainian language was twice banned. The Ukrainians mourned their glorious Cossack past and resented the new order. They were certain that their

nation was going to their graves with them.

They were wrong: the revival of Ukrainian identity came with newer elites of lowlier origins. The most influential figure in this revival was Taras Shevchenko (1814-1861). Born a serf, he rose to prominence as a national poet. In his poetry, Shevchenko glorified Ukraine's Cossack past but disdained the assimilated Cossack elites: they were "Moscow dirt, Warsaw scum." His heroes were the Ukrainian common people: "I will raise up/Those silent downtrodden slaves/I will set my word/ To protect them." His model of the new Ukrainian nation was close to that of the French Revolution. Indeed, to the monarchs, Shevchenko sounded just like a Jacobin: "Ready the guillotines/ For those tsars, the executioners of men." He was arrested for his poetry and sentenced to exile as a private in the army without "the right to write." His personal martyrdom enhanced his image as a national prophet. His poetry came to be read with an almost religious fervor. As one of his followers wrote, "Shevchenko's muse ripped the veil from our national life. It was horrifying, fascinating, painful, and tempting to look."

Shevchenko's formula of Ukrainian identity became paradigmatic. Its strength lay in its double message of social and national liberation. Later generations of Ukrainian leaders were said to carry Shevchenko's poetry in one pocket and *Das Kapital* in the other. In the words of Mykhailo Drahomanov, a leading nineteenth-century Ukrainian thinker, in conditions in which most Ukrainians are impoverished peasants every Ukrainian should be a socialist and every socialist should be a Ukrainian. When it came to Jews and Poles, Drahomanov envisaged for them a broad national autonomy in exchange for their support of the Ukrainian cause.

This formula proved successful once the Russian empire collapsed during the Russian Revolution in 1917. The

Ukrainian socialists managed to create the Ukrainian People's Republic with massive support from the Ukrainian peasantry. But the peasants subsequently turned their backs on this state once it was attacked by the Russian Bolshevik army. Later the peasants rebelled against the Bolsheviks as well. In the end, the moment for Ukrainian independence was lost, and Ukraine was integrated into the Soviet Union. Ukrainians paid dearly for this loss: in the 1930s most of their elites were repressed, while peasants became the victims of Stalin's collectivization and famine, the infamous Holodomor.

The failure of the Ukrainian People's Republic led to a reconsideration of Ukrainian identity. The key figure in this respect was Viacheslav Lypynsky (1882–1931). He was born to wealthy Polish landowners in Ukraine. Driven by a feeling of *noblesse oblige*, he decided to shift from a Polish identity to a Ukrainian one. Lypynsky blamed Ukrainian leaders for their narrow concept of Ukrainian identity. In his opinion, one could not build the Ukrainian state while relying exclusively on peasants. One had to attract professional elites, which in most cases were non-Ukrainians. Lypynsky propagated a civic model of the Ukrainian nation informed by the American example, "through the process of the living together of different nations and different classes on the territory of the United States."

His ideas made little headway among Ukrainians. In Soviet Ukraine his works were forbidden, like those of many other Ukrainian authors. Beyond Soviet rule, in interwar Poland and in the post-war Ukrainian diaspora in the West, the minds of Ukrainians were intoxicated instead with "integral" nationalism — a militant nationalism that required exclusive and even fanatical devotion to one's own nation. Its ideology took shape in the shadow of the defeat of the Ukrainian

state in 1917–1920. The key ideologue was Dmytro Dontsov (1883–1973), a prolific Ukrainian literary critic. For him, the main problem with Ukrainian nationalism was that it displayed too little ethnic hatred. Dontsov admired fascism and saw it as the future of Europe. His views became very popular among members of the Organization of Ukrainian Nationalists (OUN) and the Ukrainian Insurgent Army (UPA), founded, respectively, in 1929 and 1943. True to these ideas, the UPA was responsible for the ethnic cleansing of Poles in Western Ukraine and, partially, for the Holocaust. Among Ukrainian nationalists, the most emblematic figure, the hero, was Stepan Bandera (1909–1959). He was a symbol of struggle against *all* national foes. Bandera was imprisoned by the Poles in 1936–1939, by the Nazis in 1941–1944, and assassinated in 1959 by a Soviet agent. Even though he was not directly involved in the wartime anti-Polish and anti-Jewish violence — at the time he was a prisoner in the Sachsenhausen concentration camp — Poles and Jews hold him accountable for the crimes of Ukrainian nationalists.

The xenophobic ideology of integral nationalism was not an isolated Ukrainian phenomenon. Commenting on Ukrainian nationalists' rallying cries — "Long live a greater independent Ukraine without Jews, Poles and Germans!" "Poles behind the river San, Germans to Berlin, and Jews to the gallows!" — the Hungarian-American historian István Deák wrote: "I don't know how many Ukrainians subscribed to this slogan. I have no doubt, however, that its underlying philosophy was the philosophy of millions of Europeans." His remark reflects one of the main features of Ukrainian identity: it changed along with fluctuations in the European *Zeitgeist*. Its earliest articulation resonated with the formula that arose in the European religious wars of the sixteenth and seventeenth

centuries; it was reinvented in the nineteenth century within ideological trends initiated by the French Revolution; and its evolution during the first half of the twentieth century kept pace with the growth of totalitarianism in most of the European continent.

The latest round of rethinking Ukrainian identity was similarly shaped by European developments — and the establishment of liberal democracy in post-war Europe. Since at that time Ukraine had no access to the rest of Europe, this sympathetic vibration was rather unexpected. All Ukrainian ethnic territories, including Western Ukraine, were united under Soviet rule, and tightly isolated from the outside world. A small tear in the Curtain was made in 1975 by the Helsinki Accords; in its search for a *modus vivendi* with the capitalist West, the Kremlin committed itself to respecting human rights. The anti-Soviet opposition in Ukraine immediately saw this as an opportunity. They linked human rights with national rights. Ukrainian dissidents declared that in a free Ukraine, not only would the rights of Ukrainians be respected, but also the rights of Russians, Jews, Tatars, and the other nationalities that were represented in the country.

Instinctively, Ukrainian dissidents reconnected with the ideas of Drahomanov and Lypynsky. And the revival of the civic concept coincided with the failure of the xenophobic Dontsov doctrine. Its decline began as early as the years of the Second World War, when, under the Nazi occupation, the nationalists in Western Ukraine tried to establish contacts with their compatriots in the Ukrainian East. But local Ukrainians turned a deaf ear to the slogan "Ukraine for Ukrainians!". They were more interested in the dissolution of the Soviet collective farms and the introduction of the eight-hour workday and other social reforms. By the end of the war, the Organiza-

tion of Ukrainian Nationalists revised their ideological tenets and moved to a more inclusive slogan: "Freedom to Ukraine, freedom to all enslaved nations."

Throughout its history, Ukrainian identity kept evolving and changing. There has been no single canonical formula for how to be Ukrainian. Even within Ukrainian integral nationalism there were dissident groups that opposed anti-Semitism and stood for a civic concept of the Ukrainian nation. Still, for a variety of reasons, since the end of the nineteenth century, there was a growing tendency, among both Ukrainian nationalists and their opponents, to conceive of Ukrainian identity in ethnic terms. In this conception, it was the Ukrainian language that became the main criterion of Ukrainian identity. Since, as the outcome of Ukrainians assimilating into Russianness under the Russian Empire and the Soviet Union, the number of Ukrainian speakers was dramatically decreasing, the resulting impression was that the Ukrainian nation was doomed. Thus, in 1984, Milan Kundera, in his famous essay "The Tragedy of Central Europe," declared that the Ukrainian nation was disappearing before our eyes, and that this attenuation may be indicative of the future of Poles, Hungarians, and other nations under Communism.

This perspective was opposed by some Ukrainian historians who had the advantage of the long-term perspective. They claimed that even if Ukrainians, like the Irish, stopped speaking their native language, it would not necessarily make them less Ukrainian. In their view, the fundamental difference between Russians and Ukrainians was not in language but in age-old political traditions, in a different relationship between the upper and the lower social classes, between state and society. This, they argued, was owed to the fact, that despite various handicaps, Ukraine was genuinely linked with the

Western European tradition and partook in European social and cultural progress.

2

History does indeed hold the key to the Ukrainian identity. The current Russian-Ukrainian war can be largely regarded as a war over history. Most of Putin's arguments for his aggression are of a historical nature. He claims that Russia originated from the early empire of Rus in the medieval centuries. The core of this empire lay in present-day Ukraine, with its capital in Kyiv. In Putin's opinion, since he equates Rus to Russia, and since many contemporary Ukrainians speak Russian, Ukraine is destined to be Russian in the future.

Nothing could be further from the truth. Kyivan Rus was not Russia. It was, rather, similar to Charlemagne's empire in the West. That formation covered the territories of present-day France, Germany, and Italy. None of these nations can claim exclusive rights to its history. Yet there was also a significant difference between Charlemagne's empire and Kyivan Rus, which created long-term "national" effects. Western countries took Christianity from Rome along with its language, which was Latin. Rus adopted Christianity from Byzantium, and without its language: all the necessary Christian texts were translated from Greek into Church Slavonic. This severed the intellectual life of Kyivan Rus from the legacy of the ancient world and made it (in the words of George Fedotov, the Russian émigré religious thinker) "slavishly dependent" on Byzantium. If we were to collect all the literary works in circulation in the Rus lands up to the sixteenth century, the total list of titles would be equal to the library of an average Byzantine monastery. The differences between Western Christianity and Eastern Christianity became even more pronounced following the advent of the

printing press. In the wake of its invention and until the end of the sixteenth century, two hundred million books were printed in western Christendom; in the Eastern Christian world, this figure was no more than forty to sixty thousand.

Literature is one of the key prerequisites for the formation of nations. As the Russian-born American historian Yuri Slezkine has put it, nations are "book-reading tribes." From this perspective, the world of Rus was like the proverbial "white elephant" or the "suitcase without a handle": a hassle to carry around but too valuable to abandon. Rus ceased to exist as a result of the Mongol invasion in the mid-thirteenth century, and its territories were divided between the Grand Duchy of Lithuania and later the Polish-Lithuanian Commonwealth, on the one hand, and the Moscow Tsardom, on the other. Inhabitants of the former Rus expanses had some idea of the origin of their Christian civilization from Kyiv, and spoke mutually intelligible Slavic dialects, and prayed to God in the same Church Slavonic language. But these commonalities made them neither one great nation nor multiple smaller nations. Their world was largely a nationless world: they lacked the mental tools to transform their sacred communities into national societies.

By this token, the making of the Russian and Ukrainian nations inevitably marked the destruction of the conservative cultural legacy of Rus. Recent comparative studies suggest that both nations emerged more or less concurrently with the Polish and other European nations, that is, in the sixteenth, seventeenth, and eighteenth centuries. But then the Russian nation was "devoured" by the Russian empire. Like most modern empires, the Russian empire did not tolerate any nationalism, including Russian nationalism: a national self-identification of the Russians might lead to imperial collapse. By this token, antagonism between the Russian Empire, on the one

hand, and the Polish, Ukrainian, and other nationalisms, on the other, should properly be regarded as a conflict between a state without a nation and nations without states.

And the same was true, *mutatis mutandis*, of the Soviet Union. At its inception in the 1920s, Soviet rule was promoting nation-building in the non-Russian Soviet republics. Among other considerations, this was meant to stem the growth of local nationalism — and the strong nationalist movement in Ukraine in the wake of the revolution in 1917 was particularly unnerving. Later, when Stalin came to power, these attempts were abandoned. The Soviet Union returned to old imperial ways, and Ukrainians were particularly targeted by the Stalinist repressions of the 1930s.

Formally, all of the Soviet republics were national republics. In fact, they were republics without nations. Their future could be best illustrated by a party official's answer to the question of what would happen to Lithuania after its Soviet annexation: "There will be a Lithuania, but no Lithuanians." This did not mean the physical destruction of all Lithuanians or other nations. The objective of Soviet nationality politics was to relegate all these nations to the status of ethnic groups with no particular political rights.

After the death of Stalin in 1953, and for the first time since the beginning of the Soviet Union, Ukrainians were promoted to high positions both in Moscow and Kyiv. The situation was similar to that of the eighteenth century, when they were invited to play a prominent role in running the empire. Still, to make a career, they had to reject their own national ambitions. All attempts to extend the autonomy of Soviet Ukraine were vociferously quashed. In relation to Ukraine, Leonid Brezhnev, who was the General Secretary of the Communist Party of the Soviet Union from 1964 to

1982, set two goals: to strengthen the fight against Ukrainian nationalism and to accelerate the assimilation of Ukrainians. This had a paradoxical effect: during the last decades of the Soviet Union, Ukrainians were overrepresented both in Soviet power and in the anti-Soviet opposition.

Ukrainians, like Lithuanians, Georgians, and others, were to be dissolved into a new historical community — the Soviet people. Being a Soviet meant being a Russian speaker. The prevailing belief was that Russian would become the language of communism very much like French had been the language of feudalism and English the language of capitalism. Still, if being Soviet meant being a Russian speaker, the reverse did not work: Russian speakers were not necessarily Russians. Rather, to paraphrase the title of Robert Musil's famous novel, they were to be men without national qualities. This was in accordance with the Marxist principle that nations were relics of capitalism and bound to disappear under communism. The ambitious Soviet project aimed to create a homogenous society but without a national identity. A case in point was Donbass, the large industrial region in eastern Ukraine. Even though its population was predominantly Russian speaking, the Russian identity was underrepresented. Inhabitants considered themselves "Soviets" and "workers."

It is worth mentioning again and again that nations are political entities. They are not exclusively, or even primarily, about language, religion, and other cultural criteria — they are about political rights, and who can exercise those rights. Nations presume the existence of citizens, not subjects. This principle was multiplied and strengthened by the French Revolution, with its slogan "liberty, equality, fraternity." In the Russian empire, this revolutionary slogan was counterposed by the ideological doctrine of "Orthodoxy, Autocracy,

Nationality." And the "nationality" (*narodnost* in the original) in this formula was not related to a nation. It meant rather a binding union between the Russian emperor and his subjects. The slogan reflected a recurrent feature of Russian political culture: the idea of the unlimited power of a ruler. In this sense, there is no substantial difference between a Moscow Tsar, a Russian emperor, a leader of the Communist party, or, today, a Russian President.

This is not to say that there were no attempts to democratize Russia. The past two centuries have seen several such attempts. Of these the two most significant were the reforms of Alexander II in the 1860s-1880s and then the Russian president Boris Yeltsin in the early 1990s. These attempts were rather short-lived and were followed by longer periods of authoritarianism or totalitarianism. Ultimately, Soviet Russia failed to become a nation. Ukrainians failed to become a full-fledged nation, too. But some of them — Ukrainian- speaking cultural elites, local communist leaders and the population of western Ukraine, where the effects of Sovietization were least felt — had preserved national ambitions. Very much like their compatriots in the nineteenth century, they hoped that once the colossal empire fell to pieces, Ukraine would form a breakaway state.

When Gorbachev came to power in 1985, he believed that, in contrast to the Baltic peoples, Ukrainians were true Soviet patriots. In his opinion, Russians and Ukrainians were so close that sometimes it was difficult to tell them apart. Even in western Ukraine, he claimed, people did not have "any problems" with Bandera. There were experts in Gorbachev's milieu who kept warning him about the dangers of Ukrainian

separatism — but he preferred not to heed their warnings.

The moment of truth came with the Ukrainian referendum in December 1991, when ninety percent voted for the secession of Ukraine from the Soviet Union. This number exceeded both the share of ethnic Ukrainians (seventy-three percent) and the share of Ukrainian speakers (forty-three percent). This overwhelming support for Ukrainian independence was the result of an alliance between three very unlikely allies: the Ukrainian-speaking Western part of Ukraine, the national communists in Kyiv, and the miners of the Donbass, the last of whom hoped that their social expectations would be better met in an independent Ukraine than in the Soviet Union. This alliance soon fell apart as independent Ukraine plummeted into deep economic and political crises. In late 1993, the CIA made a prediction that Ukraine was headed for a civil war between the Ukrainian-speaking West and the Russian-speaking East that would make the Balkan wars of the time look like a harmless picnic.

These Ukrainian presidential elections in 1994 reinforced these fears. They revealed deep political cleavages consistent with the linguistic divisions. The main rivals were the incumbent president Leonid Kravchuk and his former prime minister Leonid Kuchma. Under the Soviets, Kuchma had been director of a large Soviet factory in Eastern Ukraine. Kravchuk was supported by the western part of the country, and Kuchma by the East.

Russia was likewise undergoing a deep crisis at the time, but of a different nature. In December 1992, the Russian parliament rejected the appointment of Yegor Gaidar, the father of the Russian economic reforms, as acting prime minister. After several months of acrimonious confrontation, President Yeltsin dissolved the parliament and the parliament in turn

impeached him. In response, Yeltsin sent in troops, and tanks fired at the parliament building. In early October 1993, several hundred people were killed or wounded in clashes on the streets and squares of Moscow.

Unlike in Russia, the Ukrainian political crisis was resolved without bloodshed. Kravchuk lost the election and peacefully transferred power to Kuchma. This was a key moment in the divergence of political paths between Ukraine and Russia. In contrast with Russia, Ukraine launched a mechanism for the alternation of ruling elites through elections. As the Russian historian Dmitry Furman observed, Ukrainians had successfully passed the democracy test that the Russians failed. It is worth noting that Ukrainians passed that test on an empty stomach, because the economic situation in Ukraine at the time was much worse than in Russia.

The Kuchma years — the decade between 1994 and 2004 — were a period of relative stability, but at a high cost: corruption skyrocketed, political opposition was suppressed, and authoritarianism was on the rise. Very much like Yeltsin, who "appointed" Putin as Russia's next president, Kuchma approved Viktor Yanukovych, the governor of the Donetsk region, as his successor. A worse choice would be difficult to imagine: it was akin to nominating Al Capone to run for the American presidency. By that time the worker movement in the Donbass had diminished, and the region was run by a local mafia-like clan, of which Yanukovych was a key figure. His attempts to come to power and to stay in power sparked two separate waves of mass protests in Kyiv, known as the Orange revolution of 2004 and the Euromaidan of 2013–2014. They managed to win, despite harsh weather conditions — both revolutions took place in winter — and despite the mass shooting of protesters in the final days of the Euromaidan.

Russia had experienced similar mass protests in the winter of 2011–2012. By that time, the ratings of Putin and his party had plummeted to record lows, and the discontent of Russians grew. Putin was brought to power in rigged elections, catalyzing mass protests on Bolotnaya Square in Moscow. Tragically, several factors contributed to the protest's failure. One was that mass passive discontent did not transform into mass active participation. At the very height of the protests in Moscow, their leaders managed to attract only one hundred and twenty thousand people. This was the largest mass political action in the post-Soviet history of Russia. At the Euromaidan, by contrast, the largest meeting numbered, according to various estimates, from seven hundred thousand to a million people. And consider that the populations of Kyiv and Ukraine at the time were three to four times smaller than those of Moscow and Russia. But the difference was not merely quantitative.

This brings us back to the definition of Ukrainian identity considered above: a basic difference between Ukraine and Russia lies in the capacity for self-organization. Ukrainians at the time protested against everything that Yanukovych stood for: corruption, fraud, crime. But they were perfectly aware that behind Yanukovych stood Putin and his regime. Therefore, their protests also had a national dimension; they were fighting against Russia and its regime as well. It is safe to presume that this incontrovertible fact provided a strong mobilizing effect. The Kremlin tried to paint the Euromaidan revolution as an outburst of ethnic nationalism, led by Ukrainian nationalists, or even by Nazis. In reality the protesters were bilingual and included broad swathes of Ukrainian society. The Ukrainian journalist Mustafa Nayem, an ethnic Afghan, was the leader of the protest movement. The first victim to be shot dead at the Euromaidan was Serhiy Nigoyan, who came from an Armenian

family. The second was Mikhail Zhiznevsky, a Belarusian. The Euromaidan also included a large group of Ukrainian Jews. They were slurred by Kremlin propaganda as "Jewish Banderites" (*Zhydobanderivtsi*) — and they adopted this absurdly oxymoronic moniker as a badge of honor.

True, Ukrainian nationalists were present on the Euromaidan. But the focus on Ukrainian nationalists ignores the crucial point: the Euromaidan was centered around values, not identities. It is not for nothing that was it was called the Revolution of Values. They are the values of free self-expression, and they are likely to inspire elite-challenging mass action. They are also characteristic of post-industrial societies, and in the mid-2000s Ukraine underwent a shift from an industrial to a post-industrial economy. A major part of the country's GDP was produced in the service sector — the tech sphere, the media, education, the restaurant business, tourism, and so on. Historically, the industrial economy in Eastern Europe had been closely connected to the state. This relationship reached its peak in the Soviet industrialization. Since large industrial enterprises require centralization and discipline, the ethos of an industrial society is naturally hierarchical. In contrast, a post-industrial economy grows from private initiative. As a result, in Ukraine there emerged a large sector that was less dependent on the state and less affected by corruption. To survive and to compete successfully, those who work in the service economy need fair rules of the game. Thus, they strive for change.

The social profile of Volodymyr Zelensky and his team may serve as a good illustration. With the exception of Dmytro Shmyhal, none of these people had previous experience in state administration. Volodymyr Zelensky and Andriy Yermak came from the entertainment industry, Mykhailo Podolyak started his career as a journalist, David Arakhamia

worked in the IT sector, Oleksii Reznikov was a private lawyer, and Rustem Umerov was a businessman. Another important characteristic is the generational dimension: their average age is forty-five — which also happens to be the average age of the soldiers in the Ukrainian army. Taken together, these three attributes of "Zelensky's men" — their multiethnic character, their social profile, and their age — attest to the same phenomenon: the emergence and coming to power of a new urban middle class in Ukraine. It must be clearly emphasized that this class does not constitute the majority of the Ukrainian population. It is a minority, but it is a decisive minority that pushes Ukraine on the path of liberal order.

The history of Ukrainian nationalism follows the "now you see it, now you don't" formula. In peaceful times, it is hard to detect and seems almost non-existent. Ukrainian national feeling emerges, however, during large geopolitical upheavals — as was the case during the crisis of the seventeenth century, the First and Second World Wars, the collapse of communism, and, most recently, the Russian-Ukrainian war.

133

The fact that the Ukrainian nation springs collectively to life during crises is partly responsible for the bloodthirsty image of Ukrainian nationalism. Since Ukraine has been a very ethnically diverse and geopolitically highly contested borderland, these crises evolved in Ukraine into a Hobbesian "war of all against all." This led, in the past, to outbursts of shocking violence. Like so many other nationalist movements in the region, Ukrainian nationalism committed acts of great violence. There is no doubt that the crimes of some Ukrainian nationalist groups were outrageous, and an independent

Ukraine must come to terms with its sins. Still, those who point the finger at Ukraine would do well to remember that this bloodlust was not unique, or even the most voracious, in the region. There was plenty of brutality to go around.

Ukrainian nationalism has had a very protean nature, and evolved with social changes. Among other things, it rarely articulated Ukrainian identity in strictly ethnic or strictly civic criteria, but mostly as a combination of both. The general balance was defined by a group that made up the core of national Ukrainian elites: Ukrainian Cossacks in the seventeenth and eighteenth centuries, the Ukrainian intelligentsia of the nineteenth century, the integral nationalists in the interwar period and during World War II, the post-war anti-Soviet Ukrainian dissidents, the Ukrainian national communists and national democrats in independent Ukraine, and most recently, the new urban middle class. In recent years, Ukrainian nationalism has been largely a liberal nationalism. In present-day Ukraine, the overwhelming majority (ninety percent in 2015–2017) believes that respect for the country's laws and institutions is a more important element of national identity than language (sixty-two percent) or religion (fifty-one percent). Civic identity peaked during the two Ukrainian revolutions of 2004 and 2013–2014, and once the Russian-Ukrainian war began it became dominant across *all* socio-demographic, political, and religious groups in the country.

In present-day Ukraine, nationalism serves as a vehicle for democracy. This remarkable fact has been emphasized by Anne Applebaum. During her first visits to Ukraine, she seemed to share the prejudices similar to those expressed above by Michael Ignatieff, but the Euromaidan caused her to change her mind. In her opinion, nationalism is exactly what Ukraine

needs, and the very opposite of the poison that "cosmopolitans" denounce in it. One need only look at Russian-occupied Donbass, she has written, to see

> what a land without nationalism actually looks like:
> corrupt, anarchic, full of rent-a-mobs and mercenaries...
> With no widespread sense of national allegiance and no
> public spirit, it [is] difficult to make democracy work...
> Only people who feel some kind of allegiance to their
> society—people who celebrate their national language,
> literature, and history, people who sing national songs
> and repeat national legends—are going to work on that
> society's behalf.

Universal values have found a home in contemporary Ukrainian nationalism to an exhilarating degree. In the wake of the Russian-Ukrainian war, the prominent Italian historian Vittorio Emanuele Parsi similarly observed that Ukraine's courageous resistance confirms that the idea of the nation

> is very much alive in the world debate and represents a
> formidable multiplier of energy, self-denial and spirit
> of sacrifice: it is able to create a civic sense that, in its
> absence, does not succeed in making that leap forward,
> the only one capable of welding the experience of the
> communities in which each of us is immersed with the
> institutions that create and guarantee the rules of our
> associated life.

135

Parsi uses the words "nation" and "motherland" interchangeably, and he is unabashed about attributing a positive connotation to both.

Since the Second World War, both terms have been compromised in Italy and other West European countries by their associations with fascist Italy, the Third Reich, and Vichy France. Now they are largely monopolized by the conservative right in the West and by Putin in Russia. To strengthen liberal democracy, however, liberals have to reclaim the original meaning that these words had acquired in the wake of the French Revolution: as ultimate values that are worthy of personal sacrifice in order to protect liberty and a decent civic spirit. As many Western intellectuals remarked during the Euromaidan in expressing their support for the democractic rebellion, Ukraine is now a beacon of Western liberal values.

War is always hell, it is always catastrophic, but it also creates opportunities. It accelerates certain processes and mandates a shift of paradigms. Suddenly everything is in flux, including pernicious status quos that seemed intractable. Every large war brings radical change. The moral character of the future changes largely depends on how and when this war will end. It is strongly in the interests of the West that Ukraine win and that Putin lose. For this reason, the West is properly obliged to help Ukraine with weapons and resources. We are in this together. Still, material assistance is not the only vital variety. The West must support Ukraine also philosophically, which is of course a way of supporting the West's own ideals of freedom and tolerance and equality. As Ukraine fights for its liberty, it is time to think again about the benefits of nationalism, and to celebrate its compatibility with civic diversity and democratic openness.

DAVID RIEFF

Liberland: Populism, Peronism, and Madness in Argentina

For Carlo Pagni

1

Too many electoral results are described as earthquakes when in reality they are little more than mild tremors, but the self-described anarcho-capitalist Javier Milei's victory in the second and deciding round of Argentina's presidential election over Sergio Massa, the sitting minister of the economy in the former Peronist government, who in the eyes of many Argentines across the political spectrum has wielded far more power than the country's president, Alberto Fernández, truly does represent a seismic shift in Argentine politics, the radical untuning of its political sky. On this, ardent pro-Peronists such as Horacio Verbitsky, editor of the left online magazine *El Cohete a la luna*,

and some of Peronism's most perceptive and incisive critics, notably the historian Carlos Pagni - people who agree on virtually nothing else - find themselves in complete accord. "Demographically and generationally," Verbitsky wrote, "a new political period is beginning in [Argentina]." For his part, Pagni compared the situation in which Argentina now finds itself, to "the proverbial *terra incognita* beloved of medieval cartographers," and "heading down a path it had never before explored" — a new era in Argentine political history.

The country's disastrous economic and social situation was the work of successive governments, but above all its last two — the center-right administration of Mauricio Macri between 2015 and 2019, and the Peronist restoration in the form of Alberto Fernández's government between 2019 and 2023, in which Fernández was forced for all intents and purposes to share power with his vice-president, Cristina Fernández de Kirchner, who had been Macri's predecessor as president for two successive terms, from 2007 to 2015, having succeeded her husband Néstor, who was president between 2003 and 2007. Cristina (virtually every Argentine refers to her by her first name) remains — for the moment, at least — Peronism's dominant figure. Despite some success during the first two years of his administration, Macri proved incapable of either sustainably mastering inflation or of stimulating high enough levels of international direct investment in Argentina. Cristina had left office with inflation running at twenty-five percent annually. Under Macri's administration, that figure doubled to fifty percent, a level not seen in the country for the previous twenty years, and the key reason why Macri failed to win reelection in 2019. But during his four years in office, Alberto Fernández accomplished the seemingly impossible: making his predecessor's failure seem almost benign. The legacy that

he has left to Milei — unlike Macri, he knew better than to seek reelection — is an inflation rate of one hundred and forty-two percent, nearly three times higher than under Macri.

It is not that Argentina had not suffered through terrible economic crises before. Three of them were even more severe than the present one. The first of these was the so-called *Rodrigazo* of 1975 (the name derives from then President Isabel Perón's minister of the economy, Celestin Rodrigo), when inflation jumped from twenty-four percent to one hundred and eighty-two percent in a year. The *Rodrigazo* was not the main cause of the coup the following year that overthrew Isabel Perón and ushered in eight years of bestial military dictatorship, but the panic and disorientation that it created in Argentine society certainly played a role. The second was the hyperinflation of 1989, during the Radical Party's leader Raúl Alfonsín's second term as president. Alfonsín, who was the first democratically elected president after the end of military rule in 1983, is generally regarded in Argentina, even by Peronists, as having impeccable democratic credentials, although Milei has rejected this portrayal, instead calling him an "authoritarian" and a "swindler" whose hyperinflation amounted to robbery of the Argentine people. The last and by far the worst was the economic and financial crisis of 2001–2002, which saw Argentina default on virtually all its foreign debt and brought it to the brink of social collapse. There was widespread popular repudiation of the entire political establishment, exemplified by the slogan, "*Que se vayan todos,*" "they must all go." Milei own promise in the 2023 campaign to get rid of what he calls *La Casta*, and by which he means the entire political class, resurrects that anti-elitist revulsion in the service of the populist right rather than the populist left that took to the streets in 2001.

But in 2001, there was finally no social collapse (even though Argentina had five presidents in a period of two weeks). That the country would weather the storm was anything but clear at the time. That it did so at all, as Pablo Grechunoff, one of Argentina's most distinguished economic historians and himself no Peronist, was Néstor and Cristina Kirchner's great accomplishment. (They were always a team politically, rather like Bill and Hillary Clinton.) The Kirchners, Gerchunoff has written, were not only able to "contain the social and political bloodbath [that had occurred] in 2001," but also managed to "reconstitute both presidential authority and a [functioning] political system." On the economic front, even most of the Kirchners' anti-Peronist critics — except the contrarian Milei, of course — find it hard to deny that during Néstor's presidency and Cristina's first term in office the Argentine economy made a powerful recovery. To be sure, these critics are also quick to point out that this recovery was not only fueled in large measure fueled by the huge spike in world commodity prices — "a gift from heaven" is the way Gerchunoff has described it — but also by the fact that Néstor's predecessor as president, Eduardo Duhalde, had instituted a series of harsh economic measures, including a brutal devaluation of the currency, and so he had a freedom of maneuver enjoyed by few Argentine presidents before or since to refloat the Argentine economy and vastly increase welfare payments and other forms of social assistance for the poorest Argentines.

It is this seemingly cyclical character of Argentina's economic crises — "Boom and recession. Stop and go. Go and crash. Hope and disappointment," as Gerchunoff summarizes it — and at the same time the country's repeated capacity to recover and once more become prosperous that still leads

many Argentines to take something of a blase approach every time the country gets into economic difficulty. But while it is true that, so far at least, Argentina has indeed emerged from even its worst economic crises, it is also important to note that each time it was left with fewer middle-class people and more poor people. The crisis of 2001 was the tipping point. Before that, even after the *Rodrigazo* and Alfonsín's hyper-inflation, Argentina continued to be not only one of Latin America's richest countries and to sustain a middle class proportionally much larger than those of other countries in the continent, but, most importantly, to be a society in which, for most of the years between 1870 and the crisis of 2001, social mobility was a reality for the broad mass of the population. After 2001, however, it was no longer possible to deny the melancholy fact that Argentina was quickly becoming — and today has become — very much like the rest of Latin America. As the sociologist Juan Carlos Torre has put it, in previous periods of its history "Argentina had poor people but it did not have poverty [in the sense that] the condition of being poor in a country with social mobility was contingent." But in the Argentina of today, social mobility scarcely exists. If you are born poor, you stay poor for your entire life, as do your children, and, if things don't change radically, your children's children. As a result, poverty, and all the terrible moral, social, and economic distortions that flow from it (including narcotrafficking on a massive scale), has become the country's central problem.

It is in this context that Milei's rise and unprecedented victory needs to be set. According el Observatorio de la Deuda Social Argentina (ODSA) of la Universidad Cátolica Argentina, a Jesuit-run think tank whose intellectual probity and method-ological sophistication are acknowledged by Argentines across

the political spectrum, by the time the presidential primaries took place on August, 13, 2023 the national poverty rate had reached 44.7%, while the rate of total immiseration had climbed to 9.6%. For children and adolescents, the figures were still more horrific: six out of ten young Argentines in these two age cohorts live below the poverty line. In aggregate, 18.7 million Argentines out of a total national population of forty-six million are unable to afford the foodstuffs, goods and services that make up the so-called *Canasta Básica Total*, of whom four million are not able to meet their basic nutritional needs.

Again, the 2001 statistics had been just as bad in a number of these categories — but this time, going into the 2023 election, there was a widespread feeling that there was no way out. Neoliberalism Macri-style had been a disaster, but so had Peronism Alberto Fernández-style (though hardline Peronists rationalized this to the point of denial by claiming that Alberto had betrayed the cause and if he had only carried out the policies Cristina had urged upon him, and on which he had campaigned, all would have been well). That was why Milei's populist promise to do away with the entire political establishment resonated so strongly. Flush with revenues from agro-business, the Kirchners had managed to contain the crisis for a while by rapidly establishing and then expanding a wide gamut of welfare schemes — what are collectively known in Argentina as *los planes sociales*. As the political consultant Pablo Touzon has observed, in doing so the Kirchners succeeded in achieving what had been the priority of the entire political establishment, Peronist and non-Peronist, which was "to avoid another 2001 at all costs."

The problem is that commodity prices are cyclical and that the agricultural resource boom of the first decade of the century proved, like all such booms, to be unsustainable. And

when price volatility replaced consistent price rises, for all the Kirchners' talk of about fostering economic growth through a planned economy and a "national" capitalism focused on the domestic market, there proved to be no non-commodity-based engine for sustained growth and thus no capacity to create jobs that would restore the promise of social mobility. (The many government jobs that were created could not offer this.) As a result, the mass welfare schemes that had been created rapidly became unaffordable. The commentator who likened Argentine society in 2023 to an intensive care patient who remains in agony despite being on an artificial respirator called the state was being hyperbolic, but that such an analogy could be made at all testifies to the despair that is now rampant in the country. And it is this the despair that has made it possible for the bizarre Milei to be elected.

Joan Didion's famous observation that we tell ourselves stories in order to live has never seemed quite right to me, but there is no question that it is through stories that most people try to grasp where they stand in the world. What the Peronists do not seem to have been able to face, even during the four year-long social and economic train wreck that was Alberto's presidency, was that many of the voters whom they believed still bought their story had in fact stopped doing so. Some blamed Alberto, and when Massa ran in effect asked the electorate for a do-over. Others simply found it impossible to believe that Milei could be elected. Peronism is both Manichean and salvationist. Peronism has never conceived of itself as one political party among other equally legitimate political parties. It regards itself as as the sole morally legitimate representative of the

Liberland: Populism, Peronism, and Madness in Argentina

Argentine people and of the national cause. When Perón joked that all Argentines were Peronists whether they knew it or not, the anti-pluralist subtext of his quip was that one could not be a true Argentine without being a Peronist. And that conviction remains alive and well in Kirchnerism. So to indulge in the very Argentine habit of psychological speculation — after all, Argentina is the country which has one hundred and forty-five psychiatrists for every one hundred thousand inhabitants, the highest proportion in the world — it may be that Peronists were so slow in recognizing Milei's threat because, for the first time since Juan Perón came to power in 1946, they faced a candidate just as Manichaean and salvationist as they are. Peronism had always seen its mission to sweep away the "anti-national" elites, so that Argentina could flourish once more. Having become accustomed to seeing political adversaries as not only their enemies but also as the enemies of the Argentine nation, the Peronists did not know what to do with someone who viewed them in exactly the same light. As a result, the Argentine election of 2023 was the confrontation between two forms of populism, which is to say, between two forms of anti-politics.

Going into the campaign, the problem for the Kirchnerists was that Alberto was in denial about the social crisis and a few days before he left office he even saw fit to challenge the accuracy of these figures. Without offering any countervailing data, Fernández simply said that many people were exaggerating how poor they were. If the poverty rate really had reached 44.7%, Fernández insisted, "Argentina would have exploded." To which Juan Grabois, a left populist leader and union organizer with close links to Pope Francis and whose base of support consists mostly of poor workers who make their living in what the International Monetary Fund calls the informal economy — work that not only in not unionized,

but in which government labor regulations, from health and safety to workplace rights, go completely unrespected — retorted: "It *has* exploded, Alberto. It's just that we got used to it; it didn't explode, it imploded. That makes less noise, but the people bleed internally."

For the Argentine middle class, the situation, though self-evidently not the unmitigated disaster that it is for the poor, is quite disastrous enough. An inflation rate of one hundred and forty-two percent — which even Milei has conceded will not end soon, a bleak prediction which his early days in office supports — makes intelligent business decisions impossible, seeing that it involves trying to guess what the Argentine peso will be worth next month or even next week. In practice, the currency controls instituted by Fernández's government damaged and in many cases ruined not only the retailer who sell imported merchandise, but also the pharmacist whose stock includes medicines with some imported ingredients, the machine tool company that, while it makes its products in Argentina, does so out of imported steel or copper, and the publisher unable to assume with any confidence that paper will be available, let alone guess at what price. Nor is the psychological dimension of the economic crisis to be underestimated. Confronted by rising prices, many middle-class people now buy inferior brands and versions of the items that they have been used to buying. In the context of a modern consumer culture such as Argentina's, there is a widespread sense of having been declassed, of having been expelled from the middle-class membership which they had assumed to be theirs virtually as a birthright. This has produced a different kind of implosion, of being bled dry, than the one to which Grabois referred, but an implosion just the same.

An implosion is a process in which objects are destroyed by collapsing into themselves or being squeezed in on themselves, and, by extension, a sudden failure or fall of an organization or a system. What Milei's election as president has made clear is just how fragmented and incoherent and fragile the two forces that have dominated Argentine life since the return of democracy — the Peronists one one side, and the Social Democrats and Neoliberals on the other — have now become. That this should be true of the center and center-right parties that had come together to form the *Cambiemos* coalition that Macri successfully led to power in 2015 is hardly surprising. For *Cambiemos* had united very disparate forces in Argentine politics — the neoliberals of Macri's party, the *PRO*, two more or less social democratic parties, the *Union Cívica Radical* (UCR), the party of Raúl Alfonsín, and a smaller party led by the lawyer and activist Elsa Carrió that had broken off from the UCR in 2002 and since 2009 had been known as the *Coalición Cívica*. Somewhere in between were anti-Kirchnerist Peronists, one of whom, the national senator Miguel Pichetto, had been the vice-presidential candidate in Macri's failed bid to win re-election in 2019. These various groupings within *Juntos por el Cambio*, as *Cambiemos* was renamed going into the 2019 campaign, were united largely by their anti-Peronism. This should not be surprising. Since Juan Perón was elected president in 1946, Peronism has been for all intents and purposes the default position of the Argentine state — except, obviously, during the periods of military rule, which had their own kind of Manichaean salvationism. A central question that Milei's election poses is whether the seventy-eight-year-long era has finally come to an end. Is Argentina on the verge of a political path that, in Carlos Pagni's words, "has never before explored," or will the days

ahead be only a particularly florid instance of the exception that proves the rule?

Apart from the fact that it is salvationist and Manichaean, and that it is a form of populism, usually though not always on the left, Peronism is notoriously difficult to define. It is both Protean and plastic in the sense that it contains within itself such a gamut of political views that a non-Argentine can be forgiven for wondering whether, apart from the morally monopolistic claims that it makes for itself, it is one political party among a number of others or instead all political parties rolled into one. Horacio Verbitsky tried to account for the fact that it had been at various times left and at other times right by saying that Peronism must be "a mythological animal because it has a head that is on the right while its body is on the left." A celebrated remark of Borges sums up Peronism's diabolical adaptability. "If I must choose between a Communist and a Peronist," he quipped, "I prefer the Communist. Because the Communist is sincere in his Communism, whereas the Peronists pass themselves off in this way for their advantage." And as Carlos Pagni has observed, "This empty identity gives them an invaluable advantage."

Even assuming that Milei's victory turns out to bring down the curtain on Kirchnerism, this does not mean that Peronism is over. After all, Argentines have been at this particular junction before. When Macri became president in 2015, his election was widely viewed as representing much more than one more anti-Peronist intermission between acts of the recurring Peronist drama. It was seen to mark the inauguration of an era of straightforward neoliberalism, which would transform Argentina both economically and socially — the instauration in the country, however belatedly, of the Reagan-Thatcher revolution. Certainly that was what Macri thought

he was going to put in motion. Instead his government was an abject failure. Macri seems to have believed that a non-Peronist government combined with what he perceived as his own special bond with the international financial world — which, as the son of an extremely rich Argentine entrepreneur, was his home ground — would lead to widespread direct foreign private investment. The problem was that not only was his economic team not up to the job, but, far more importantly, the structural problems of the Argentine economy, above all that the country had been living beyond its means for decades, would have been very difficult even in a country far less politically divided. As a result, the only important investments outside the agribusiness sector during Macri's presidency were what in the financial markets are referred to as "hot money," that is, speculative bets by hedge fund managers who are as happy to sell as to buy, rather than by more economically and socially constructive long-term investors.

In 2018, three years into his administration, with a currency crisis looming that was so severe it would almost certainly have led to the Argentine state becoming wholly insolvent, Macri turned as a last resort to the International Monetary Fund. There were echoes in this of the loan facility that the IMF had provided to the government of Fernando de la Rúa that was in power at the time of the 2001 crisis. But this time, instead of demanding radical austerity measures, and when these were not fulfilled to the Fund's satisfaction cutting off the loans, the executive board of IMF, prodded by the Trump administration, which viewed the demagogic anti-elitist Macri with particular favor, voted to grant Argentina a loan of fifty-seven billion dollars — the largest in IMF history. As the institution would itself later concede, in doing so the board broke its own protocols and failed to exercise the most basic due diligence.

148

Both Peronists and non-Peronist leftists are convinced that the IMF's goal was simply to prop up Macri's government, and this is certainly what impelled the Trump administration to intervene. But even if one takes at face value that, in the words of a subsequent IMF report, the institution's main objective had been instead to "restore confidence in [Argentina's] fiscal and external viability while fostering economic growth," this is not at all what occurred. "The program," the IMF report concluded, "did not deliver on its objectives," and what had actually happened was that "the exchange rate continued to depreciate, increasing inflation and the peso value of public debt, and weakening of real incomes, [weakened] real incomes, especially of the poor."

It was under the sign of this disaster that the Argentine electorate voted Macri out of office, installing Alberto as president and Cristina as vice-president. One might have thought that, as the undisputed leader of Peronism, she would have run for president herself. Certainly, this is what the overwhelming majority of hardcore Peronist militants had hoped and expected. But Cristina soon made it clear that she believed herself to be too controversial a figure to carry Peronism to victory in 2019. This did not lessen the expectation among most Peronists that Cristina would be the power behind the throne. But to their shock and indignation, Alberto refused to bow to these expectations. At the same time, he was too weak to put through a program of his own, if he even had one. But the disaster that was his government should not be allowed to obscure just how dismal a failure Macri's presidency had been. And it is in the context of these successive failures, first of the neoliberal right and then of Peronism, that Milei's rise to power must be understood. He was the explosion that followed the implosions.

Liberland: Populism, Peronism, and Madness in Argentina

The implosions were sequential. The first round of Argentine presidential elections includes a multitude of candidates, and this often leads to a run-off between the two top vote-getters. In that first round, it was the turn of *Juntos por el Cambio*'s candidate, Macri's former Security Minister Patricia Bullrich, to come up short. Bullrich campaigned almost exclusively on law-and-order issues, and there is no doubt that her emphasis on these questions resonated with an Argentine population increasingly terrified by the dramatic rise over the past decade of murder, assault, violent robberies, and home invasions — the regular disfigurements of present-day Argentine society. On economic questions, however, she more or less followed a standard neoliberal line, but in a manner that did not suggest that she had any intention of shaking up the political status quo. To the extent that she spoke of corruption, Bullrich pointed exclusively at Kirchnerist corruption, whereas corruption in Argentina is hardly restricted to Peronism.

To the contrary, every Argentine knows full well that their entire political class, regardless of party, faction, or ideology, has nepotism, corruption, and looting all but inscribed on its DNA. As Argentina's most important investigative journalist, Hugo Alconada Mon, wrote in his definitive analysis of the phenomenon, *The Root of All Evils: How the Powerful Put Together a System of Corruption and Impunity in Argentina*, "Argentina is a country in which prosecutors don't investigate, judges don't judge, State supervisory bodies do not supervise, trade unions don't represent their rank and file, and journalists don't inform." Given all that, Alconada asked, "Be they politicians, businessmen, judges, journalists, bankers, or trade unionists, why would any of them want to reform the system through which they have amassed illegiti-

150

mate power and illicit fortunes with complete impunity?" To which the answer, of course, is that they don't, as Alconada has illustrated in his most recent investigation of phantom jobs on a massive scale within the legislature of the province of Buenos Aires. As the evidence mounted and a prosecutor was named, the Peronists and anti-Peronists in the legislature finally found there was something on which they agreed: a blanket refusal to cooperate with the investigation.

The reality is that the only way not to see how corrupt Argentine politics are is to refuse to look. But since Peronist corruption is generally artisanal, that is to say, a matter of straightforward bribes in the form of money changing hands, or, at its most sophisticated (this innovation being generally attributed to Nestor Kirchner) officials being given a financial piece of the companies doing the bribing, Peronist corruption is more easily discerned. When pressed, those Peronists who do concede that there is some corruption in their ranks still insist that it has been wildly overstated by their enemies in what they generally refer to as the "hegemonic media." In any case, one is sometimes told, too much attention is paid to what corruption does exist. "What should be clear," wrote the Peronist economist Ricardo Aronskind in Horacio Verbitsky's *El Cohuete a la Luna* in the wake of Milei's victory, "is that the decency or indecency of a political project cannot be defined by certain acts of corruption that arise within it, but rather by the great economic and social processes that it sets in motion in the community: its improvement and progress, or its deterioration and degradation." In other words, Peronists are not just on the side of the angels, they *are* the angels, and their blemishes should not trouble anyone that much.

Whether Peronist corruption is worse than that of their neoliberal adversaries is a separate question. There is

no doubt that the alterations to the tax code that Mauricio Macri made over the course of his administration made it possible for his rich friends to make fortunes, thanks both to the insider information they seem to have secured and to various forms of arbitrage they were able to execute in the currency markets. And this "white-gloved" variety of corruption is thought by many well-informed observers to have involved profits at least as large and possibly larger for those who had benefitted from it than whatever the Kirchners and their cronies have been able to secure for themselves. Milei's promise to sweep away *La Casta*, the entire political elite, made no distinction between Peronist and ant-Peronist corruption. It was his promise throughout the campaign to sweep it all away — a pledge that he routinely illustrated in photo-ops with him waving around a chainsaw — combined with a far purer and more combative version of neoliberalism than Bullrich could muster that allowed Milei to see her off in the first round. Nothing that she could possibly say could have competed with Milei's rhetoric of rescue, as when he shouted at rallies, "I did not come here to guide lambs, I have come here to wake lions!" No one was surprised by the result — by some accounts not even Bullrich herself.

Against the pollsters' predictions, however, it was Massa, not Milei, who came in first. This was somewhat surprising, since on paper Massa should never have stood a chance. For openers, Massa had been minister of the economy from July 2022 to the 2023 elections. It was on his watch that inflation had reached triple digits. Massa was more than just an important figure in Alberto's government. Owing to the looming threat of hyper-inflation, the economy eclipsed all other issues during the last eighteen months of Alberto's presidency. The president did not know the first thing about

economics, and by late 2022 he had become a kind of absentee president, who, with the exception of some foreign-policy grandstanding that largely consisted in paying homage to Xi, Putin, and Lula, seemed to prefer to play his guitar at Los Olivos, the presidential retreat. As a result, almost by default, Massa became in practical terms the unelected co-president of Argentina. This gave him enormous power, but it also meant his taking the blame for the government's failure to do anything to successfully mitigate runaway inflation.

And yet Milei seemed so unstable personally and so extreme politically that many Argentines, particularly in the professional classes, in the universities, and in the cultural sphere — which in Argentina, as virtually everywhere else in the Americas and in Western Europe, all but monolithically dresses left, including in the Anglo-American style of identitarianism and wokeness — allowed themselves to hope that Massa would pull off the greatest comeback since Lazarus. They drew comfort from how many civil society groups, not just in the arts but also in the professions, the trade unions, feminist groups, even football associations, were coming out in support of Massa, presumably because they assumed, wrongly as it turned out, that these groups' members would vote the way their leadership had called for them to vote. Even seasoned journalists and commentators with no love for Massa took it as a given that he was in command of the issues that confronted Argentina in a way that Milei was not. In contrast, it was generally agreed that Milei was barely in command of himself. After his televised debate with Massa, the gossip among political insiders was that Milei's handlers were less concerned with the fact that Milei had lost the arguments so much as relieved that he had not lost his cool and given vent to the rages, hallucinations, and name-calling that had been

153

his stock-in-trade as a public figure since he burst onto the Argentine scene in 2015.

2

To describe Javier Milei as flaky, as some of his fellow libertarians outside of Argentina have done as a form of damage control, is far too mild. This is a man who in the past described himself as a sex guru, and now publicly muses about converting to Judaism. During the trip he made to the United States shortly after his election to speak with Biden administration and IMF officials, Milei took time out to visit the tomb of the Lubavitcher rebbe Menachem Mendel Schneerson in Queens. At the same time Milei is a proud devotee of the occult, confessing without the slightest embarrassment to his habit of speaking to a dead pet through a medium. He also claims to have cloned the pet in question, an English mastiff named Conan, to breed the five English mastiffs that he now has, four of which are named after neoliberal and libertarian economists. Cloning, Milei has declared, is "a way of reaching eternity." It often seems as if he lives entirely in a world of fantasy and wish-fulfillment that closely resembles the universe of adolescent gamers. And he is, in fact, an avid devotee of cosplay, though here Milei's fantasy life is harnessed to the service of his economic views: at a cosplay convention in 2019, Milei introduced his character General Ancap, short for "anarcho-capitalist", the leader of "Liberland, the country where no one pays taxes." The life mission of General Ancap is to "kick the Keynesians and the collectivist sons of bitches in the ass."

Milei's public persona seems designed to reflect these wild convictions and obsessions. He has a mop of unruly hair, which he proudly claims never to comb. He thinks it makes him look leonine, and being a lion leading a pride of Argentine lions is

154

one of Milei's most cherished images of himself, and one that proved to resonate deeply with the Argentine electorate. In public appearances Milei always seems to be on the verge of a hysterical tantrum, and often he explodes into one. And Milei's economic program can seem at least as wild as his fantasy life. He has promised to address the collapse of the Argentine peso by scrapping the national currency and replacing it with the dollar; to abolish the central bank; to privatize many industries, from the national airline to the national oil company; and to open up the Argentine market to foreign competition while at the same time abolishing such protectionist boondoggles as the electronic assembly plants in Tierra del Fuego in Argentina's far south, where, free of federal tax and VAT, some Argentine entrepreneurs have made fortunes assembling electronics from Korea, Vietnam, and China that could have just as easily and much more cheaply assembled in the factories that produced them in their countries of origin. Milei has spoken of offering people educational vouchers as an alternative to public education. Some of this, such as educational vouchers and privatization, are straight out of Margaret Thatcher's playbook. Milei has said that he greatly admires her, which is an odd stance for an Argentine politician to take regarding the British prime minister who repelled the Argentine effort to seize or (depending on your flag) regain rightful control of the Malvinas or (depending on your flag) Falkland Islands. At least Milei has backtracked from his proposals to allow the commercial trade in human organs, even if he did so reluctantly, indignantly demanding in an interview: "That the state should want to enslave us is allowed, but if I want to dispose of some parts of my body...What's the problem?"

The irony is that in large measure it was the widespread belief within the Peronist establishment that Milei was too

extreme to be electable that proved crucial to Milei's successful quest for the presidency. Born in 1970 into a lower middle-class family in Buenos Aires, educated in parochial schools and trained as an economist, Milei worked for a number of financial institutions before becoming chief economist at the privately held *Corporación America*, the holding company of Argentina's sixth richest man, Eduardo Eurnekian, whose fortune largely rests on *Aeropuertos Argentina 2000*, which manages Argentina's thirty-five largest airports as well as roughly the same number internationally. He is also rich from media interests and agribusiness. By most accounts, it was Eurnekian who in 2013 launched Milei's media career. Why Eurnekian did this remains unclear. According to one version, Eurnekian had become deeply dissatisfied with the policies of Cristina's government and wanted a mouthpiece to express this dissatisfaction in the noisiest way possible in the media. According to another, it was Milei himself who had had decided that he wanted to do more than work behind the scenes at *Corporación America* and chose to seek a more public role. Whatever the case, it hardly seems likely that it was coincidence that a media outlet which hired Milei, first as an occasional contributor in 2013 and then, the year later, as a full-time columnist, was the website *Infobae America*, a news outlet in which Eduardo Eurnekian's nephew Tomás held a twenty-percent stake. The first article that Milei published in *Infobae* was titled "How to Hire a Genius."

Four years later, in 2017, halfway into Macri's term in office, at the time when the government was facing its first major economic crisis, Milei became an important media figure. He moved from print to television and social media and came to national prominence as a pundit — a success that was largely due to his propensity for provocation, his seemingly

unslakable thirst for on-air confrontation. At the time of Eurnekian's break with Macri, then, Milei certainly did not require Eurnekian's, or, indeed, anyone else's help to secure public exposure. In 2021 a magazine named him the fourth most influential person in Argentina. (The top spot went to Cristina.) He was giving forty speeches a year preaching his anarcho-capitalist gospel, initially in person and then, during the pandemic, over the internet. He even mounted a theatrical piece to proselytize his ideas, *El consultorio de Milei*, in which, in the form of a psychotherapy session, he offered a whirlwind tour of the previous seventy years of Argentine economic history from a libertarian perspective.

Milei once said of himself: "Take a character out of Puccini and put him in real life and you have me." Tosca or Scarpia? A bit of both, I think. But what seemed to most turn him on in his media appearances was hurling very unPuccinian insults in all directions. "The state," he said in one interview, "is the pedophile in a kindergarden where the little kids are chained up and covered in Vaseline." Pope Francis is one of his favorite targets. Over the years Milei has called him an "imbecile who defends social justice" (coming from Milei's lips "social justice" is a slur), and a "son of a bitch preaching Communism," and "the representative of the Evil One on earth." When Horacio Rodriguez Larreta, a major political figure of the center-right, was head of government of the City of Buenos Aires, Milei characterized him as "a disgusting worm" whom he could "crush even while sitting in a wheelchair." He confessed on a talk show that one of the ways he let off steam is by throwing punches at a mannequin across whose face he has glued a photo of Raúl Alfonsín.

In the midterm elections of 2021, which inflicted a stinging defeat on Alberto Fernández's government, Milei was elected to Diputados, the lower chamber of Congress, as a member of a new libertarian political party called *La Libertad Avanza*, which counted among its members another libertarian economist, José Luis Espert. Once seated, Milei remained true to his libertarian creed, even opposing a law to expand Argentina's congenital heart disease treatment program for newborns on the ground that could well lead to more opportunities for the state to "interfere in the lives of individuals." The *Libertad Avanza* delegation not only included libertarians such as Espert and Milei himself, but also figures of the hard right such as Victoria Villarruel, an activist lawyer notorious in human rights circles for what they view as her denial of the crimes of the military dictatorship of 1976–1983, accusations that she has denied though not very convincingly. *Libertad Avanza* never made any secret of its hard-right sympathies. Milei, Espert, and Villarruel were enthusiastic signatories of "The Madrid Charter: In Defense of Freedom and Democracy in the Iberosphere," which had been produced by La Fundación Disenso, the think tank of Spain's extreme conservative Vox Party. (The current Italian prime minister Giorgia Meloni and the right-wing Chilean politician José Antonio Kast were also among the signatories.) Santiago Abascal, the leader of Vox, the radical right party in Spain, has said that his feeling for Milei is one of "brotherhood." Milei subsequently broke with Espert, renaming his own party *La Libertad Avanza*. He did not, however, break with the hard right, and few Argentines were surprised that it was to none other than Villarruel to whom he turned as his running mate in the recent election.

In the speech that he made at his inauguration — a ceremony one of whose more curious sideshows was Cristina

giving the finger to journalists as she was driven onto the grounds of Congress, and then chatting amiably with Milei while ignoring Alberto completely — Milei spoke of the political class in Argentina as having followed "a model that considers it the duty of a politician to oversee the lives of individuals in as many fields and spheres as possible." Milei's solution was the classic libertarian one: Liberland! The state simply needs to get out of the way. Only when this happens can the free market flourish, and people live up to their potential to be "a pride of lions and not a flock of sheep." Quoting the Spanish libertarian economist Jesús Huera de Soto, whose work has greatly influenced him, Milei declared flatly that "anti-poverty plans only generate more poverty, [and] the only way to exit from poverty is through more liberty." And he went on to contrast the Argentina of the pre-World War I boom, when it was one of the richest countries in the world, when it had been, as he put it, "the beacon of the West," with the Argentina of today, drowning in poverty, crime, and despair. This, he insisted, was because the model that had made Argentina rich had been abandoned in favor of a suicidal collectivism. "For more than a hundred years," he thundered, "politicians have insisted on defending a model that has only generated more poverty, stagnation, and misery, a model that as citizens we are here to serve politics rather than that politics exists to serve citizens."

The problem with this account of Argentine history is that it is spectacularly selective. It leaves out too much to be quite credible. Yes, Argentina's pre-1914 economic golden age did indeed make the country rich — if proof were needed, the grand bourgeois architecture of Buenos Aires attests to the prosperity. It was also an era in which the foundations of mass education in Argentina were laid and great advances

took place in public health. But the Argentine middle class kept expanding prodigiously until 1930, sixteen years after Milei claimed its prosperity had been shattered by statism, and it began to expand again, if anything more prodigiously, between 1946 and 1955, during Juan Perón's first two terms as president. Nor would you know from Milei's account that universal male suffrage was not introduced in Argentina until 1912, during the presidency of Roque Sáenz Peña with the support of Hipólito Yrigoyen, the leader of la Union Cívica Radical (UCR), or that the first time it was applied was in the presidential election of 1916, which brought Yrigoyen to power, while Argentine women did not get the right to vote until 1947, under Perón. Nor would you learn that when, in his inaugural address, Milei eulogized Julio Argentino Roca as "one of Argentina's best presidents," he was paying tribute to a figure who, in 1878, while still General Roca, two years before his election as president of Argentina, had led the genocidal *Campaña del Desierto* against the indigenous peoples of the south of the country, and for this reason is one of the most controversial figures in Argentine history. Milei's revered Roca had fiercely opposed not just universal suffrage, but also the secret ballot.

When Milei speaks of the disastrous model of the past hundred years, what he is actually talking about is the Argentina that began to take shape in 1916, when Yrigoyen became president. What Milei certainly has in mind is Yrigoyen's creation of a state-owned national railway system and his partial nationalization of Argentina's energy resources. What he leaves out is not only Yrigoyen's role in establishing democratic practices such as the secret ballot and universal male suffrage, but also the reform and expansion of the university system and the creation of the first retirement

160

funds for workers. In Milei's version of the twentieth century in Argentina, the great movements of social reform that led to the legitimization of trade unions, paid holidays for workers, progressive tax regimes, and so on, were all wholly unnecessary, because the markets eventually would have sorted all these problems out to everyone's satisfaction. Forget communism: on this account, even social democracy was an act of collective self-harm. Milei said as much in the speech he gave at the World Economic Forum in Davos five weeks after his inauguration. Whatever they might call themselves, he declared, "ultimately, there are no major differences" between Communists, Fascists, Social Democrats, Christian Democrats, neo-Keynesians, progressives, populists, nationalists, and globalists. All are "collectivist variants" that held that "the state should steer all aspects of the lives of individuals." Milei made no bones about his ambition to redeem not just Argentina but the entire Western world. "We have come here today," he told his tony audience, "to invite the Western world to get back on the path to prosperity" and to warn it "about what can happen if countries that became rich through the model of freedom, stay on this path of servitude."

To accept this, one would have to believe that sometime around a century ago the Argentine people lost its collective mind and that it took the advent of Milei to bring them back to their senses and guide them back to the prelapsarian days of the late nineteenth century. As for Peronism, it was either completely imposed on the population, or it remains one of history's most extraordinary examples of the madness of crowds. The historical facts say otherwise. What Milei is pleased to call the liberal order but what was in fact an oligarchic one was first seriously challenged when Yrigoyen was elected, and it was finally broken only in 1946 with the rise of

Perón. Indeed, Perón's own personal ascent from obscurity was at least partly due to the fact that the earthquake that reduced most of the Province of San Juan to rubble in 1944 was widely understood at the time, both regionally and nationally, as demonstrating the bankruptcy of the old social order, while Colonel Perón's successful effort to rebuild the province offered a glimmer of a different and better Argentina. (Mark A. Healey's brilliant study, *The Ruins of the New Argentina: Peronism and the Remaking of San Juan after the 1944 Earthquake*, shows this in painstaking detail.) The reason that so many Argentines remained loyal to Peronism for so long was because of its accomplishments, beginning with that of upholding the rights of the working class. (Good libertarian that he is, Milei would doubtless respond that classes do not have rights.) Most Argentines know this, which is why, despite all its failures, they have turned back to Peronism again and again.

The fact that, despite their knowing this, Milei could not only defeat Massa, but best him by eleven points, a landslide in Argentine political terms and the worst defeat that Peronism has suffered in seventy-five years, is eloquent testimony to the anger about the present and the despair about the future that now grips so many Argentines, including those who in the past voted Peronist. Out of Argentina's twenty-three provinces as well as the city of Buenos Aires, Massa won only three — the Province of Buenos Aires (not to be confused with the city) and the provinces of Formosa and of Santiago del Estero. And even in the Province of Buenos Aires, Massa won only by a two percentage points, whereas to have had any chance at winning the presidency he would have had to win there overwhelmingly. Still, to view Milei's election as a vote against the government rather than a vote for him is to misunderstand what has taken place in Argentina.

Milei's appeal is both deep and wide, and it cuts across all social classes. The antipathy of the cultural and professional elite towards Milei was always visceral, and with his election it is now dumbfounded as well. They are appalled by the persona that he projects, with its signature aggression and its rigidly Manichaean division of Argentine society into *la gente de bien*, the good people, and the corrupt elite of *La Casta*. It is not that the cultural elite does not believe in emotion in politics; the left is hardly immune to the excitements of populism, and the Argentine left is profoundly sentimental in its vision of the Argentine people, above all, as the Italian political scientist Loris Zanatta has argued, in their adherence to the element in liberation theology that assigns a unique moral worth to the poor. The problem, as the Kirchnerists and their supporters in the cultural left demonstrated time and time again during the campaign, is that they do not believe in the sincerity of any emotion that they do not themselves feel. The pundits, on the other hand, underestimated Milei because they viewed the campaign too rationally, as when, for example, Massa won the arguments in his public debate with Milei, as if populist politics cares a whit about arguments. For many poor people, especially poor young men who work in the informal economy, what had resonated so strongly with them in the debate, as it had throughout Milei's campaign, were not the policy details that Milei mentioned but the promise of rescue that he offered.

The issues of trans rights and even human rights that now have captured the moral imagination of the cultural elite and of the professional managerial classes — in Argentina just as much in the United States and the United Kingdom — are simply not of much concern to the poor and the economically stranded, and cultural issues such as whether or not Milei

would cut off government funding to the Argentine cinema are irrelevant to them. As for the memory of the dictatorship: during the campaign it was repeatedly brandished by the left as a powerful argument, morally and politically, against Milei and Villarruel. This was not surprising, since it is perhaps the Argentine left's deepest conviction that democracy and memory are inseparable. The fact that the election took place on the fortieth anniversary of the return to democracy only reinforced these feelings. But then Milei won, and they groped for answers. Some of these were of a generational high-handedness that were painful to read, as when the Lacanian Peronist (only in Argentina!) Jorge Alemán argued that "the superimposition of the images that erupt on social media has generated an empire of the ephemeral that threatens the dynamic of emancipatory narratives to the point of rendering them inoperable." For the Peronist sociologist Fernando Peirone, *La Libertad Avanza* "had succeeded in tuning in to those web-based narratives that renounce argument, memory, and the idea of truth itself." What the Argentine cultural elite still has not been able to come to terms with is that in human terms it is the purest wishful thinking to imagine that a twenty year-old voter in the slums who is too young to have experienced the dictatorship would promote this historical memory into the determining factor in their vote.

Just as the elections of Trump and Bolsonaro were to the American and Brazilian cultural elite, Milei's election is quite incomprehensible to most of the Argentine elite. They certainly don't know anyone who voted for him! But one must be careful here. The conventional left-liberal view of Milei, which is that he is simply an Argentine version of Trump or Bolsonaro, and that his victory is one more feather in the cap of global rightwing populism, alongside

164

Meloni in Italy or Orban in Hungary, is at best a half-truth. Like Trump, Bolsonaro, and Orban, Milei is a savior figure. What distinguishes him from the rest of the Black International is his appeal to poor voters, many of whose opposite numbers in the United States or Brazil would never dream of voting for Trump or Bolsonaro. In this, curiously, for all the talk on the left that Milei is a throwback to the military dictatorship, and to the economic policies of the junta's economics minister José Alfredo Martínez de Hoz, he actually resembles Perón in 1946 more than he does Perón's enemies in the old oligarchy. In his many impassioned defenses of Peronism, Horacio Verbitsky has often said that while there are those who associate Peronism with fascism, this is false because, as he once put it, "fascism is a movement of the bourgeoisie against the working class, [whereas Peronism] represents the working class, its rights, and its forms of organization."

Although he would doubtless reject the suggestion, Verbitsky's view helps to explain what distinguishes Milei from Trump, Bolsonaro, and Orban. While Peronism in 2024 may still be said to represent the Argentine working class, it represents only the organized working class. And with the exception of a few leaders of Peronist-leaning social movements, the most consequential of whom is Juan Grabois, Peronism has failed to address the problems, and thus have failed to sustain the allegiance, of the informal workers who now make up forty percent of Argentina's labor force. The unionized working class may still feel that Peronism speaks in their name (though given the corruption of the trade union leadership, even this is debatable), but the workers in the informal economy most definitely do not. As Carlos Pagni has said, there is a "crisis of representation" in Argentine politics. Milei's great strength has been his ability to make so many

165

informal workers feel represented. He has done so by speaking to their sense of abandonment by government, to their belief that the entire political class, Peronist and non-Peronist alike, are in it only for the money and the power, and that if there is any hope of change they must put their faith in him. Again, Trump and Bolsonaro inspire the same hope in their constituencies, and Milei's margin of victory — 55% — is roughly the same as Bolsonaro received when he was elected. But if you are a Trump-supporting Evangelical you are not someone who would ever cast your ballot for Cornel West, and Bolsonaro lost badly among Brazil's poorest voters, whereas Milei has triumphed among the poor as well — precisely those voters whom a Juan Grabois or an Argentine Trotskyist would think of as their core constituency.

Having ridden to office on a wave of emotion, how will Milei actually govern? *La Libertad Avanza* was largely a vehicle for his presidential hopes and it fielded very few candidates for election to Congress. It is true that Milei came into office believing that that he could impose a part of his program by issuing a series of what in Argentina are called DNUs, the Spanish acronym for "Necessary and Urgent Decrees". And ten days into his term that is exactly what he did. But instead of promulgating a handful of decrees whose urgency could indeed be justified to the public at large as an immediate response to the economic crisis, as he had justified the devaluation of the Argentine peso by one hundred and twenty percent that he had put into effect almost immediately after taking office, Milei issued a "Mega Decree" that included most of the major elements of the remaking of the Argentine economy and Argentine society that he had promised to enact if elected. Milei's omnibus DNU either radically altered or annulled three hundred and sixty-six economic regulations,

structures, and — most controversially — laws, including the removal of all rules governing the relations between landlords and tenants, loosening labor laws (above all employment protections), limiting the right to strike, scrapping export controls, rescinding government subsidies for public transport and fuel, and voiding regulations preventing the privatization of state enterprises. At the same time, the DNU cut off subsidies to the public broadcasting system — widely considered, much in the way National Public Radio is viewed by many in America, to skew to the left in its reporting and its commentary — as well as to other cultural institutions.

Even many who in principle support the major changes that Milei wants to effect are disturbed by the fact that he so clearly seems to be trying to transform Argentine society without Congress's approval. There is even some question as to whether what Milei is doing is constitutional, and despite his threat to call a plebiscite should Congress not allow the Mega-DNU to go through, there is little doubt that the issue will eventually be decided by Argentina's Supreme Court. Milei's decision to go forward is the standard populist leader's playbook for dealing with a recalcitrant legislature: claim that his election is all the justification that he needs go forward with his program, in defiance of Congress if necessary. He is the leader who incarnates the people. Whether this strategy will work is another matter. For now the DNU has largely taken effect, though one change in labor law has been blocked by a court. But if both the Senate and the Diputados reject it, its provisions will have to be rescinded. Meanwhile, day by day omnibus legislation is being whittled down in order for the government to secure the votes needs so that at least some of it is passed. Even if Milei makes many more concessions than he seems currently prepared to countenance, it is by no means

167

clear that he will succeed. Milei won a crushing victory for himself, but he had no legislative coattails and the Peronists are close to having a majority in the Senate. To put the matter starkly, having come into office pledging to do away with *La Casta*, Milei now finds himself depending on it, not just in order to be successful but even to survive in office.

Many Argentines were surprised that Milei asked for so much all at once. They should have known better. Never in his career has Milei gone for less than everything he wanted. He believes that the only way to transform Argentina is to as much as possible right away. It is the anarcho-capitalist equivalent of shock and awe. Whether Milei, who thinks that he is Argentina's savior, can withstand the fact that Congress has other ideas is anyone's guess. More threateningly still, the Peronist trade unions and left social movements are beginning to take to the streets. They will not topple Milei tomorrow. But if in a few months, inflation has not begun to come down and economic conditions continue to worsen, then all bets are off. In that case, there could be a social explosion that would chase Milei from office in much the way De La Rúa was chased from office in 2001. But whether it is the halls of Congress or in the streets, what is clear is that Carlos Pagni has observed sardonically, for Milei *la realidad avanza*.

LEN GUTKIN

Curricular Trauma

A number of years ago — sometime in the decade between the financial crash and the advent of Covid — I found myself at the hotel bar of the Modern Language Association's annual conference (in Vancouver? Boston? Chicago?) arguing with a professor about modernism. Or rather, about modernism as a field of current scholarship in literary studies. I wondered why the distinguished English department in which this professor taught, having failed for several years to replace a retired modernist, did not have a single senior scholar of modernism on its faculty. "Well," he said, "it's hard. It doesn't help that modernism has a problem with anti-Semitism, racism, and fascism."

What could he mean, I wish I'd asked him, by character-
izing the first literary period in the West in which Jews were
absolutely central to the literary establishment as having
a "problem with anti-Semitism"? Or the movement that
included the Harlem Renaissance and, elsewhere, *négritude*
and affiliated developments as "racist"? The period in which
modernism flourished was, of course, one of world-historical
ideological mobilization; fascism, racism, eugenics, and so on
carved out their vicious territories across the face of the world
and the world of the mind. But it was also the period of suffrag-
ettism, of varieties of national determination both liberatory
and murderous, of Bolshevism. Did the professor just mean
that some of the most important modernists were themselves
fascists and anti-Semites? That is true, of course. Did he mean
that in some cases modernist aesthetics and fascism drew on
common idioms, made use of common sources? That is true,
too: but so did modernism and anarchism; so did modernism
and socialism; so did modernism and a certain species of
secular liberalism.

I didn't raise those obvious objections because I was so
surprised. My interlocutor was an intelligent and sensitive
scholar and normally not susceptible to this sort of faddish
moralizing. Had I quarreled, I am sure he would have
withdrawn the sloppy charge. But the fact that this judgment,
in a moment of thoughtlessness, emerged so easily is testament
to its status as a piece of common sense in the field. Thought-
less remarks can be very revealing. The professor was guilty
of a reflex, a sort of professional hiccup — a regurgitation
symptomatic of the extent to which the study of literature has
become the terrain of a certain brand of vaporous politics.

"Politics." Or pseudo-politics. There are of course serious
ways of approaching modernism's fascism problem. One

of the greatest scholars of modernism, the Marxist critic Fredric Jameson, wrote a book, *Wyndham Lewis: The Modernist as Fascist*, exploring with unrivaled rigor the modernism of fascism and the fascism of modernity, including aesthetic modernity. Even if every modernist were a Wyndham Lewis or an Ezra Pound — and every modernist was not — the movement would demand scholarly attention. Totalitarian warts and all, it made us into who we are. Modernism remains, as T.J. Clark, another brilliant Marxist critic, wrote, "our antiquity ... the only one we have." To have abandoned it as a hiring field will, in the not-too-distant future, deprive college students of access to one of the keys to any understanding of the present.

Modernism's curtailment on pseudo-political grounds is an aspect of a much larger phenomenon: the precipitous decline in the prestige of the humanities in general, a decline which has seen precincts of study that seemed vital a mere fifteen years ago reduced to husks of their former selves. The situation is too well known to need detailed rehearsing here. Christopher Newfield, in his presidential address to the Modern Language Association in 2023, summed things up neatly, as least as far as literary studies is concerned. "Our profession is in trouble. We all know this. We can all instantly name the troubles that we must fix: a shrinking academic job base, in which tenurable faculty with academic freedom are replaced by a reserve army of precarious workers; declining numbers of majors in litera- ture and language fields; program closures and consolidations; and very small quantities of research funding for literature and language scholarship and for the humanities more broadly." The fundamental question bedeviling all analyses of this grim situation can be posed simply: Are the causes of the crisis external to the humanities, or do they reflect something gone awry in humanistic study itself?

Curricular Trauma

No satisfying answer should insist that either the external or the internal side of the problem is decisive. Plainly the catastrophe is, as they say, overdetermined. Declining state-level funding is obviously a problem from the outside. Administrative failures to limit adjunctification reflect problems both external (declining funding) and, to a degree, internal (a symptom of the collapse of faculty self-governance within the university). Declining major rates are more confusing. Do they reflect a sudden incapacity to feel the relevance of inherited cultural and interpretive traditions, a large-scale societal shift that the critic Simon During has called a "second secularization"? Or have students simply been warned — by parents, teachers, the broader culture — on financial grounds against taking classes in things that otherwise interest them? Or has the nature of the humanistic enterprise itself, at least as institutionalized in our colleges, changed in ways that have rendered it no longer appealing to students?

No one can be certain, and the question has polarized the academy's diagnosticians. Many observers — conservatives especially, but also some disenchanted liberals and leftists — point to what they see as disciplinary moral orthodoxies run amok, while others — including most academics themselves, at least when speaking publicly — emphasize a combination of state-level defunding and our society's philistinism, its larger hostility to humanistic inquiry on both political and instrumental grounds. The fact is that no one knows exactly how to distribute blame; anyone who pretends the crisis is univariate is propagandizing. The current intellectual culture of the humanities cannot be responsible, all on its own, for the material crisis that academic humanists face.

Yet that is hardly a reason to exempt humanists and the contemporary practice of the humanities from scrutiny. One place to begin might be the departmental statements, posted usually to a department's official website, that became common after the police murder of George Floyd in 2020. Princeton's English department, for instance, announced the following: "We confront literary study's long history as a prop to the worst forces of imperialism and nationalism, and its role in underwriting crimes of slavery and discrimination. Such a history compels us to continually reflect on how we read and teach literature and to actively dissociate literary studies from their colonial and racist uses." Its Classics department declared simply that "the history of our own department bears witness to the place of Classics in the long arc of systemic racism." The University of Chicago's English department, in a since-removed statement, asserted that "we believe that undoing persistent, recalcitrant anti-Blackness in our discipline and in our institutions must be the collective responsibility of all faculty, here and elsewhere." Harvard's English department explained that "we, as a department, as scholars, teachers, students, and staff are committed to holding up our community, past and present, to the light of recent events, specifically the movement for racial justice. We will take what immediate actions we can, as we also consider the courses, colloquia, and public talks and reading the Department is running now or planning for the future."

Departmental statements of political commitment are not in themselves expressions of academic activity, of research and teaching (although the Harvard one comes close). But they nevertheless crystallize something about the state of scholarship itself, which, although rarely as nakedly programmatic,

has indeed embraced a portfolio of activist commitments not in any obvious way entailed by humanistic objects of study. In the immediate aftermath of the murder of George Floyd, those commitments were expressed primarily with respect to the struggle against racism, although that was more incidental than essential; racial injustice is by no means the only area of political concern in the humanities.

Such disciplinary activism might seem to suffer from what John Guillory of the English department at NYU calls literary criticism's endemic "overestimation of aim." (There is no reason to restrict the diagnosis of overestimation to literary criticism; other fields in the humanities are similarly afflicted.) Guillory's distaste for what he sees as a species of moralistic grandiosity compels him to uncharacteristic polemic: "The absurdity of the situation should be evident to all of us: as literary studies wanes in public importance, as literature departments shrink in size, as majors in literature decline in numbers, the claims for the criticism of society are ever more overstated." These delusions of grandeur are themselves compensatory — consoling fantasies of relevance halluci-nated defensively against an encompassing political economy in which the humanities simply do not count. Stefan Collini puts it this way: "As academic scholars in the humanities feel increasingly vulnerable in societies governed by the imperatives of global capital, so they seek to ratchet up their 'relevance.'"

For the defense of relevance, we might look to Caroline Levine, the David and Kathleen Ryan Professor of Humanities at Cornell University. Originally a scholar of narrative and the author of a brilliant study of suspense in the Victorian novel, Levine has in recent years turned her talents toward literary scholarship's potential to produce political change. Her career

is something like an allegory for the trajectory of the larger field. In her most recent book, *The Activist Humanist: Form and Method in the Climate Crisis*, as well as in a series of articles over the last several years, Levine has attempted to make the case for what she calls the humanities' "affirmative instrumentality," an activist orientation meant to counter humanistic study's bias toward "anti-instrumentality," the for-its-own-sakeness of the study of literature, music, art history, and so on. The practical payoffs of such affirmative instrumentality remain uncashed; perhaps they will be worth the trouble.

But the interpretive payoffs are here, and they are not always encouraging. Consider "In Praise of Happy Endings: Sustainability, Precarity, and the Novel," a recent essay in which Levine sets out to "help to guide political action in the climate crisis" by offering close readings of a series of novels. Levine begins by asserting, no doubt correctly, that critics of literary fiction from Flaubert to the postmodernists have tended to promote "indeterminacy" over what she calls "happy endings." With this rather minimal account of the status quo in hand, she states her thesis:

I want to suggest that this insistence on openness has reached its limit. We live in an age of acute precarity. As neoliberal economics undoes hopes of secure work and as fossil fuels radically disrupt long-standing ecosystems, the most urgent threat facing people around the world is not oppressive stasis but radical instability — intensifying poverty and food insecurity, flooding, forest fires, violent conflicts over water, the rapid extinction of species. The poorest and most vulnerable communities are already struggling to meet basic needs, including adequate nutrition, clean air and water, and stable

Curricular Trauma

shelter. This condition of mass precarity is poised to worsen as climate catastrophes are fueling ever more massive displacements. We are used to thinking of entrenched norms and institutions as the worst engines of oppression, but right now most of the world's species are threatened most by rapid and multiplying forces of unmaking and devastation. Open-endedness is not primarily a source of pleasure and excitement for those who are afraid they will not be able to find their next meal or a safe place to sleep. Predictability and security have been bad words for artists and intellectuals, but they have also been much too easy to take for granted.

There is a sociohistorical claim embedded in this call to dogmatism that would go something like this: in the heyday of long modernism, from the 1850s through the 1970s, indeterminacy was valued because the world was so stable that privileged *litterateurs*, just to feel alive, titillated themselves with fantasies of collapse and dispersal. Stated that way, the thesis is obviously untrue. The most iconic works of modernism — *The Waste Land*, say — were responses to an "acute precarity" at least as extreme as anything experienced today. In any event, the moral and political norms proposed here are all the more bathetic because they are so absurdly impotent in the face of the political threats that Levine enumerates almost lovingly. She goes on:

> In our own moment, in fact, the open-endedness so beloved of artists and humanists has become eerily consonant with domination and exploitation. Authoritarian leaders on the right have been as much in love with rupturing rules and norms as any avant-garde artist.

In the name of freedom, the Trump administration rolled back more than ninety-five environmental regulations, including those banning fracking on Native lands, drilling in wildlife preserves, and dumping toxins in waterways. Climate denialism is itself oddly consonant with the humanistic value of open-endedness.

Again, the historical thesis collapses on inspection. Hitler also broke with legal norms and rules — is that an argument against Kafka's open-endedness? A worrying confusion of realms has occurred here. The result is a criticism that cannot tell us much either about the urgent political questions it adopts as a kind of camouflage or about the aesthetic objects it purports to explain.

Levine's bottom line is political prescription, which she awkwardly hitches to her interest in narrative form. "Rather than reserving praise for those fictions that deliberately leave us hanging," Levine says, we should admire novels "which conclude by combining the pleasures of material predictability and plenty with workable models of social relations that might help guide political action in the climate crisis." The kind of novel we need to read, study, and teach now, in other words, will both foster the right sentiments toward climate change and offer imitable tactics for activism.

Does Levine really believe that her interest in novelistic happy endings — on its own, a fine topic for a course or a book — can help inculcate activist dispositions that will mitigate climate emergencies? How could she? What would that even mean? "In Praise of Happy Endings" ends not with literary-critical analysis at all, but with an exhortation to the reader, presumed to be a professional scholar of literature, to get involved in climate politics. "As a literary studies scholar,

177

you might claim that this kind of political action is not your real business, fine for your spare time but outside of the sphere of your professional responsibilities." Not to worry — there's a place for you in the movement. "Maybe you would consider participating in the struggle to stop the financing of fossil fuels and agribusiness. There are probably groups already working to divest your campus or alma matter. There is also a growing movement to push banks and retirement funds to divest from fossil fuels — perhaps including your own." And so on. Levine suggests community projects; reading about carbon offsets; protesting fracking; partnering with indigenous people; campaigning against deforestation in the Amazon. All of her suggestions are reasonable. None has anything at all to do with the professional identity of her addressee, the skeptical "literary studies scholar" who might feel that after all environmental activism is one thing and literary studies another. The disappearance of any literary-critical vocabulary from her hortatory peroration gives the lie to the whole project. Levine has many good, if rather obvious, ideas about how citizens might fight for the environment. But none involves novels, and none is specific to scholars.

Although she was trained as a scholar of the Victorian novel, Levine's recent work falls under the banner of "ecocriticism," which is now a field in its own right. Indeed, young scholars are more likely to get hired doing something ecocritical than working on Victorian poetry. Along with a range of other subfields — disability studies, queer studies, critical race studies of various kinds — ecocriticism (or "environmental studies" or, sometimes, "the environmental human-

ities") has emerged as one of the heavy hitters among what John Guillory calls the "subfields" that paradoxically "dominate over the fields." Fields in literary study, as Guillory explained in a conversation with Matt Seybold on the podcast *American Vandal*, have traditionally been defined by "periods — and definitely connected with the category of literature, with literature as object." But then something happened. An "exhaustion with the basic organization of the discipline into literary periods" set in, and in response, in quest of new energy, literary studies turned to "ecocriticism, postcolonial studies, critical race studies, various kinds of queer studies." In sum: "A discipline that doesn't appear to have any core mission, anything that holds it together."

This centrifugal propensity is exacerbated by the fact that the subfields, as Guillory says, "have an inherently *interdisciplinary* tendency, so you have a discipline in which the field concepts seem to be exhausted, and the subfield concepts have taken over, but the subfield concepts have actually depended on interdisciplinary enterprises." The excitement of the subfields comes at a cost: the overall coherence of the larger field of literary studies. That cost is multiplied when the subfields themselves entail strong normative political commitments, as they often do. An essay such as "In Praise of Happy Endings" betrays its own desperate awareness of what has been lost.

Political conservatives, of course, have long charged that the activist entailments of the subfields threatened to degrade the fields into sites of political agitation, shorn of scholarship. In 1992, dismissing the still-young subfield of queer theory, an unsigned dispatch in *The New Criterion* from a meeting of the Modern Language Association gave that concern bigoted point: "This year's convention took the obsession with bizarre sexual subjects to new depths." For the author of this

179

dispatch — Hilton Kramer? Roger Kimball? — the focus on what he calls "'alternative' sexual behavior" was a facet of the larger politicization of the humanities, the importation of the language of the "political rally" into "the offices and classrooms of our most prestigious educational institutions." Queer theory eventually won out against such attacks; it is now not so much a subdiscipline as simply part of the field. The species of literary and cultural criticism that the formidable Eve Kosofsky Sedgwick called "anti-homophobic inquiry" wore its politics openly, and a sense of political mission was surely an element in the force and the energy that its early proponents brought to their work. But it did not reduce the fields it influenced into nothing other than politics. Sedgwick was a committed activist, but you cannot imagine her ending an academic article the way Levine ends "In Praise of Happy Endings," with a few hundred words of practical advice about, say, which organizations to make charitable gifts to.

Queer theory won out, too, because it attracted a large number of extraordinarily talented practitioners who, like Sedgwick, were the beneficiaries of a highly conventional literary-critical training. Sedgwick herself noted her "strong grounding in New Critical close reading skills." This classical and untransgressive training they turned to good account in pursuing new scholarly directions. And finally — perhaps most importantly — queer theory won out for another reason: because it was never difficult to see its connection to literature, whose traditional objects offered a ripe field for its concerns. I suspect that today even Hilton Kramer or Roger Kimball could not read Henry James, or Proust, or for that matter Shakespeare, without, in spite of themselves, being influenced in what they notice by the tenured sexual radicals they loved to hate.

Will the same ever be true of the ecocritical turn? "It seems like a little bit of a falling off," Guillory said on *American Vandal.* "It's very hard to say what literary study is doing on behalf of the climate crisis by talking about a particular poem by Wordsworth. Not that there's *not* a relation between Wordsworth and the environment, because we rediscovered the whole subject of nature in Romantic literature by way of the climate crisis. But what is it *doing?* What is that criticism doing for the climate crisis?" Here we must admit that the concerns of Kramer and Co. had a certain prescience. Questions like Guillory's can be asked of almost all of the currently fashionable subfields claiming some version of Levine's "affirmative instrumentality." Either the theoretical frame is inadequate to the political mission — as in ecocriticism — or else an achievable mission is bathetically disproportionate to the theoretical armature in which it is cloaked. My favorite recent instance of the latter is the professor of geography at a SUNY school who offered a lecture on "Decolonizing your Garden." Attendees would "learn to enjoy the benefits of a chemical-free garden using local hardy native species." The Home Depot near me offers the same service, although they don't call it decolonization.

As Guillory's comments suggest, the local concerns of much ecocriticism are perfectly valid. But that does not mean they are valid as subfields. They would be better described as topics. As topics rather than subfields, they might flexibly inform curricula and research without deforming it. As a topic, ecocriticism might use current ecological theory to bolster a focus on the mediation of the natural world by poetic or literary genres. But as a subfield, Guillory implies, ecocriticism risks subordinating literary study to an intrinsically less coherent category. And it does so in the name of activist

instrumentality, even though it plainly lacks the capacity to achieve its pragmatic goals. That is probably not a recipe for disciplinary longevity, let alone for healing the planet.

Traditionally, literary studies has been organized in two principal ways: by period ("Elizabethan," "nineteenth century") and by genre ("poetry," "the novel"). Often but not always, a faculty position consisted of some combination of period and genre ("We seek a scholar of the English literature of the eighteenth century with particular expertise in its poetry"). There are a few murkier designations, too, such as "modernism" and "Romanticism," which name both periods and aesthetic tendencies. Finally, there are, or there used to be, a handful of single authors considered so important that they constitute fields in themselves: in English, Shakespeare first of all; then Chaucer, Milton, and, distantly, Spenser. (Of these, only Shakespeare still survives as a hiring category.) While other major figures — Dickens or Wordsworth or George Eliot or T.S. Eliot, say, and more recently Thomas Pynchon or Toni Morrison or John Ashbery — have long enjoyed robust scholarly communities, there have almost never been faculty positions devoted exclusively to them. Finally, there were the small number of subfields proper, which tended to demarcate minority literatures in a particular period (like "twentieth-century African American literature").

This was a broadly if never entirely coherent system, with rough parallels in other humanistic fields. But in the last decade, it broke down almost completely. The rudiments of the old categories persisted — or at least some of them did; others, like "modernism," flickered out of existence entirely —

but the real energy was in the subfields, like "ecocriticism." The proliferation of subfields can look bewildering and baroque to an outsider, both weirdly random and oddly specific. A perusal of some recent job advertisements gives the flavor. Skidmore seeks a medievalist "with research and teaching experience in the field of premodern critical race studies," especially one who might bring "an intersectional approach." The University of Saint Joseph, in Connecticut, wants to hire a scholar of Renaissance literature who can also teach "gender studies, postcolonial studies, and/or social media writing." Colby College needs a scholar of pre-1800 British literature (a capacious swath!) and is "especially interested in candidates whose work engages the environmental humanities or premodern critical race studies." (Perusing these ads, one notices how common is the "or" linking two utterly disparate subfields, as though the hiring committee couldn't help but admit to the arbitrariness of the whole business.) Santa Clara University would like to hire a medievalist or early modernist with expertise in "culture, race, social justice, and Digital Humanities." Vanderbilt is looking for an English professor "whose research engages the study of race, colonization and decolonization, diaspora, and/or empire"; period is unspecified, but "substantive investments in periods prior to 1900" are welcome.

The Vanderbilt posting represents the completion of the takeover of the field by the subfields. Period is left vague; genre goes completely unmentioned. Both are replaced by a list of linked historical topics. The uninitiated might wonder: Why is this a job in *literature*? The answer has to do with the political commitments, implicit in some cases and explicit in others, of the subfields, commitments that are much less obviously entailed by the older period or generic categories. This is not to imply that "race, colonization and decolonization, diaspora,

and/or empire" are somehow invalid fields of academic inquiry. They are urgent topics for political, sociological, and historical analysis. But they are also, in the context of a literary studies department, frank political signals. Less sophisticated than Vanderbilt, Santa Clara gives the game away by including "social justice" in its litany of subfields.

This is the ground — Levine's "affirmative instrumentality" is as good a name as any for it — on which the logic of solidarity and activism behind the statements urgently posted to departmental websites after the murder of George Floyd meets up with the internal concerns of the subfields. But the activist energy of the subfields has also received reinforcement from another source: the fiscal motivations of administrations. Not infrequently, the subfields take a set of priorities geared toward industry and retrofit them for the left political commitments of humanities professors. (One sees this in the funny wobble between "gender studies, postcolonial studies, and/or social media writing" in the Saint Joseph ad.) As Tyler Austin Harper not long ago observed, "If the humanities have become more political over the past decade, it is largely in response to coercion from administrators and market forces that prompt disciplines to prove that they are 'useful.'" "Largely" is an overstatement, but such misguided utilitarianism is certainly a factor at play. One reason "environmental literature" became, seemingly overnight, a ubiquitous hiring field in literary studies and other humanities disciplines is because it seemed to mesh with the top-down mission of many universities. In 2021, for instance, the University of Oklahoma released a "Strategic Research Framework" naming four areas of concentration: Aerospace, Defense, and Global Security; Environment, Energy, and Sustainability; The Future of Health; Society and Community Transformation. Faculty

were told to align their departmental missions with these areas. Scanning such a list and finding no obvious perch for poetry, drama, or the history of the novel, how is a literature department to justify asking for a new hiring line? A thousand Environmental Literary searches bloomed.

The ascension of the subfields occurred just as the overall field shrank radically. Some older hiring categories — Chaucer or modernism, for instance — simply disappeared. Others, such as Shakespeare, became so reliably attached to one or another subfield, such as premodern critical race studies, that graduate research in the field was effectively directed into one channel by fiat. Or, put another way, Shakespeare became a subfield of premodern critical race studies. The result is that many graduate students determine their research agendas in narrow conformity with a very specific and rather arbitrary set of concerns. The point is not that the study of race in pre-modern England has no valid approaches to offer the study of Shakespeare. The point is that a combination of overall scarcity and the monopoly of the subfields has elevated one or two areas of research into the entire field, practically overnight.

When, thirty years ago, conservatives such as Hilton Kramer lamented queer theory and other subfields that they considered politically suspect, they laid a trap for the present. They ensured that any concern about subfield-proliferation, especially when the subfields were politically committed in one way or another, would appear politically regressive. But the risk that literature itself would disappear in the sea of subfields was apparent even to one of the most successful subfield-innovators in the discipline, Eve Kosofsky Sedgwick,

whose famous turn from "paranoid" to "reparative" reading can be read in part as an attempt to preempt the foreseeable damage, to redirect the energy of the subfield at the point at which it begins to corrode the legitimacy of the object — literature — on which it is founded.

Consider the case of Shakespeare and premodern or early-modern race studies. When Ayanna Thompson, who teaches Shakespeare at Arizona State University, appeared on the NPR podcast "Code Switch" to discuss anti-Semitism, misogyny, and racism in Shakespeare, she named "three toxic plays that resist rehabilitation": *The Taming of the Shrew, The Merchant of Venice,* and *Othello. Othello,* Thompson says, suffers from "deep racism"; *The Taming of the Shrew* from "deep misogyny"; *The Merchant of Venice* from "deep anti-Semitism." These judgments are of course debatable (the charge against *The Taming of the Shrew* strikes me as more plausible than either of the others), though it would certainly be irresponsible to suggest that, say, *The Merchant of Venice* can be taught without any attention to the history of European anti-Semitism. But Thompson doesn't stop at the uncontroversial insistence that the evocation of historical context is one of the jobs of the English teacher. She argues that *The Merchant of Venice* is in fact a kind of dangerous text, so dangerous that it should not be read by high school students at all. "You feel," Thompson claims, "more secure in your anti-Semitism after seeing this play." Thompson's larger polemical point is that Shakespeare might actually be ideologically toxic, a kind of poison. "We have a narrative in the West that Shakespeare's like spinach, right? He's universally good for you. When, in fact, he's writing from the vantage point of the sixteenth and seventeenth century." Not like spinach; like arsenic.

The reduction of *The Merchant of Venice* to something like

The Jew Süss reflects a deformation of judgment that might be suspected to follow from the eclipse of the field by the subfield, an eclipse that in Thompson's case is formally announced on her department website, in which she offers this self-description: "Although she is frequently labeled a 'Shakespeare scholar,' a more adequate label for Ayanna Thompson is something closer to a 'performance race scholar.'" And the insistence that literary texts are dangerous, and that students must be protected from their harmful effects, is consonant with a prominent strain of activism among students, which insists that exposure to some literature and art is so wounding that certain works should be either optional or removed from the curriculum entirely. In 2015, an op-ed in Columbia University's student paper, titled "Our identities matter in Core classrooms," warned about the "impacts that the Western canon has had and continues to have on marginalized groups": "Ovid's 'Metamorphoses' is a fixture of Lit Hum, but like so many texts in the Western canon, it contains triggering and offensive material that marginalizes student identities in the classroom. These texts, wrought with histories and narratives of exclusion and oppression, can be difficult to read and discuss as a survivor, a person of color, or a student from a low-income background." In 2020, a group of University of Michigan students, unhappy about the artist Phoebe Gloeckner's class on the artist Robert Crumb, summed up their complaints thus: "Prof. Gloeckner should know better than to embed racism and misogyny in her curriculum for the class. This results in curriculum-based trauma." Nor are such complaints confined to the activist left. Alison Bechdel's graphic novel *Fun Home*, for instance, was rejected by a group of Christian students at Duke because, as one of them said, "it was insensitive to people with more conservative beliefs."

187

When students and faculty converge on a conviction
that large swathes of literature and art are too poisonous to
approach, the disciplines undergirding the various subfields
will become anemic indeed. How can you persuade people
about the essential importance of art if you make yourself
complicit in their fear of it? Skepticism is one of the habits
of mind that the humanities classroom is designed to
inculcate. But horror, revulsion, the easy and self-congratula-
tory condemnation of the aesthetic artifacts of the past? The
discovery of "trauma" in the contents of the syllabus? The
transformation of the representational concerns of the project
of canon-revision into therapeutic concerns about safety and
harm is not the only face of the crisis of the humanities, but
surely it is one of them.

ELLIOT ACKERMAN

Mercenaries

In the summer after the fall of Afghanistan, I received an invitation to speak at CIA headquarters. I used to work as a paramilitary officer at the Agency and a former colleague of mine attended the discussion. Afterward we went back to his office to catch up over a drink. The two of us had once advised the CIA-backed Counter Terrorist Pursuit Teams in Afghanistan. At their height, the CTPTs numbered in the tens of thousands. During the fall of Kabul, they played an outsized role in bringing any semblance of order to the evacuation after the government and national army dissolved.

As we discussed those dark days and the role that the

CTPT had played, my friend reached behind his desk. He pulled out two overhead surveillance photographs blown up and mounted on cardstock. When Congressional leaders had asked about the CTPT's performance versus that of the Afghan National Army, the CIA had shown them these photographs. Both were taken at Kandahar airfield in the final, chaotic days of the war. In the first image, a C-17 cargo plane sits on the runway, its ramp lowered with a gaggle of panicked soldiers clambering aboard. Their equipment is strewn on the airfield behind them. "That's a photo of the last Afghan Army flight out of Kandahar," my friend explained. He then showed me the second image. It had been taken a few hours later, also at Kandahar airfield. In it, the C-17 is in the exact same position, its ramp lowered, except the soldiers loading into the back are ordered in neat, disciplined rows. There is no panic and they are carrying out all their equipment. "This is a photo of the last CTPT flight out of Kandahar."

Having worked as an advisor to both the Afghan National Army and the CTPTs, this difference came as no surprise. The Afghan National Army, which had systemic issues with discipline and graft, was deeply dysfunctional, while the CTPT was as effective as many elite U.S. infantry units. Unlike the Afghan National Army, the CTPT didn't report to the Afghan government, but rather to the American government through its CIA handlers. It was a private army.

After the fall of the Taliban in 2001, the newly established government of the Islamic Republic of Afghanistan needed an army. National cohesion was placed at a strategic premium, lest the defeat of the Taliban return the country to the factionalism of the 1990s, in which rival warlords battled one another for primacy. A national army could create national cohesion, or so the theory went. It would seat military power in Kabul

and away from the warlords. The creation of an Afghan army designed to recruit from across Afghanistan was viewed as essential to the success of the Afghan national project. At the time we did not focus on the fact that, in Afghanistan's tribal culture, an ethnically Hazara soldier from Mazar-e-Sharif deployed to Helmand Province would inevitably be viewed by the local Pashtuns as being as foreign as any American.

In those early years, while the Afghan government was building its army, its American allies, led by the CIA, were also hunting al-Qaeda terrorists in Afghanistan. America's counter-terrorists needed their own Afghan forces and, unconstrained by participation in the Afghan national project, they created a different type of army. The CTPTs would, by and large, be recruited locally, relying on tribal ties to provide the cohesion essential to any unit. If a soldier in the Afghan National Army was found guilty of incompetence, graft, or any other infraction, he was held accountable by a vague disciplinary system in Kabul. In contrast, if a member of the CTPT committed a similar infraction, he was held accountable not only to the military discipline that existed within the unit, but also to those in his tribe, because his noncommissioned officers and officers served double duty: they were also his cousins and uncles.

Systems of tribal discipline, though effective, were deemed inappropriate for a national army. The concern of the central government — which was not without merit — was that a national army recruited tribally would devolve into a nation governed by tribal armies. In the end, the CIA would play the tribal game even if the Afghan government wouldn't. The CIA needed Afghan partners of the highest competence to capture or kill al-Qaeda; this was a job for the professionals regardless of how they factored into the broader Afghan national project.

For the duration of the war, the CIA's private army would serve not only as a counterterrorist force; it would also secure hundreds of miles of the border with Pakistan as it gained a reputation as being the most competent force in the country. The army that the Agency built was the one that American policymakers could quietly rely on. It would become a strategic backstop, called upon by four successive presidents, culminating with President Biden when his administration relied on the CTPT to secure critical sections of Kabul International Airport during the disastrous evacuation.

Throughout the history of warfare, private armies have come in many forms and served many purposes on the battlefield. In the case of the CIA-backed CTPT, their mission evolved from being a small counter-terrorism force used to hunt down al-Qaeda to a counter-insurgency force used to capture and to kill the Taliban leadership, eventually evolving into a border security force used to hold the country together, at least as long as it could.

Private armies have played a critical role in virtually all wars; the CIA-funded CTPT in Afghanistan and the Wagner Group in Ukraine are only the most recent examples. Broadly speaking, they serve two distinct purposes: they act as a force multiplier that expands the regular military's capacity, and they create political deniability both for a domestic and international audience. Private armies remain a tool used by democratic leaders and authoritarians alike. They are as old as war itself.

In the game of empire, expansion fuels prosperity, and war sustains expansion. Except that war is a dirty business, one that citizens of most wealthy and prosperous nations would rather

avoid. But someone has to fight these wars and, afterward, secure the peace. Whether it's Pax Americana, Pax Britannica, or Pax Romana, *pax imperia* isn't really peace: it is the illusion of peace sustained by the effective outsourcing of war. This doesn't impugn an imperial peace — I certainly would have preferred to live in Pax Romana as opposed to the medieval turbulence that followed — but rather it shows how these periods of political and economic stability are sustained.

During the Roman Republic — before Pax Romana — when the Senate declared war, the two chief officers of the state, the consuls, levied from the citizens whatever military force they judged necessary to accomplish the war's objectives. Conscription was then executed through a draft of male citizens. The Latin SPQR — *Senatus Populusque Romanus,* The Senate and People of Rome — stamped onto the standard of every legion embodied the social contract bonding the military with the will of those it served.

But this contract frayed and then tore apart under the burden of imperial expansion. In 49 B.C., after Julius Caesar delivered to Rome a series of unprecedented victories in the Gallic Wars — building a bridge across the Rhine, even invading Britain — the Senate feared that his popularity would eclipse their authority. They dismissed Caesar from his command. He responded by openly defying the Senate. With the support of his veteran army, he crossed the river Rubicon and marched on Rome. This crossing ended the Roman Republic. An empire was born.

One of Caesar's first decrees as *dictator perpetuo,* dictator for life, was a program of social and governmental reforms. Two centerpieces of these reforms were the generous provisioning of land for his veterans, and the granting of Roman citizenship to those occupying the furthest reaches of

the nascent empire. Changing the preconditions of citizenship altered the composition of the army, which had profound effects on Rome, the army being its most important institution. Titus Livius, a historian who lived at the time of Caesar, understood the centrality of the Roman military to Roman society, writing that "so great is the military glory of the Roman People that when they profess that their Father and the Father of their Founder was none other than Mars, the nations of the earth may well submit to this also with as good a grace as they submit to Rome's dominion."

Rome fundamentally changed as it entered its imperial period because the composition of its army changed. Most critically, service in the legions would increasingly fall to non-native Romans. At its height, the Roman military protected seven thousand kilometers of imperial borders and consisted of over four hundred thousand men under arms. At such distances from the empire's center, legionnaires who fought for the glory of Rome would typically never have seen Rome. In the later years of the Empire, most didn't even speak Latin. These non-native legionnaires fought the perpetual wars of empire, but their loyalty was often more to their native-Roman officers than to the abstraction of a Rome they barely knew.

This dissolution of Roman identity within the ranks proved fatal in the Empire's final years. Those garrisoning the hinterlands became native to those lands, Romans in name only. The burden of empire can only be outsourced for so long. Eventually, the Western Roman Empire collapsed under its own weight. One of its last gasps came in 476. When a barbarian mercenary named Odoacer, who had fought for Rome, was not sufficiently paid, he decided to take Rome for himself. He overthrew the last of the emperors, Romulus Augustulus, and sent the defunct Imperial insignia east, to Constantinople.

The mercenaries who fueled the empire's expansion became its undoing. This is not to say that the outsourcing of military service away from Rome's center was ineffective, even if the slow dissolution of Roman identity within the ranks culminated in the eventual dissolution of Rome itself. Indeed, few nations can boast a military that conquered and garrisoned an empire over a period of thirteen hundred years. For this reason, it comes as no surprise that other erstwhile empires would appropriate many of the societal and military techniques that Rome pioneered.

And none more so than the British.

There was no greater latter-day evangelist of the British Empire than Winston Churchill. He was born at its height, witnessed its dissolution in the catastrophe of the First World War, and led its defense against German fascism in the Second World War. His favorite verse as a child, which he often delivered from memory as an adult, was Thomas Babington Macaulay's long poem "Horatius at the Bridge", written in 1842 and based on an episode in Plutarch. This epic, which blends classical poetic forms with those of a British ballad, recounts the story of the Roman officer Horatius Cocles (or "Cyclops", because he had lost an eye in battle), who defended the Pons Sublicius bridge into Rome from an invading Etruscan army in the sixth century B.C. As the Etruscans advanced, Horatius faced certain death.

> Then out spake brave Horatius,
> The Captain of the Gate:
> To every man upon this earth

195

Death cometh soon or late.
And how can man die better
Than facing fearful odds,
For the ashes of his fathers,
And the temple of his gods?

That this poem, which recounts the defense of a bridge, resonated with Churchill — or with any young British officer — is no wonder. From the perspective of Britons, their empire *was* a bridge. It connected their small island nation to a broader world, delivering it outsized wealth, influence, and power. Like the Pons Sublicius, the empire had to be defended at all costs; and, like "brave Horatius, the Captain of the Gate," Churchill and his contemporaries imagined themselves as its defenders.

The jewel in the crown of the British Empire was, of course, India. Queen Victoria, who reigned from 1837 to 1901, longer than any of her predecessors and over more territory, was always queen in Britain but it was her overseas colonies, and India in particular, that elevated her to an empress. Parliament voted to grant her that title in 1876, two years after Churchill's birth. This was a period of significant reform and expansion for the British military, to include a rebalancing of the Empire's reliance on regular versus private armies.

Like the Romans, the British had increased their reliance on non-British soldiers as their empire expanded. Unlike the Romans, the British did not extend rights of citizenship to the diverse array of cadres that composed their military forces, making them British; instead, they incorporated their imperial charges into the empire as subjects of the Crown. The British East India Company fielded the largest of these private armies, which they paid for with company proceeds. Indian sepoys (an originally Persian term for a native soldier serving

under foreign orders) filled the ranks while native-born British officers led them, but those officers held commissions of inferior rank to those in the regular British Army.

The mission of the East India Company's army was, simply, to secure the interests of the company on the subcontinent. The governance of colonial India is a remarkable example not only of military privatization but also of the privatization of empire. Company rule in India effectively began in 1757, after Lord Robert Clive defeated a force of fifty thousand Bengalis with thirty-one hundred East India Company sepoys at the Battle of Plassey. Company rule extended until 1858, when those same sepoy regiments revolted in what became known as the Indian Mutiny. During this intervening century, Britain's privatized holdings in India, secured by a private army, delivered vast riches to the empire. East India Company trade accounted for approximately half the trade *in the world* during the late 1700s and early 1800s.

The Indian Mutiny represented an existential threat to the British Empire. It was the result of an accumulation of social and economic resentments, as opposed to a single cause. The fighting continued for a year with garrisons of sepoys across the country killing their British officers and their families. By the end of that year the British had regrouped and, along with sepoys loyal to the East India Company, defeated the rebels. Parliament, having concluded that the East India Company was too big to fail, passed the Government of India Act. This placed the administration of India directly in the British government's hands, creating what became known as the British Raj, which would endure another century. The East India Company continued for a decade, before becoming insolvent in 1874, the year of Churchill's birth.

The Indian Mutiny was a debacle. It caused British

leaders to question the composition and the quality of their military forces. Between 1868 and 1874, a series of reforms implemented by British Secretary of State for War Edward Cardwell would transform the British Army from a force of gentleman-soldiers to a professional army with a robust reserve that could be mobilized in a time of war. If the Indian Mutiny revealed the dangers of the reliance on private armies, it was the Franco-Prussian War of 1870, in which the German Empire routed the Second French Empire, that proved the importance of having a military reserve which a nation could rapidly mobilize.

After the Napoleonic Wars, British soldiers served brutally long twenty-year enlistments. Often these soldiers would spend many of those years far from home in the colonies and, upon retirement, older and weakened by prolonged active service, they would be of little military use as reservists. This left Britain without a pool of soldiers to mobilize in wartime. Cardwell's reforms shortened enlistments to as little as six years, allowing soldiers to return to civilian life but remain in the reserve at reduced pay. This new policy granted Britain access to a large reserve army, should they need it.

Prior to the Cardwell Reforms, officers in the British Army didn't earn their commissions, they purchased them, with commissions in the most prestigious guards, grenadier, and cavalry regiments fetching the highest premiums. Cumulatively, British families invested millions of pounds in the purchase of commissions. Those who could not afford them served as officers in colonial regiments, which held inferior standing within the British Army. By the time Cardwell began implementing his reforms, this had created a dysfunctional tiered system. Regiments based in Britain saw far less combat than those based in its restive colonies.

Officers with lesser experience and acumen, yet who held places in prestigious regiments, advanced. It was the opposite of a meritocracy.

In the Crimean War, between 1853 and 1856, the British army's aristocratic incompetence was on full display. Tennyson's poem "The Charge of the Light Brigade" immortalized their ineptitude. The poet chronicles a pointless charge of light cavalry into heavy Russian guns at the Battle of Balaclava:

"Forward, the Light Brigade!"
Was there a man dismayed?
Not though the soldier knew
Someone had blundered.
Theirs not to make reply,
Theirs not to reason why,
Theirs but to do or die.
Into the valley of Death
Rode the six hundred.

The Cardwell Reforms, which abolished purchased commissions and created an effective reserve force, reversed decades of dysfunctional military policies. The era of the gentleman-soldier in the British Army was over, as was a reliance on private armies such as those deployed by the East India Company. After the Cardwell Reforms, membership in a prestigious regiment lost much of its allure for a certain type of ambitious officer.

In 1895, Winston Churchill received his commission as a second lieutenant in one such prestigious regiment, the 4th Queen's Own Hussars, based at Aldershot. His first order of business after arriving was to negotiate a posting elsewhere, to Cuba, where he heard there was a war on.

An empire, once acquired, must be maintained. It requires the control of territory, and this requires — to use the distinctly American term — boots on the ground. Yet a question that naturally follows: whose boots? The reforms that Julius Caesar made to Rome's legions, or the ones that Cardwell made to the British Army, were both efforts to answer that question.

After the Second World War, when the United States was called "to bear the burden of a long twilight struggle" against communism, as President Kennedy put it in his Inaugural Address in 1961, the question of whose boots would bear that burden became foremost in the mind of American military strategists. Although the ideological differences between the United States and the Soviet Union could not have been starker, their struggle for global hegemony in a nuclear age only existed because both superpowers had acquired an empire at the end of the Second World War. These were empires that each needed to garrison and defend against the other.

President Kennedy framed the nature of that defense in a speech at West Point in 1962:

> ... for we now know that it is wholly misleading to call this the "nuclear age," or to say that our security rests only on the doctrine of massive retaliation. Korea has not been the only battleground since the end of the Second World War. Men have fought and died in Malaya, in Greece, in the Philippines, in Algeria, and Cuba and Cyprus, and almost continuously on the Indo-Chinese peninsula. No nuclear weapons have been fired. No massive nuclear retaliation has been considered appropriate. This is another type of warfare, new in its intensity, ancient in its origins,

war by guerrillas, subversives, insurgents, assassins, war by ambush instead of by combat; by infiltration instead of aggression, seeking victory by eroding and exhausting the enemy instead of engaging him.

At the time Kennedy delivered this speech, he had already authorized a significant expansion of special operations forces within the U.S. military, deploying them as an economical form of civil defense in nations facing Communist aggression. In an official White House memorandum on guerilla warfare, dated April 11, 1962, in which Kennedy authorized members of the U.S. Army's Special Forces to wear the green beret, he declared: "Pure military skill is not enough. A full spectrum of military, para-military, and civil action must be blended to produce success." Kennedy understood that wars of empire are wars of exhaustion, and that conventional militaries tire quickly. His commitment to unconventional warfare as a pillar of national defense was a strategic pivot as profound as those that took place in Britain and Rome.

After Kennedy's death, the "other type of warfare" he envisioned in his West Point speech would become a reality in Vietnam and a pillar of American warfare into the next century. Department of Defense concepts such as "foreign internal defense" and "counter-insurgency strategy," the latter first seen in the Philippines in the early twentieth century and then further developed in Vietnam, would appear again in Iraq and Afghanistan. They rely on the American military to train a partner force that, eventually, takes responsibility for the conduct of the war, requiring far fewer American "boots."

This was the strategy of "Vietnamization" that sought to bolster the South Vietnamese military. In Iraq, this was the "Surge" and the "Sunni Awakening," in which American

forces doubled down on training the Iraqi military while co-opting Sunni militias once loyal to al-Qaeda. (In 2006, General David Petraeus authored a book-length manual on counter-insurgency strategy.) In Afghanistan, it was a second surge and reinvestment in the Afghan National Army. What these examples all have in common is an American method of warfare that shifts the burden to an indigenous force allowing American troops to withdraw. It also shifts the conditions of victory, which is less defined by conditions on the battle-field. Victory today is defined — this is an extraordinary development — by outsourcing the prosecution of a war and withdrawing our troops. Whether that outsourcing is to a national army, militias, mercenaries, or a blend of all three is important, of course, but not as important as ensuring that our troops return home.

In Vietnam, Iraq, and Afghanistan, this strategy yielded at best mixed results. Vietnam and Afghanistan are wars that America unequivocally lost. With Iraq, it would be difficult to argue that the United States won, but it is equally difficult to go so far as to say that we lost. The Iraqi government that was created after the American invasion endures, and, most critically, the security services that the United States helped train have successfully carried the burden of their own security, in recent years defeating Islamic extremists such as ISIS with little aid from American boots.

When President Biden announced the withdrawal of troops from Afghanistan in a speech on April 14, 2021, he explained that the United States would be more formidable if it focused on future challenges. "Our diplomacy," he said, "does not hinge on having boots in harm's way — U.S. boots on the ground. We have to change that thinking." Although he mentioned China and the pandemic as among these future

challenges, he did not mention Ukraine. Few predicted that as America ended its longest war, it would within months find itself enmeshed in an ally's war of defense against one of its oldest adversaries, Russia.

The war in Ukraine began as a mercenary war. When Russia invaded Crimea in February 2014, it claimed this invasion was the work of separatists. The soldiers who invaded wore no Russian military insignia, causing many to refer to them as "little green men." During this first invasion of Ukraine, the explicit appearance of Russian soldiers would have cost Putin more politically than he was willing to accept. In the eyes of the international community, as well as in the eyes of his citizens, there was value in deniability. Putin needed to launder his activities in Ukraine. Mercenary armies are very good at doing such laundry.

To lead this mercenary venture, Putin made what seemed like an unlikely choice: Yevgeny Prigozhin, a coarse former restauranteur who many referred to as Putin's "chef." Backed by cadres of battle-tested field commanders, Prigozhin helped to found the Wagner Group in 2014 and presided over its rapid expansion. Not long before Russia's "anonymous" incursions into Ukraine, Putin had intervened in Syria. After Bashar al-Assad crossed President Obama's "red line" on chemical weapons with no meaningful response from the American administration, Putin saw an opportunity. If the use of sarin nerve gas against civilians failed to provoke a strong American reaction, the deployment of Russian mercenaries — and, later, units of the regular Russian military — into Syria seemed a less risky prospect. Enter Wagner.

203

Between 2014 and 2021, Wagner rapidly expanded its size and deployments, delivering Russian boots on the ground in places no Russian boots should be. The approximately fifty-thousand-strong Wagner Group would, in those years, fight in Libya, Ukraine, Sudan, Mali, Venezuela, the Central African Republic, and directly against American troops in Syria at the Battle of Khasham in February 2018. All this while the Kremlin denied Wagner's involvement and, in some cases, their existence.

The Wagner Group delivered Putin what he wanted. He had an effective military force that he could deploy anywhere in the world that granted him political cover. When Putin decided to invade Ukraine in February 2022, the Wagner Group would participate, contributing about a thousand soldiers to the invasion, but it never assumed the lead. That job would fall to the regular Russian military, which hadn't taken on an operation of this scope in more than a generation.

Ukraine's staunch resistance to Russia's invasion surprised the world and shocked Putin, who expected to march into Kyiv in a matter of weeks if not days. Second only to Putin's miscalculation of the Ukrainian peoples' resolve was his miscalculation as to the capabilities of the regular Russian army. Putin's authoritarian rule, combined with a corrupt kleptocracy, had hollowed out the once vaunted Russian military machine, leaving it with capabilities on paper that did not translate to the field. It was swiftly exposed as a mediocre and confused force, proving the dangers of might without competence, particularly for any ruler who would stake their own security on raw force.

Six months into the war in Ukraine, the Russian military was in crisis. After sustaining heavy losses, Putin needed to replenish his ranks. But how could he sell the Russian people

on a mobilization for a war that wasn't even a war, but rather "a special military operation"? There is no more dire threat to a political leader's power than a failed war. This is emphatically true in Russia, where successive regimes — from the Tsar in the First World War to the Soviets in Afghanistan — can trace their demise to failures on the battlefield. Knowing that Putin needed to marshal his military forces while continuing to insulate his political base in Moscow, St. Petersburg, and other affluent urban centers, he expanded his reliance on the Wagner Group, increasing its size and allowing its cadres to recruit in Russia's prisons, adding another fifty thousand soldiers to Wagner's ranks.

As the war in Ukraine entered its second year, Wagner Group soldiers played a prominent role, serving as the lead assault force in strategically important and bloody battles, such as Bakhmut. Although increased reliance on Wagner prevented widespread and unpopular conscription in Russia, it created a different type of political liability for Putin. Like Julius Caesar's legions, or Britain's Indian sepoys, Putin would learn the dangers of vesting military power in private hands.

For months, Prigozhin had been feuding with Russian Defense Minister Sergei Shoigu, Chief of the General Staff Valery Gerasimov, and other senior commanders, characterizing them as incompetents. After Ukraine's successful Kharkiv counteroffensive, Prigozhin had said of Russia's senior military leadership that "'all these bastards ought to be sent to the front barefoot with just a submachine gun." Prigozhin never attacked Putin in public. Instead, he framed Putin as the victim of generals who weren't serving his, or Russia's, best interests.

For Prigozhin's Wagner Group soldiers, he became a charismatic populist leader, airing their grievances against

Russia's military establishment. After Wagner Group forces defeated Ukrainian forces in Bakhmut at tremendous cost, delivering Russia a rare victory, Prigozhin's rhetoric against the Defense Ministry intensified. Prigozhin stood over the bodies of several dead Wagner Group soldiers in Bakhmut and, in a video complaining about chronic ammunition shortages, declared: "Now listen to me, bitches, these are somebody's fathers and somebody's sons. And those scum who don't give ammunition, bitch, will eat their guts in hell. We have a seventy-percent ammunition shortage. Shoigu, Gerasimov, where the fuck is the ammunition? Look at them, bitches!"

Prigozhin had, at great cost, given Russia a sorely needed military victory. And no achievement vests a leader with political power more quickly and acutely than battlefield success. Military leaders so often become political leaders because military achievements neatly translate into political power. This is one of the great dangers of placing military power into the hands of private military leaders, a lesson which Putin would learn early on the morning of June 24, 2023, when Prigozhin marched his Wagner Group soldiers off the battlefield and back into Russia.

Prigozhin's mutiny (which might have turned into a coup) failed, with his cadres absorbed into the regular Russian army or banished to private wars in Africa, and with Prigozhin assassinated two months later — yet it serves as another example of the dangers that exist when a nation uses private armies. Whether Caesar crossing the Rubicon or Indian sepoys mutinying against their British officers, the investiture of military power outside of state hands often leads to a struggle. Sometimes the only thing more dangerous than a state's monopoly of force is the lack of such a monopoly.

From Pax Romana, Pax Britannia, and Pax Americana, each story includes distinct yet similar applications of indirect military power. Significant strategic and ethical differences exist between Russia's reliance on a mercenary force such as the Wagner Group and America's reliance on a partner force such as the Afghan National Army, or even the CIA-funded CTPT; but all these types of out-sourced military units reside at different points along a spectrum that exists to insulate a domestic constituency from the costs of war.

We should remain extremely cautious of wars fought with this indirect approach. Proxy wars have long been elements of strategy in international great-power competition, but a war fought under our flag by mercenaries is different from a proxy war. A nation that requires private armies to sustain popular support for wars is likely fighting those wars for the wrong reasons. The "good wars" — wars that *must* be fought and are typically fought for the *right* reasons — seldom rely on private armies.

Who are Ukraine's mercenaries? There are none. Who are Israel's? There are none. War, even just war, is a dirty business. Once it starts, no one keeps their hands clean. But be wary of a nation unwilling to do its own fighting; it will often end up the dirtiest of all.

ALFRED BRENDEL

Observations on Mozart

As we know, a musical composition does not by nature have the presence of a picture, a sculpture, a novel, or a movie. It lays dormant in the score and needs to be made audible. It is the performer's obligation to kiss it awake. "Bring the works to life without violating them," was Edwin Fischer's advice.

First, I'd like to explain what Mozart means to me. He is certainly not the charmingly restricted Rococo boy wonder that he may have appeared to be some hundred years ago. I consider him one of the very greatest musicians in the comprehensive humanity of his da Ponte operas, in the universe of his piano concertos, in his string quintets (which

are matched only by those of Schubert), in his concert arias and his last symphonies. For the pianist, his piano concertos are one of the peaks of the repertoire; they reach from tenderness and affection to the border of the demonic, from wit to tragedy.

How may we characterize Mozart's music? Considering the character of a composer, we are prone to assuming that the person and the composer are an equation. Yet the music of a great composer transcends the personal. There is a mysterious contradiction: while the person is clearly limited, the mastery and the expressive force of the great musician is well-nigh unlimited. In his work, Mozart, according to Busoni, presents the solution with the riddle. Among Busoni's Mozart aphorisms, we find the following: "He is able to say a great many things, but he never says too much." And: "His means are uncommonly copious, but he never overspends." To find such a measure of perfection within a great composer is particularly rare as it is usually the followers, the minor masters, who smooth out whatever the great ones have offered in ruggedness and uncouthness.

Not that his contemporaries noticed such perfection. Time and again, they considered his music to be unnatural, full of unnecessary complication and unreasonable contrast. The exception was Haydn, who pronounced Mozart to be the greatest of all composers.

We find amazing boldness particularly in late Mozart. Think of the second movement of his F major Sonata KV 533, or the beginning of the development section in the G minor Symphony's finale. It would be a mistake to exaggerate such passages in performance — they speak for themselves. The transitional bars in the G minor Symphony almost amount to a twelve-tone row — there is just one note missing (the G).

Observations on Mozart

In my contemplation of Mozart, I like to start not with musical speech but with singing. Once more, Busoni finds the right words: "Unmistakably, Mozart's music proceeds from singing, which results in an unceasing melodic production that shimmers through his compositions like the beautiful female contours through the folds of a light dress." Mozart was a *cantabile* composer. Not unreasonably, he bears the reputation of being the greatest inventor of melodies next to Schubert. (Permit me to mention in this context a third name, that of Handel.) We can only register with astonishment the fact that there were contemporaries who complained about a lack of *cantabile* in Mozart's operas. The operatic traits in his piano concertos, the characterizing incisiveness of many of his themes have been frequently noted.

Not without good reason, the pianist Andras Schiff has called Mozart's concertos a combination of opera, symphony, chamber music, and piano music. There we imagine a singer singing, but the operatic also includes the characters embodied on stage, the action of temperaments, the lifeblood. The pianist, like the singers, operates within a firm musical frame. Mozart, in his letters, describes his rubato playing as occurring within a firm rhythmical scheme. To be sure, there also will be some modifications of tempo, but they should remain conductible. I know there were scarcely conductors in Mozart's time. Tempi therefore had to be stricter, you had to play together, and one could often not expect more than one run-through rehearsal, if any. Performances in Haydn's or Mozart's time must have been quite different from what we expect today — a rather cursory experience, a rough outline of a work without the refinement of a well-studied concert.

In Mozart's correspondence, singing and *cantabile* are frequently mentioned. How does one sing on the piano?

Continuous finger legato is not the answer. Singing has to be articulated. We know that the piano literature offers examples of *cantabile* passages played by the thumb or the fifth finger. Here and elsewhere, the pedal will be of considerable assistance. I know there are pedal purists. I am not one of them.

Cantabile calls for continuity. Mozart's father Leopold, one of the leading musical authorities of the eighteenth century, writes in his *Treatise on the Fundamental Rules of Violin Playing*, known as the *Violin School*: "A singer who would pause with every little figure, breathe in, and perform this or that note in a particular fashion would unfailingly provoke laughter. The human voice pulls itself spontaneously from one note to the next... And who doesn't know that vocal music should at all times be the focus of attention of all instrumentalists for the sake of being as natural as possible?" According to Mozart's father, the bow should remain on the violin wherever there is no real break, so that one bowing can be connected with the next. (Leopold Mozart's *Violin School* appeared first in 1756, the year Wolfgang was born. My citations are from the third edition, published in 1787.)

Evidently, an all-too-fragmented delivery that dissects the cohesion of the music will not do justice to this ideal. Which doesn't mean that we may ignore Mozart's articulation marks at will. I have always done my best to respect them all.

Cantabile themes are most likely happening in the piano's upper middle range. This is one of the reasons why I prefer the modern piano to a Hammerklavier, notwithstanding the peculiar charms of the older instrument. On our pianos, the sound is longer and lends itself better to singing, in case the pianist feels the inner urge to make it sing.

Already around 1800, Mozart was compared to Raphael, a favourite artist of the nineteenth century, but also to Shakespeare. The German Romantic writers Tieck and Wackenroder enjoyed spreading such ideas. I readily subscribe to the Shakespeare parallel on account of Mozart's da Ponte operas. The tombstone of the great French writer and *melomane* Stendhal testifies for his veneration of Mozart and Shakespeare, with Cimarosa added for good measure.

The equation with Raphael is another matter: it shows how much the perception of this revered Renaissance master, but also of Mozart, has since changed. Here is what Wackenroder writes about Raphael: "It is obviously the right naivety of mind that observes the poorest and darkest lot of human destinies in a light and jocular manner, facing the most deplorable misery of life with an inner smile." A similar image of Mozart has dominated for quite a while. Nothing seems easier than to launch dogmatic ideas; like infectious diseases, they spread in no time, and remain difficult to eliminate.

In connection with a performance of Haydn's *Creation*, Goethe and Zelter called naivety and irony the hallmarks of genius, a distinction that should be equally valid at least for part of Mozart's personality.

I see Mozart's piano concertos not only as the pinnacle of the species but as one of the summits of all music. Already in his Concerto in E flat KV 271, written in 1777 when he was twenty-one years old, Mozart gives us a masterpiece of a distinction that he had not reached before and hardly would surpass after. It was only with his Sinfonia Concertante KV 364 that he connects to it. The C minor Andante remains one of his greatest slow movements. In it, Gluck's loftiness is elevated to Mozart's heights.

Among the later piano concertos, the two works in minor

keys occupy a different ground. Mozart in minor seems to me almost a changed personality. Both first movements are composed in a procedural manner while elsewhere Mozart prefers to string together his themes and ideas like ready-mades. (He does it with such immaculate seamlessness that it appears it couldn't be otherwise.) Mozart's concertos reach from the private to the most official (as in KV 503), and from the loving to the fatefulness of KV 466 and KV 491.

The significance of his piano sonatas dawned on me much later. Here, another of Busoni's aphorisms seems to fit: "He neither remained simple, nor did he turn out to be overrefined." It may still be useful to point out that Mozart is not easier to play because he presents fewer notes, chords and bravura passages. Possibly "the experience of the player has to pass through an infinite" — as in Heinrich von Kleist's "Essay on the Marionette Theatre" — "before gracefulness reappears." Artur Schnabel's remarks on Mozart's sonatas are well-known: "Too easy for children, too difficult for artists"; or, in a different wording, "children find Mozart sonatas easy thanks to the quantity of the notes, artists difficult due to their quality." Mozart is so demanding because each note, each nuance, counts and everything lies bare, particularly in the utmost reduction of the piano sonatas. You cannot hide anything.

In addition, mere piano playing is not enough. While in the concertos the piano sound needs to clearly stand out against that of the orchestra, in the sonatas it frequently acts as a proxy. If we look at his A minor Sonata KV310 — again a piece from another world — we perceive the first movement as an orchestral piece, the second as a scene from an *opera seria* with a dramatic middle section, and the third as music for wind instruments. (I have, by the way, heard the first movement of this work frequently played *presto* while it bears the tempo

213

marking *allegro maestoso*. Leopold Mozart, in his explanation of musical terms, characterizes "maestoso" as "with majesty, deliberate, not precipitated".) The famous A major Sonata KV331 also appears to me orchestrally conceived. For the "Turkish March", Mozart would have enjoyed the cymbalom pedal that some Biedermeier pianos presented a few decades later. The Sonata in C minor KV457, as well as the Fantasy KV475, show many orchestral features as well: two marvelous, autonomous works which I would not perform consecutively. (Here I know myself in agreement with Fischer and Schnabel.) Thirty years later a number of orchestral versions of both works were published, one of them produced by Mozart's pupil Ignatz von Seyfried.

Mozart's notation offers extremes hardly encountered elsewhere. It reaches from the completeness of the Jenamy Concerto KV271 to the near-absence of performing instructions in works not prepared for the engraver. In KV271, there seems to be nothing that needs to be added. In contrast, the overly rich markings of Mozart's solo works in minor keys pose a challenge to the player's sensitivity and understanding. While the autograph of the superb C minor Concerto shows a hurried hand, it contains a number of variants but also errors and some incompleteness. In contrast to Mozart's orchestral and chamber music works and their meticulous dynamic markings, the performance of some of the piano sonatas is left to the player's tastes. Here a different kind of empathy is required, an identification with the composer that should enable the performer to supplement the dynamics in Mozart's style.

Liberties

The warrant of a Mozart player considerably surpasses that of a museum clerk. Where Mozart's notation is incomplete, the written notes should be supplemented: by *filling* (when Mozart's manuscript is limited to sketchy indications); by *variants* (when relatively simple themes return several times without Mozart having varied them himself); by *embellishments* (when the player is entrusted with a melodic outline to be decorated); by *re-entry fermatas* (which start on the dominant and must be connected to the subsequent tonic); and by *cadenzas* (which lead from the six-four chord to the concluding tutti). Mozart's own variants, embellishments, lead-ins, and cadenzas — of which, to our good fortune, he left a considerable number — give the player a clear idea of his room for maneuver: in lead-ins and cadenzas the basic key is never left, in embellishments and variants the basic character is always maintained. (No transgressions like those by Hummel and Philipp Carl Hoffmann!) It is a pity that original cadenzas for the minor key concertos are missing, his cadenzas in major hardly being indicative, as the different compositional process of these works seem to demand composed-through cadenzas like the one of Bach's Fifth Brandenburg Concerto that leads from the six-four chord to the orchestra in one sweep.

Embellishments that contradict the basic character of the movement need to be avoided. After all, simplicity and clarity can characterize a piece as well. Sometimes Mozart makes do with highly economical alterations, as in the recapitulations of the first four bars of the scene of KV491's middle movement. Here to do more would be a misunderstanding.

In the slow movement of the so-called Coronation Concerto, on the other hand, the extremely simple and frequently recurring first bars of the theme crave embellishment. This movement is hardly more than a vehicle for the

215

player's extemporizing gifts. The left hand of this movement, by the way, is only elusively written down.

In the Adagio of the A major Concerto KV488, I see two possibilities: to keep embellishment to a minimum, imagining a woman singer singing the long notes, or to remember the copiously ornamented version published by the Bärenreiter Edition's critical resumé. It seems to have belonged to Mozart's estate, though it was written not by Mozart himself but by his esteemed pupil Barbara Ployer, providing evidence that embellishment may be called for.

It should be noted that, for good reason, orchestral and chamber music does not feature improvised variants. Why, we may ask ourselves, should the listener and player necessarily feel bored by hearing the same notes played again? When dealing with a melodist of the highest order, wouldn't it be desirable to play a theme so convincingly that the listener would be happy to encounter it again? Wouldn't it suffice that the performance is slightly modified? Expertise in elaboration may have the effect that the attention of the listener is focused more on the performer than on the music: see how brilliant I am! Here is another quotation from Leopold Mozart: "Some think that they produce wonders when, in an *adagio cantabile*, they thoroughly curl up the notes, and turn one single note into a few dozen. Such musical butchers show their lack of discrimination, shivering when they need to sustain a long note or play a few of them in cantabile fashion without applying their ordinary and awkward embellishment."

The questions to ask are: What does the work need? How much can a work take? What is harmful to a work? While C.P.E. Bach pronounced embellishing to be one of the crucial features of interpretation, we are hardly able to agree with him today. Simplicity easily gets confused with a lack of imagina-

tion. For me, inspired simplicity is one of the most precious qualities. Whoever is interested in moving the listener will not discount it. How many of us would be able to remember a theme and its elaboration after one hearing? Constant embellishment, the ceaseless ambition to prove oneself, can become a burden under which a piece of music is crushed.

Not everything that is suggested by historicizing performance practice is relevant for us today. We are not people of the eighteenth century. Since my young years, Mozart performances have changed considerably. Some conductors and orchestras, but also chamber musicians and soloists, have adopted things that no one would have imagined some decades ago. Baroque performance practice has spilled over to the music of the late eighteenth century. Among the most remarkable gains were the correct execution of appoggiaturas: countless wrong notes have been righted in opera alone. Some other performance habits, on the other hand, deserve a critical evaluation. The majority of them are occasionally valid. Where they are applied in a dogmatic way, however, resistance is called for. Music is too diverse to be left, in its execution, to simplifying recipes. Each case needs to be judged on its own merits. It may come to a surprise to some people that the effect of a musical performance is no less determined by the detail than by the vision of the whole.

The point of departure of a performance should not be, in my view, textbooks of interpretation — textbooks that frequently are connected to a certain time and place are rarely original from most composers — but rather the fact that each masterpiece contributes something new to the musical experi-

217

ence, that each theme, each coherent musical idea, differs from any other. What we need to observe are not just the similarities (they are easier to spot) but the differences, the diversity, the quality that is particular to a musical idea, and exclusively so. As for the technical demands, we can say that a few recipes and established habits will not suffice. The suitable technical solution has to be found for each single case. There is no limit to discovery.

Among the habits that have been spreading dogmatically there is the striking accentuation in two-note groups with a strongly accented first note and a soft and short second. I should also mention the compulsion to play whole phrases, repeated staccato notes, and even decisive endings of movements *diminuendo*; the separation of small units – an overreaction against the "big line" that combines such units; the short clipping of end notes; or the separation of final chords, that are only played after a hiatus. Most of these practices have their justifications as long as they are not applied in a dogmatic and automatic way. They are sometimes right. Two-note groups with a hard-driven first note are never right. I have heard performances where such accents have been routinely exaggerated to such a degree that they sounded like the main purpose of the composition. There are, on the other hand, emotionally charged words like *Dio!* or *Morte!* that call for an accent that is expressive without being stiff.

If a number of two-note groups are linked in a chain, the emphasis should stay with the second note. If two-note groups are draped around one note, this central note deserves to be slightly emphasized. Where, in the composer's notation, the second note is shortened by a rest, the curtailed note needs to stand out! We can still find this kind of notation in Schubert (for example, in the Finale of the A major Sonata D959).

Liberties

The advice to accentuate heavy beats is so simpleminded that it seems hard to explain how it ever found its way into serious musical textbooks. Franz Liszt called it "discharging potatoes." The saying, "If I only could afford it, I would print all music without bar lines!", comes from Artur Schnabel. My own experience tells me that one of the hallmarks of a good Mozart performance consists precisely in avoiding accented heavy beats, and even counteracting them, provided that they aren't dealing with marches or dances. Besides dancing and stamping, music, after all, is entitled to be able to float.

The way long notes are executed can strongly contribute to the flavor of a performance. If we look at Baroque instruments, there are several possibilities. The organ will maintain them in continuous loudness. An oboe renders them *cantabile*. The harpsichord starts each note with an accent. Strings and the human voice can modify their approach. Long notes should often sustain the musical tension and carry it on. If they are rendered abbreviated or without vibrato, they will hardly be able to do so. A good oboist will often play them most naturally. To play such notes routinely *diminuendo* or to start the note without vibrato and vibrate later (a mannerism some singers have adopted as well) I find neither necessary nor desirable. Edwin Fischer demonstrated that long notes can be sustained on the modern piano without noticeable accent. Here the quality of the instrument should also matter.

There are musicians who believe that a historicizing approach will bring you closest to a piece. What is called for, they claim, is a different way of listening. The listening experience that has formed us is an obstacle that has to be discarded. I am not ready

219

to be that radical. Even if it were conceivable to return a work to its original meaning and condition, would this really solve the problem of performance?

The most important criteria remain that the piece should impress, move, and entertain. We cannot and should not discard what we have held precious. There are things that I find unacceptable, such as long notes without vibrato — a crass offense against *cantabile* — or the routine of equating *pianissimo* with non-vibrato in the belief that the timbre thus produced strikes one as mysterious and uncanny. No, the sound is merely deprived of any color, it is cold and dead.

A singer who sings naturally will do this with a vibrating voice, and even with very fast vibrato — think of Lotte Lehmann or Kathleen Ferrier. These days, fast vibrato is unpopular. But shouldn't the whole range of vibrato be at a singer's or string player's command? The use of vibrato is documented since 1600, both for singers and string players.

It is precisely as a pianist that I want to plead for singing. These days, in the wake of historicizing performance practice, *cantabile* has widely fallen into oblivion. Within my understanding of music, however, singing, at least before the twentieth century, is at the heart of music.

It doesn't tally with my experience that old masterpieces only sound beautiful and persuasive when performed on old instruments. There is, on the other hand, music that I wouldn't like to hear on modern ones anymore. To listen to Monteverdi on the instruments of his time was a liberation, and two Scarlatti recitals by Ralph Kirkpatrick convinced me that the harpsichord is indispensable for this remarkable composer. Permit me to quote Nikolaus Harnoncourt: "How did they do it at the time? What may the sound have been like? There will, however, be hardly a musician who would

make a profession out of this kind of quest – I would call such a person a historian. A musician will ultimately look for the instrument that is most useful to himself. I would therefore like to restrict my observations to those musicians who prefer certain instruments for purely musical reasons; those who do it merely out of interest for old facts and circumstances, do not count for me as musicians. They may, in the best case, be scientists, but not performers." Here one can only agree with Harnoncourt.

Whoever insists on old instruments should remember that some of the great composers have frequently transcribed works of their own or those of other composers, such as Bach transcribing Vivaldi, or a work for solo violin turning into his famous Organ Toccata and Fugue in D minor. (As there is no contemporary source for this piece, it may have been done by a later composer. In its toccata, the work persists in one single voice, while the fugue takes consideration of the technical limits of the violin.) A transcribed violin version was performed by Sigiswald Kuijken.

Only gradually did musical performances become accessible to a wider public. Concert venues expanded in size. This asked for more powerful string and keyboard instruments. While the sound of instruments with gut strings can have a particular charm, it will be too restricted for modern halls. When we look into a score we would, after all, be happy to hear what is written down. The power of the wind players used to easily drown out the strings. Only rarely would the composer have been provided with the multitude of first violins that would have enabled a proper balance with the winds. It is the first violins that frequently carry the main voice.

Here is another statement by Harnoncourt: "The composer thinks unquestionably in the sounds of his time and

by no means in some future 'utopias'." This may be correct in many cases. When, however, I think of most later Schubert sonatas, and of his *Wandererfantasie* in particular, works that turned the piano into an orchestra, the ideal possibilities of that performance surpass by far what his contemporary instruments had to offer. Broadly speaking, I would say this: a composer may compose *on,* but not *for,* the piano which graces his music room.

I have no doubt that Mozart's music is often better served by a good pianoforte than by the fortepiano. Proceeding from his operas, orchestral works, and chamber music, we are bound to notice that the wider range of color and dynamics will do better justice to Mozart's requirements. As a rhythmical model as well, the orchestra and ensemble playing should give us a better example than a manner of performance that has lost the firm ground under its feet. Here is Leopold Mozart's amazing dictum: "The pulse makes the melody: therefore it is the soul of music. Not only is it enlivened by it, it also keeps all its limbs in good order."

Permit me, in conclusion, to return to the character of Mozart's music and quote what I wrote in my younger years in order to specify what Mozart was *not*: "Mozart is made neither of porcelain, nor of marble, nor of sugar. The cute Mozart, the perfumed Mozart, the permanently ecstatic Mozart, the 'touch-me-not'-Mozart, the sentimentally bloated Mozart, must all be avoided. There should be some slight doubt too about a Mozart who is incessantly 'poetic.' 'Poetic players' may find themselves sitting in a hothouse into which no fresh air can enter; you want to come and open the windows. Let poetry be the spice, not the

main course. A Mozart who combines sensitivity and fresh air, temperament and control, accuracy and freedom, rapture and shudder in equal measure, may be utopian. Let us try to come near to it."

ARASH AZIZI

Persecution and The *Art* of Filmmaking

Iran today may be best known for two things: one of the most repressive regimes in the world and one of the most impressive cinemas in the world. The coexistence of the two is a conundrum that perplexes many people. How does a country known for ferocious repression of dissent and artistic freedom produce some of the most remarkable films in the world? What does this tell us about the relationship between autocracy and art? And how are we to understand Iran's cinematic community, often a victim of the regime's policies of censorship and persecution? Are Iranian films political by nature and if so, what is their politics?

If one wants to think about art and politics, Iran is a worthy starting place, particularly with the most renowned director in Iranian history, whose films were born not out of engagement, positive or negative, with politics, but out of an emancipatory rejection of politics. Abbas Kiarostami began making a name for himself in film festivals in the 1990s. Then in his fifties, the Iranian director had been making films for more than two decades, and was best known in his homeland for his experimental documentaries. If your interest in cinema went beyond the transitory thrills of film festivals, you would have known that his career predated the Iranian revolution of 1979 by many years. Kiarostami had first practiced his art in the Institute for Intellectual Development of Children and Young Adults, a remarkable center founded in the 1960s by Farah Pahlavi, Iran's last queen. But it was Kiarostami's first post-1979 fiction film that helped him break out on the festival circuit — and in the process, give birth to a new Iranian cinema.

Made in 1987, *Where is the Friend's Home?* had initially struggled to find a global audience. In 1988, it was shown in the Out of Competition section at the Festival des 3 Continents, a smallish affair in Nantes, dedicated to films from Asia, Africa, and Latin America. A holdover from France's *tiers-mondiste* flirtations of the 1960s, the festival in Nantes helped to "discover" directors from places such as Mali, Thailand, and Tunisia. In 1985 it gave its top award, the Golden Balloon, to Amir Naderi's *The Runner*, the first time that a film made in the Islamic Republic of Iran received international accolades. The film told the story of Amiru, a young boy in southern coastal areas of Iran, who earns a living selling ice and shining shoes for visiting foreigners, while also learning the alphabet and going to night school, dreaming of a life beyond the Persian Gulf.

The Runner's eschewing of a linear narrative and stark formalist imagery made it popular to European festival-goers. Edited by Bahram Beizaei, the dean of Iranian performing arts, the film features the protagonist and his teenage peers in visually unforgettable scenes: running while reciting the alphabet, shouting to drown the whizz of overhead airplanes; young boys sweating in the deadly heat of the Iranian south, made worse by the burning flames of the nearby oil fields. The fact that the film starred teenaged amateurs was not accidental. The elaborate star system of Iran's film industry had been virtually wiped out overnight by the revolution, with many of its leading names having their careers destroyed forever, often reduced to a meager living in Los Angeles or other destinations of exile. Even before 1979, censorship had long bedeviled Iranian cinema, making most political issues off-limits. But with the puritanical zeal of the nascent Islamic Republic in place, the circle of exclusion, on and off screen, broadened significantly. Most forms of music were now banned, and women could not be portrayed without a veil (just as they had been forced to don it in real life.) How could you make a film in such conditions? Relying on teenage boys and breathtaking scenery was one way.

Kiarostami's *Where is the Friend's Home?* also relied on teenage boys and breathtaking scenery. But the similarities end there. Naderi's film was set in his native Abadan, the grand industrial port city on Iran's southwestern border with Iraq, fabled for its sweltering heat and housing some of the largest petrochemical complexes in the world. The film's aesthetic is correspondingly rough and austere, filled with abrupt jump cuts reminiscent of Eisenstein. Given Beizaei's penchant for epics, the film's visual sensibility is overwhelming to the point of being suffocating. In this sense, it also bore the marks of the

226

1980s, a harsh decade for Iranians who were suffering from an excruciatingly long and bloody land war with Iraq and a repressive regime that sent thousands of political dissidents to the gallows.

Where is the Friend's Home? looks so profoundly different, it could have been made at a different planet. In fact, it was made on the other end of Iran, about a thousand kilometers to the north, in the green temperate fields of Gilan, close to the shores of the Caspian Sea. The film tells the straightforward story of a simple quest. Ahmadreza, a schoolboy, realizes that he has mistakenly taken home the homework notebook of a classmate, who will be punished if he arrives empty-handed to school the next morning. He resolves that he must return it, and to accomplish this mission of schoolboy honor he must traverse the tough rolling hills of the Gilani countryside to get to his friend's home. There is something so poignant about the child's quest that even thinking of the film makes me shed a few tears. At a time of war and revolution, when Iranian culture had become so brutal and cruel, Kiarostami created a film whose protagonist was not a stand-in for another ideology; he was a simple schoolboy who would defy all authority and brave forbidding terrain to shield his friend from trouble.

The film's title was taken from a poem by Sohrab Sepehri (1907–1980), an Iranian poet and painter whose "Eastern" influences and Buddhist inclinations made him an object of derision by the literati of his time. How could you write poems about rivers and the blue sky, a fellow poet once asked Sepehri, when so many people were being killed nearby? Yet that is precisely what Kiarostami had done. It was so refreshing, to his own people in Iran and beyond. While the Iran-Iraq war was raging, and the ayatollahs were consolidating their tyranny,

his simple, humane, and endearingly warm tale of a Gilani schoolboy seemed prophetic, as if it wanted to will a different world into being. One way of triumphing over politics is to neglect them. But the film was not just an escapist route out of the tough Iranian reality; it remained so profoundly and unmistakably Iranian. It relied on the mood-making of Sepehri's poetry, the delicate sound of the *setar* (a Persian lute), the magically simple forms of rural Iranian architecture, and the traditions of figurative Iranian art, all deeply familiar to Kiarostami, who had started out as a graphic designer. In its sovereign indifference to the political situation of its day, it was as if the film was telling us: a different Iran is possible.

Following the showing in Nantes, the film found broader audiences. It won the Bronze Leopard in Locarno in 1989. Two of his subsequent films, *And Life Goes On* (1992) and *Through the Olive Trees* (1994), set in the same area of Gilan and now known, together with *Where Is the Friend's Home?*, as the Koker Trilogy, were shown in Cannes, with the former winning the top award in the Un Certain Regard adjunct to the festival and the latter being the first Kiarostami film shown in the Cannes competition, the top showcase for global cinema. With these subversive but non-protest films, Iranian cinema entered a new era of filmic accomplishment and international prestige.

Kiarostami's simple-looking poetic cinema, mixing documentary and fiction, actors and amateurs, would soon come to be denounced as gimmicky by many in Iran. But foreign festival-goers could not get enough. There was something so deeply humane in his elementary tales; he found universal themes in the most provincial corners of the Iranian countryside. In 1997, with the extraordinary *A Taste of Cherry*, Kiarostami finally achieved the greatest cinematic honor, the Palme d'Or at Cannes. The film's plot resembled his

228

previous work in some ways but was also a departure from it. Almost the entirety of this beautiful film takes place inside a car, as a middle-aged man drives around rural areas just outside Tehran, seeking to hire someone for a peculiar task: burying him alive. The first two men he sounds out, a conscript soldier and an Afghan cleric, refuse his macabre proposal, but the third one, a museum worker, agrees, although we never see if he actually follows through on the job.

In its portrayal of rolling hills and simple conversations about life, *A Taste of Cherry* was reminiscent of the Koker Trilogy. But its protagonist, a Tehrani intellectual-sounding figure played by Homayoun Ershadi, couldn't have been more different from the plain-speaking northern schoolboy of *Where is the Friend's Home?* His quest for a strange assisted suicide was markedly different from the schoolboy's simple act of courageous charity.

Only three non-Western nations — Japan, Algeria, and Turkey — had ever landed the Cannes trophy before. Despite its increasing global isolation, despite harboring one of the severest regimes of censorship anywhere in the world, Iran had now joined the upper ranks of the cinematic universe. It would now be known to many in the world not just by the angry and menacing frown of the Ayatollah Khomeini and his fellow "mad mullahs," or by the racist imagery of the American film *Not Without My Daughter* (1991), but by the colossal humanity of its art films. With his darkly tinted glasses, which masked his eyes and gave him an aura of stylish mystery, the soft-spoken and relaxed Kiarostami became an unlikely ambassador for a country whose revolution had shocked the world less than a generation earlier.

Events soon showed that Kiarostami's poetic humanism had been in some ways a taste of things to come. After the

war with Iraq ended in 1988 and Khomeini died a year later, Iran experienced many changes. Just as state socialism was collapsing in the Soviet Union, Iran's loud ideologues of the previous decade went through their own Damascene conversions. A most exemplary case was the filmmaker Mohsen Makhmalbaf. Born in Tehran in 1957, he was active as a teenager in an underground guerilla group against the Shah's regime. In the early years of the revolution, he was a militantly Islamist filmmaker who made intensely ideological films — and a thug who physically attacked opponents of the Islamic Republic. But in 1990, starting with his film *Time of Love*, which was shot in Istanbul and is almost entirely in Turkish, Makhmalbaf went through a shocking transformation. His films subsequently told the stories of earthly romances and poetic meanderings, warm tales of young people seeking a better life. After a successful screening in Tehran's film festival, *Time of Love* was banned in Iran. The same fate awaited many of Makhmalbaf's later films. He went on to become a harsh opponent of the Islamic regime, leaving Iran for an exilic life between London and Paris. In 2013 he was a guest of honor at the Jerusalem Film Festival.

230 Makhmalbaf's transformation was echoed in politics by a group of reformist officials who, under popular pressure from disenfranchised women and youth, attempted to take post-Khomeini Iran in a different direction. Was life imitating art? Just a week after Kiarostami got his Golden Palm, the reformist mullah Mohammad Khatami cruised to a surprise victory in the presidential elections in 1997. A new era of struggle opened in Iran, as partisans of democratic reform fought head-on with the guardians of the theocratic establishment. Although the regime was hard at work trying to train its own cinematic talents, Iranian film remained

mostly the realm of the regime's critics, forever struggling valiantly against censorship. Their efforts took matters beyond where Kiarostami left them. He had never set out to be a political filmmaker, but the very nature of his work made him enemies in the establishment. In fact, his films were not all that alienated the hardliners. After winning the Palm d'Or at Cannes, he kissed the cheeks of Catherine Deneuve, who chaired the jury. Upon his return to Iran, angry pro-government mobs were after him for this public sacrilege. Like Makhmalbaf, he would soon be hounded out of his homeland.

Iranians have yet to win the battle of democracy, despite hundreds of people losing their lives in the fight. But Iranian cinema has only grown in global stature. Kiarostami, who died in 2016, is still a name to be reckoned with, but now at least a dozen more men and women, working inside Iran and outside, have come to represent the country on the red carpets. One of his most worthy heirs is Jafar Panahi, whose first film, the celebrated *The White Balloon* made in 1995, was based on a script by Kiarostami. Panahi's didactic regime-critical cinema and his open support for Iranian freedom movements has earned him repeated bans from filmmaking and landed him in jail. Even from behind the bars, he has collected many laurels from festivals such as Cannes and Berlinale.

As Panahi is persecuted by the regime, Iran's cinematic community stands firmly behind him. Support has come from all quarters, including from the filmmaker who has towered over Iranian cinema since Kiarostami — Asghar Farhadi, two of whose films, *A Separation,* from 2011, and *The Salesman,* from 2016, have won Oscars for Best Foreign-Language Film, making Iran part of the very small club of countries that have received more than one Oscar. (The only other non-European countries to have gained this honor are Argentina, Japan, and

the Soviet Union.) Just as Kiarostami had started a revolution in Iranian cinema, Farhadi led his own. Instead of the heavy dose of allusion, abstraction, and poetic inference that had long defined Iranian artistic movies, Farhadi's hard-hitting dramas of middle-class life relied on the masterful weaving of plot. If Kiarostami had been an arthouse darling, Farhadi knew how to write a tight script. While Kiarostami had lionized the simple country people living far from the cities, Farhadi's protagonists were Tehrani men and women, many of whose urban woes could have been set in Buenos Aires or Bucharest. His films depicted and dissected the complexities of Iran's modern society, a far cry from the attractive rural simplicities of others.

While Kiarostami's *auteur* films were mostly lauded by critics and festivals, Farhadi's dramas have found also commercial success, making him into one of the most sought after filmmakers anywhere in the world. On a break from Iran, when he decided to make a film somewhere else with an entirely non-Iranian story, he was able to land such stars Javier Bardem and Penelope Cruz for a story set in their native Spain, and *Todos lo saben* was given the honor of the opening Cannes in 2018. On the very same day, Donald Trump abandoned the Iranian nuclear deal of 2015, dashing any hopes of Iranian-American reconciliation and escalating tensions in the Middle East, just as the saber-rattling of Iranian hardliners had done previously. For Iranians, life and art continue to interact in curious ways. As Iranians watched Farhadi in the Cannes spotlight that night, many wished that the fate of their country would be left to people like their beloved filmmakers, and not to their brutal and inhumane theocrats.

The artistic successes of Kiarostami and Farhadi stirred the national pride of Iranians everywhere. A steadfastly patriotic people, Iranians followed the festival news as avidly as they would the fortunes of the country's football team in the World Cup or that of its weightlifters and wrestlers in the Olympics. In recent years, however, as things got increasingly worse in the country, and as Iranians have mourned hundreds of their fellow citizens who were murdered in the anti-government protests of 2017–2018, 2019–2020 and 2022–2023, there is much less enthusiasm for celebration of any kind, and much less excitement for Cannes or the World Cup. As Iranians have failed to bring down the unpopular Islamic Republic, many bitterly snipe at each other, engaging in an often mindless and increasingly hysterical blame game. Some attack filmmakers such as Farhadi for somehow not doing enough against the regime. What they seem to imply is, People are being killed and all you can do is make a film?

In May 2022, as the thirty-two-year-old director Saeed Roustayi walked up the steps of Le Palais de Festival in Cannes for his film *Leila's Brothers,* he had a lot to be proud of. His very presence there was a grand achievement — and a sign of how far things had come for Iranian cinema since the 1990s. Of the twenty-one films being presented in the main competition at Cannes, *Leila's Brothers* was the only one that did not hail from a rich country. (All were from the West, except for two films from South Korea.) After the Belgian Lukas Dhont, who turned thirty-one a few days before the festival, Roustayi was also the youngest director in the competition. But given the national mood, many Iranians were no longer lining up to cheer.

Certainly the sourness and the disillusionment came as no surprise to Roustayi. His films bristle with bitter hopelessness. Throughout the 2010s, as Iran suffered under the twin

pressures of American sanctions and the economic incompetence and mismanagement of the ruling theocracy, the middle classes depicted in Farhadi's films were increasingly pauperized and destroyed. Indeed, it is accurate to say that, with hopes for change dashed time and time again, Iran is going through the most despairing period of its modern history. And this bleak outlook is perfectly reflected in Roustayi's films.

His debut, *Life and a Day*, from 2016, tells the story of Somayeh, a young woman from a poor and troubled family, about to marry an Afghan man of higher means. She wrestles with the decision: should she marry up and escape her dire straits, as urged by one of her brothers (played by Peyman Maadi, a Farhadi favorite)? Or should she stick with her family, as another brother (played by Navid Mohammadzadeh, a rising star) pleads? With its theme of extreme poverty in southern Tehran, *Life and a Day* can sometimes feel exploitative and Mohammadzeh's acting is at times exaggerated. Yet the film showed great directorial ingenuity and became an instant cult favorite. A monologue by Mohammadzadeh pleading with his sister to stay ("Somayeh, don't leave") is guaranteed a place among the most memorable scenes in all of Iranian cinema. Most importantly, Roustayi's uncompromising and realistic portrayal of poverty was refreshingly unsentimental. This was no schoolboy display of humanity, no treacly preaching on the meaning of love. This portrayal of lives in Tehran is as brutal and dark as they actually feel. His films perhaps can best be described as *Aye-ye Ya'as*, a Persian figure of speech which accuses those with a negative attitude of singing "a song of despair." With Iran as desperate as it is today, don't we need to sing such songs?

With *Leila's Brothers*, Roustayi has brought new mastery to the same bleak theme. This film, too, is a song of despair, a cup of tea "more bitter than poison," to use another Persian turn

234

of phrase. Again, this is not a consolatory cinema, a cinema of false hopes, uplifting tales, or feel-good gimmicks. Yet *Leila's Brothers* is not poverty porn, either. In fact, the main family of the story does not quite live in extreme poverty. The movie's bitterness comes not from an exaggerated portrayal of squalid conditions, but from its sober depiction of tragic constraints that limit even previously middle-class families of modern Iran. The titular character, played by Taraneh Alidoosti, another Farhadi favorite and perhaps the most impressive Iranian actress of her generation, holds an office job which helps her support much of her family. Leila lives in an old house owned by her pensioner father, Esmayil, alongside her mother and two of her four brothers, the unemployed Farhad, who is a bit dim and spends most of his days watching professional wrestling, and Parviz, who has a large family of five daughters and a wife pregnant with their first boy, but only a meager job as a toilet cleaner in Leila's office. Of the other two brothers, Alireza works a factory job outside Tehran while Manoocher compulsively chases get-rich-quick schemes.

The story starts with two events: the one-year anniversary commemorations of the death of Haj Qolam Jorabloo, the patriarch of Esmayil's extended family, which created an internecine jostling for the succession; and the closing down of the factory that employed Alireza, thus sending him home to his parents and siblings. The two events contrast the different stakes faced by the father and his most able son. Esmayil lusts after the patriarch position, even though it is merely symbolic, a figurehead, whereas Alireza has just lost his source of income. But what the two have in common is their pathetic responses to their respective crises. Despite being the oldest surviving Jorabloo, Esmayil is not taken seriously as a

contender for the family patriarchy. The position is clearly being prepared for Qardash Ali Khan, a shady gangster-like character with deep pockets. When he so much as dares to suggest himself for the honor, Esmayil is rudely shouted down by others, including Qolam's son Bayram. Although Iranians are supposedly respectful of their elders, no one cares for Esmayil's old age. The traditional customs are breaking down; now money rules. Esmayil submits to his fate, yet he lies to his relatives about being feted by the family and wants to force Parviz to name his first son after Qolam. "I shit on all your traditions and customs," an angry Parviz tells his father, rejecting his request.

For his part, when the laid-off workers rise up against the closure of the factory in a wildcat riot, Alireza simply runs the other way. As workers fight a pitched battle with security forces, shouting "death to the tyrant," he changes out of his work clothes and flees the scene. A fellow worker confronts him: "The man without honor and the coward is the one who leaves, because he is sure that his comrades are here and will win back his wages." Soon we discover Alireza's escape is not owed to cowardice. Having grown up in the chaos of his miserable family, he has adopted an impregnable calm as a strategy for guarding his individual autonomy in hostile circumstances. Like all stoics, he is not a fighter. Later we hear him admonish his siblings as they debate the rights and wrongs in each of their lives: "We are a bunch of cows who haven't learned how not to interfere in each other's lives." Spurned by the collective, he has retreated into himself. Who are we to judge him?

This question of determining heroes and anti-heroes in the film, this moral question, nags us to the end. It is not hard to see Esmayil as a villain. His slavish devotion to his

clan is repeatedly rebuffed by them, but he persists in it at the expense of his own family. We learn that he has shooed away Leila's only suitor by warning him about her chronic bone problems in the hope that she would one day marry a Jorabloo. (In reality, no Jorabloo would have her.) In an outrageous act that becomes the film's central plot point, he secures forty golden bullion coins so that he can offer the top gift at the wedding of Bayram's son and thus effectively buy the family's useless position of patriarch. He is clearly being used as a dupe by Bayram, who is exploiting Esmayil's gullibility to pay for a lavish wedding. Meanwhile Leyla wants to use the coins to help start a business that could employ her brothers. Esmayil is a vain father who wastes a fortune that could help his sons — a bad man. Some critics interpreted Esmayil allegorically, as a symbol for Ayatollah Ali Khamenei, the Supreme Leader of the Islamic Republic — a man who has squandered his country's wealth on his quixotic adventures in the region and beyond. And yet Esmayil is perhaps more pathetic than villainous. We know that he has worked hard for close to four decades before retirement, never getting any respect from his family. Can we blame him if he wants to gain some symbolic status in the last years of his life? Besides, as he says at one point in the film, why should he be responsible for the livelihood of his adult offspring who are already in their forties?

But if we are not sure about the villain, can we at least see Leila as the undisputed heroine of the film? A woman holding it all together in a world of feckless men? The film's structure and title, and Alidoosti's breathtaking performance as Leila, has led many to such a conclusion, usually made in a feminist register. In a hair-raising scene Leila slaps her father in the face, showing the intensity of her disgust at his actions, and the magnitude of her own autonomy. Is this the hero slapping the villain?

Yet if Leila is a heroine, she is an ambiguous one. In conditions as dark as these, no hero can lead to salvation. When she slyly steals the forty gold coins and helps to buy the shop for her brothers, we want to applaud her, even as Esmayil is utterly humiliated in front of everyone at the wedding, brought down from his majestic chair at the stage, losing his patriarchal position immediately. But things get complicated when we learn that Esmayil had given a legal promise to Bayram: if he doesn't give him the coins, he will go to jail. It is now time for the humiliation of the indignant siblings: they must give the shop back to keep their father out of prison, and recover the down-payment, which includes what they had sold the coins for plus all their life savings.

And things will only get worse. Musings by Trump about leaving the Iran deal leads to massive price jumps for the American dollar and everything else — including the golden coins. Now Leila and the brothers cannot even buy half the golden coins they had their hands on just a week earlier. In a bitter scene that would be painfully familiar to every Iranian, a gold trader tells the siblings: "Each gold coin was sixty million rials yesterday. But Trump gave a speech and it climbed to seventy million. He then tweeted and it became eighty million." It doesn't matter, in other words, if you are vain like Esmayil, smart and strategic like Leila, dumb like Farhad, cunning like Manoucher, or stoic like Alireza. This is a tragedy in its traditional Greek meaning: the circumstances leave no possibility of anything but the pre-determined outcome of misery.

This is not misery for everyone, of course. Throughout the film we see the obscene wealth that surrounds the lives of the siblings. The shopping malls are full of people who lavish cash on shoes and clothes. Just when the siblings realize that the disastrous rise in prices has left them destitute, they see a

bunch of well-dressed young women emerge from a massive car: their bags, their clothes, their chic scarves, their pricey dark glasses and, most importantly, their carefree smirk show that they come from a different Iran, from a different world. This is a film with a class-consciousness based in reality; it is also more directly political. In Iran in 2022, the elites who lived (and still live) such privileged lives are almost invariably tied to the theocratic government in one way or another. These are the so-called "rich kids of Tehran" living in an obscene bubble as Rome burns.

Roustayi is a gifted director, adroit when filming intimate spaces such as Esmayil's dreary living room, or grand scenes such as the workers facing off the cops in the factory, or the ridiculous floridity of the siblings and their father dancing at the wedding. The latter led some critics to compare *Leila's Brothers* to *The Godfather*. (Of course there is nothing phony or shabby about Don Corleone's patriarchy.) The film's symbolic gestures are never too tendentious or didactic (a problem that plagues the films of Panahi and many others.) Roustayi's narrative skills may not be as good as Farhadi's, but they suffice to keep us on the edge of our seats for the film's long running time of two hours and forty minutes.

My favorite scene is the one in which Leila and Alireza strategize on the roof, conniving a way out of their predicament. He gives her a cigarette, demonstrating that, despite her hiding it for years, he knows that she smokes. (Iranian society places a strangely severe taboo on smoking.) As the only two siblings with their heads properly screwed on, they have a special bond. "I still don't know," Leila ponders. "What happened for us to get to where we are? It wasn't so bad when we were kids." Alireza replies: "I've learnt that growing up means that no matter how long time passes, you

239

are not supposed to get what you want." And in what seems like Roustayi's rejoinder to *Anna Karenina*'s storied opening sentence, Leila says: "All the rich people know each other because there is only a few of them around. But the miserable don't know one another because there are so many of them. Yet they recognize the misery in each other's faces."

In another poignant allusion, Leila fondly remembers *Oshin*, a Japanese television drama from the 1980s that was hugely popular in Iran. It told the story of the tribulations of a humbly born Japanese woman who rises to the top, from the Meiji period up to the 1980s. Her many hardships reminded Iranian viewers of the wartime Iran of 1980s. "Do you think Oshin is now alive?" Leila asks Alireza. "If it wasn't for her story, we would never learn how to cope with misery." This simple bit of dialogue is in fact quite explosive, since Ayatollah Khomeini once ordered the execution of a woman who had dared to cite Oshin as her favorite role model, as opposed to Fatima, the daughter of the Prophet Mohammad and a holy figure for Shia Muslims.

But what makes *Leila's Brothers* among the best Iranian films of this generation is not its skillful direction and acting, its engrossing plot or its wise and politically relevant dialogue. It is its courage in depicting unvarnished misery, its unapologetic, relentless account of the disastrous breakdown of modern Iranian society. Its remorseless realism is itself a kind of slanted protest. Brecht famously said that art should be "not a mirror held up to reality, but a hammer with which to shape it." This, of course, is easier said than done. The pretensions of artists to be what we call "change agents" have resulted in a great deal of terrible art without altering much in the real world. Art is anyway never a substitute for politics. But politics — certainly a politics of opposition to tyranny — must begin

240

in truth, and Roustay, by producing an unflinching portrait of absolute hopelessness, courageously shows us the abyss that we are in. If there is to be a way up, we have to first see where we are.

A few months after the curtains went down in Cannes, a massive anti-government revolt erupted in Iran. This time the impetus came from the killing of Mahsa Amini, a twenty-two-year-old woman who had been detained by the morals police because her headscarf fell short of the imposed Islamic standards. Tens of thousands took to the streets. Women threw off their shackles — that is, they publicly burned their mandatory hijabs. The regime went on to kill hundreds of people as it faced a months-long rebellion.

Many in the country's cinematic community took unprecedented actions of solidarity with the protesters. A self-proclaimed feminist, Alidoosti had never shied away from being outspoken. Now she published a picture of herself without the hijab on Instagram, and brandished a banner with the movement's slogan, borrowed from the Kurdish movements in Syria and Turkey: *Women, Life, Freedom*. She was thrown in jail in December, only to be freed in January after posting a huge bail. Other actors and filmmakers suffered similar fates.

As he had promised in Cannes, Roustayi refused to accept any of the suggested cuts that the Iranian authorities had imposed on *Leila's Brothers* as a condition for its public screening. The film was thus denied a permit, imposing a massive financial cost on the producers. It was able to earn around seven hundred thousand dollars from its screenings in France and a meager amount from those in the Emirates.

As expected, pirated versions of the film soon circulated everywhere in Iran, turning it into a much-debated work of art. In August 2023, Roustayi, along with his film's producer, was sentenced to six months in prison for the crime of taking the film to Cannes without permission from the Islamic Republic's Ministry of Islamic Culture and Guidance. This led to much outrage in Iran and beyond. Francis Ford Coppola and Martin Scorsese were among many who advocated for his release. He served about nine days, with the remainder of his sentence "suspended over five years," during which period he would have to take a course in Islamist re-education and stay away from members of the Iranian film community.

Meanwhile the pro-regime media in Iran continue to attack the film ferociously. One outlet derided it for its damning portrayal of Iranian family structures and went on to suggest a conspiracy. The film, it said, had been "pre-arranged" to collude with the *Women, Life, Freedom* movement that broke out a few months after its premiere in Cannes. "The ultimate goal of the director is the same of the rioters," it ominously declared. About that, however, the perfidious state media may be right. For the hated Islamic Republic of Iran, Saeed Roostayi's mirror is as dangerous as any hammer.

As Iranian filmmakers have flourished in recent years, the conditions of their country have worsened in every way. In Iran, there seems to be a perverse relationship between cinematic excellence and governmental cruelty. No, the cinematic community has not overthrown the government or changed things fundamentally. Nor are most Iranian films directly political or of the journalistic speak-truth-to-power kind. But those who demand that the artist pick up a bullhorn, or a machine gun, forget the roots of Iran's cinematic triumph. Iranian films have countered a political regime bent on

penetrating every aspect of life by centering a force of sheer humanity; by showing that there was more to life than slogans; by demonstrating that truth is not absolute. In a climate of hostility and repression, what has mattered is not what Iranians films do or say, but what they are. And what they are is a zone of freedom, shrewdly and miraculously extracted from the unfreedom that surrounds them. Their very persistence is an act of heroic cultural resistance against a dark regime and its campaign to suppress and deny the richness of Iranian culture, old and new.

Writing in 1983, at the height of the bloodletting by the nascent Islamic Republic, a short poem by Ahmad Shamlou, addressing his oppressors, wonderfully encapsulates what art can be in the times of persecution.

I am a poison for you, without an antidote.
If the world is beautiful, it is singing my praises.
O you stupid man,
I am not your enemy,
I am your negation.

243

MICHAEL KIMMAGE

The Bad and The Beautiful

"Genius and evildoing are two things that do not combine," Mozart remarks in *Mozart and Salieri*, Alexander Pushkin's short play written in 1832. The Mozart of Pushkin's play is an impure genius. He does not see perfection in himself or seek perfection in others. He has a natural humility and earthiness. On his way to visit his friend and fellow composer Antonio Salieri, Mozart hears a blind violinist playing one of his melodies in a tavern, and to Salieri's irritation Mozart brings the violinist along with him. He wants this street musician to perform for Salieri. Mozart is enamored of the blind violinist's rude art, leaving it to Salieri to spell out his disdain: "No. I don't

find it funny when some worthless dauber/makes smears and drips on Raphael's Madonna,/ I don't find it funny when some vulgar showman/ reels off parody that dishonors Dante." For Salieri, the very point of genius is the escape from impurity that it enables. "You, Mozart, are a god," Salieri declares, "and you don't know it." In this play Salieri is so consumed by envy that he poisons Mozart. Too refined to tolerate smears or drips on a Raphael painting or to suffer through a parody of Dante, Salieri becomes a murderer. Whereas Mozart, already writing his *Requiem* at the behest of a mysterious black-clad visitor, is human enough to be mortal.

Pushkin's Mozart believes in genius no less than Salieri does. Artists are not godlike for Mozart, though they "form a priesthood seeing only beauty," and the members of this priesthood "are but few." Musing about this small priesthood, Mozart advances his thesis about genius — that "genius and evildoing do not combine." Salieri and Mozart diverge in the degree of their talent, but they diverge more fundamentally in the ethical tenor of their talent, a distinction mirrored in Salieri's homicidal jealousy and in Mozart's affection for the blind violinist, which is his love for his audience or for humanity, of which the actual Mozart was such a stupendous benefactor. Surely Pushkin must have seen himself in Mozart: an artist not so pure as to be inhuman and no snobbish connoisseur of Raphael and Dante (like Salieri), but a poet of innately moral genius. He belonged to the priesthood seeing only beauty and who, by creating beauty, could not be involved in evildoing. To complete the affinity between author and subject, Russian poet and Austrian composer, Pushkin died at the age of thirty-seven, two years older than Mozart had been at the time of his death. Pushkin's global following is smaller than Mozart's, but his posthumous fame is certainly Mozart-like in Russia.

245

The Bad and The Beautiful

Outside of contemporary Russia, very little of Mozart's angelic innocence accrues to Pushkin. In an essay in *The New Yorker* called "Reading Russian Classics in the Shadow of the Ukraine War," the writer Elif Batuman episodically addresses the careers of Tolstoy and Dostoevsky, but she keeps circling back to Pushkin. She describes a movement known as *Pushkinopad*, "Pushkin fall," which began "sweeping Ukraine [in April 2022], resulting in the dismantling of dozens of Pushkin statues." In ways she herself had not recognized before the Russian invasion of Ukraine, "the Pushkin who championed individual freedom was always alternating with the Pushkin who celebrated the [Russian] Empire." Throughout Batuman's essay, Pushkin's art tends to melt into "the interests of the Russian Empire." She notes that Dostoevsky's speech at the unveiling of a Pushkin monument in Moscow in 1880 "is quoted on the Russkiy Mir Foundation's web site." Russkiy Mir is a Russian government initiative intimately connected to the war in Ukraine, to Vladimir Putin's notion that Ukrainians and Russians are one people, and to the Russian government's efforts to snuff out Ukrainian language and culture.

Pushkin's Mozart has a purity that Pushkin himself does not possess, although the historical Mozart was never free from political appropriation. Together with Bach and Beethoven, Nazi Germany upheld Mozart as an example of German cultural superiority. Pushkin has the distinction of having been instrumentalized by imperial Russia, by the Soviet Union, and by post-Soviet Russia. Nor is this, in Batuman's view, an accident of fate. The politicization stems from Pushkin's literature. Complicit in the spread of Russian imperialism, Pushkin is anything but pure, and his impurity is not the humdrum impurity of his fictional Mozart; it is not broadness of mind or closeness to the people. Batuman does

not dispute Pushkin's genius, and she does not argue against reading or teaching Russian literature, but she comes down on the opposite side of the argument from Pushkin's Mozart or (possibly) from Pushkin himself. Genius and evildoing are two things that can go together. (Batuman's essay is a kind of apologia for her book *The Possessed: Adventures with Russian Books and the People Who Read Them*, a puckish and entirely apolitical celebration of Russian literature published some ten years after Putin came to power. In 2023, she suddenly writes to register her discomfort with Pushkin and with Russian literature in general, with its newly discovered political impurity, or, as Batuman might put it, its old impurity suddenly perceived.)

Scrutinizing the terrible uses to which great art can be put is a necessary exercise for lovers of beauty. "There is no document of civilization that is not at the same time a document of barbarism," Walter Benjamin famously declared. Whether or not *every* document of civilization is simultaneously a document of barbarism, civilization and barbarism are certainly intertwined. Brutal dictators have had their favorite painters and writers — Hitler's outsize love of Rembrandt, Stalin's studied love of novels and especially of poetry. Empires have always projected themselves forward through art, recognizing instruments of power where others see only beauty. Even when untouched by the political powers that be, most works of art and documents of civilization betray opinions and prejudices. In antebellum America, passages from Aristotle and the Bible were deployed to justify slavery; Aristotle was a defender of slavery, and the Bible does not always validate equality, not to mention diversity and inclusion. The Dostoevsky who adoringly remembered Pushkin in 1880 let his hatred of Jews and Judaism stain his

fiction, including some of his best work — his novel *Crime and Punishment*, for example, which revolves around the killing of a sinister Jewish moneylender. Mark Twain's and William Faulkner's novels are full of racial epithets, and not only because these two writers wanted their readers to think critically about racial epithets. Figuring out the meaning of prejudice in art is the job of cultural critics, of historians and scholars of art, literature, and music. It is a public service, and one that does not make the art in question either less interesting or less artistic.

Still, however just and however helpful, identifying unclean political undercurrents in art and chronicling the corruption of art and artists by armies and political institutions carries some risk. The risk is a hunger for purity in the art itself, for an art without a trace of prejudice, without any political baggage, without any adjacency to evildoing. One senses in Batuman's essay the longing to rescue the Pushkin who championed individual freedom from the Pushkin who celebrated the Empire — to save Pushkin from Putin. In the hands of a less adept critic, this could become the desire to eliminate the "imperial" Pushkin and to exchange him for another Pushkin, one who flattered only freedom; to rewrite the past or to edit a literary *oeuvre* so that it conforms to the sensitivities of the reader; to excise the awful impurities embedded in artistic creation and to replace them with the healthful purities of our moral imaginations. After all, being uncomfortable with an alleged impurity is one of the paradigmatic cultural postures of our moment, when the perfectionist ethos of progressivism is once again ascendant.

This new enthusiasm for innocence and rectitude, which are not the same thing, of course, exacts a two-fold cost. An overly acute discomfort can imply that art — to make us

comfortable — must be morally or formally pure. This can be a stern regimen for the production of art, for which discomfiture is no liability. The aversion to discomfort could also imply that art — to make us comfortable — must turn from impurity altogether, a prescription for the omission of disturbing and otherwise unacceptable art. To the extent that artists internalize the fear of discomfort and the love of security or of purity, they will be the makers of a boring and bad culture.

Art's salutary impurity runs through different channels. There is impurity of form: art that defies expectations by rejecting the expected structures, pushing sense and language and image in bizarre, unpredictable directions, breaking up straight lines, flirting with ugliness, defying representation, leaving much unsaid, smudging borders, bubbling over into excess. This happens to be one of the main lines of what could be called modern art, in literature, in music, and in the visual arts. Then there is impurity of content: art that refuses to validate virtue or ensure that evil find its comeuppance or that endings resolve into moral schemes that can be easily recognized and articulated; art that moves not with stylized Mozartian grace but in concert with the very evildoing that Pushkin's Mozart considered incompatible with genius; art that draws its force from the diabolical, the dark, the devilish, the immoral. (Of this Mozart's own opera, *Don Giovanni*, is a stirring example, even if its moralistic subtitle is *Il dissoluto punito*.) And, finally, there is the impurity of artistic experience: not merely the depiction of evil, which is a common enough, but the programmatic insinuation of impurity or evil into the mind of the reader or the eye of the viewer, into the mind of Baudelaire's *hypocrite lecteur*, the hypocritical reader who wants to appreciate evil from a distance but not to encounter it from within. Such triune impurity is essential to

249

art. It is essential to the energy of art, to its moral and aesthetic freshness, to the achievement of contrast, to the tensions that make a work of art a living work of art, to the fullness of our response to art and, most of all, to the freedom of the artist.

The infatuation with purity in art has its modern roots in the Renaissance and its many theories of artistic perfection. It became widespread in the eighteenth and nineteenth centuries in what came to be called "classicism" and "neo-classicism", whose affinity for purity of form was associated with a deference to classical — meaning ancient — models, which permeated eighteenth-century education. For understandable reasons, the great texts and sculptures and architectural specimens of the Graeco-Roman past defined "high art." Since the Renaissance, enormous effort had been expended to recover the classical world, to preserve its textual legacy, to learn from its legacy, and then to compete with it. In 1704, Jonathan Swift satirized this long competition, this *querelle* in European culture, in "The Battle of the Books," his response to the question of whether the ancients bested the moderns or the moderns the ancients. Europe's reconnection with Greek and Latin texts and its reconnection with the aesthetic ideals present in classical antiquity or (imputed to it) generated multiple intellectual and artistic revolutions. The Enlightenment was not an antiquarian pastime. Its practitioners sought to discover the modern through the ancient, and one such discovery turned out to be the American Republic, which was created by a cadre of modernizing intellectuals thoroughly preoccupied with classical antiquity. That the American Republic was from the beginning a neo-classical venture is apparent from the civic

architecture of Washington, DC, and Monticello, Virginia, and countless other American towns and cities.

Radical as the encounter with antiquity could be, it was equally possible to derive a static sense of form from that which was labeled "classical." It was possible to gather noble white statues, which had once been gaudy with color, and to fetishize them for qualities they may not have had when they were made — for the restraint they represented, for their disembodied elegance, for their perfect proportions, their implicit harmony, their very will to be classical. It was possible to make "the classical" a cognate for purity of form, a tendency that would dominate the graphic arts, the plastic arts, and architecture in the late eighteenth and nineteenth centuries. (It sometimes takes effort to find the life in neo-classical marble beneath its polished white "perfection".) This regimenting and idealizing tendency could be felt in literature as well, from the written sentence, which to be pure had to follow a Latinate syntax and cadence, to the conventions of genre. Tragedy, comedy, epic, and parody were techniques for fashioning the well-wrought urn of literature. The epic *was* Homer. The tragedy *was* Sophocles. The comedy *was* Aristophanes. The parody *was* Juvenal. A pure work of literature was one that honored all that had been discovered about genre hundreds and hundreds of years ago. Studying this tradition was a method for achieving the symmetries that became synonymous with greatness in art.

If purity of form came from an eighteenth-century deference to classical models, purity of content and experience had a more nineteenth-century pedigree. These versions of artistic purity were championed in Victorian Britain, continental Europe, and the United States. Purity of content translates into rules of rhetorical or representational respect-

251

ability, into a code that determines what can be said and what cannot be said, what can be depicted and what cannot be depicted, what can be insinuated and what cannot be insinuated. These formal straitjackets certainly produced beautiful art (and of course a lot of *poshlost'*), and by no means did all nineteenth-century artists rebel against this ideal. But many of them chafed against it, some defying it at their own expense, risking marginalization or censorship, and some finding ways of undermining it from within. They launched the long and still unfinished war against bourgeois strictures. And yet the power of the code was enormous. Charles Dickens, the Victorian Shakespeare, knew exactly how to function within the code, perhaps because he did not have many disagreements with it and could therefore express it willingly. In his case, however, the tropes did not thwart his appetite for truth or wildness, for the eccentric and the grotesque. Crime and poverty, malice and cruelty, figured prominently in his novels, which, among their other effects, could be profoundly disturbing. He wrote about them with his uncanny gusto, and used his unsparing accounts of the evils of his time to plot the way from the hell of displacement to the respectable paradise of the middle-class family. He was neither a revolutionary nor an apologist for his time. The purity of content in Dickens (by the standards of the Victorian age) is not a debit of his fiction. The happy conclusion of David Copperfield's union with Agnes Wickfield certainly affirms the mores of the era, but we do not dismiss the safe climax as a surrender to a trope: it comes at the end of a harrowing search for safety, a long and sometimes pitiless story of pain and tribulation. Dickens affirmed without prettifying. This is part of what makes his fiction so satisfying, just as it is the aspect of Dickens that gets perverted into holiday kitsch.

252

Purity of content in the Victorian mode was proverbially a matter of covering up. This was especially the case with the body and with the sexual impulse. Just as the styles of dress popular in mid-century Britain and the United States constricted and hid the body from view, so too did much Victorian literature consciously obscure a great deal from view — whether it was forms of sexuality outside the heterosexual norm or simply sexuality itself, as opposed to sexuality's more respectable second cousins, marrying and having children. In the Victorian era's less exalted artistic creations, for example, piano legs were designed in such a way as to avoid resemblance to women's legs. (In Washington, DC, where I live, an array of statues — male nudes — were put up in Union Station when it was constructed in 1908, in the afterglow of the Victorian era, but because of the ensuing embarrassment they had to be given enormous shields. The statues are still there, and so are the shields.) In the graphic arts and in sculpture, however, the nude was not abandoned, though the nudity was usually chaste — until the explosive nakedness in Goya and Courbet and Manet. And a similar development away from conventionality occurred in fiction. Though the nineteenth century was the heyday of the family novel, respectability began to invoke its inverse: two of the century's greatest novels, *Madame Bovary* and *Anna Karenina*, and there were others, curved the marriage plot into the adultery and divorce plots. Neither Flaubert nor Tolstoy lived the lives of eminent Victorians, but as Lytton Strachey showed in 1918 in his book of that name, the eminent Victorians themselves did not live the lives of eminent Victorians. The magnitude of repression often measures the magnitude of desire. There were also what Steven Marcus, in his study of the licentiousness of the Victorian era, called "the other Victorians."

Not only in the straightlaced Anglo-American world was there a strong attachment to the improving purity of artistic experience. This nineteenth-century attachment was evident even on the more freewheeling European continent. The architecture of nineteenth-century artistic institutions underscored the ideal of art as elevation. One was the opera house, massive neoclassical temples built to convey urban prestige — the Wiener Staatsoper of 1869, the Opera de Paris of 1875, the Bolshoi of 1876, the Komische Oper in Berlin of 1892. (The Metropolitan Opera in New York began its life in an enormous neoclassical building, completed in 1883, before moving to the more enormous but no longer neoclassical Lincoln Center in the twentieth century.) Not just a temple to art but a place of pilgrimage, Richard Wagner's Bayreuth was finished in 1876. These opera houses take concert attendees out of the city, away from the tumult of moneymaking and cheap thrills and up the steps to a higher state of being. Even if the stories on stage were violent or scandalous, even if they were set in shabby bohemian garrets, the marriage of respectability and art gave opera its social purpose. Even Wagner's diabolical ecstasies were meant to refine one's feeling for heroes and lovers.

The other nineteenth-century institution that enshrined the edifying purity of artistic experience was the art museum. Architecturally, it could resemble the opera house. Imposing, neo-classically temple-like, many nineteenth-century European museums were designed to instruct their modern visitors in the wisdom of the ancients, introducing a few other stages on the path to cultural maturity: the pious centuries of medieval art and the aristocratic riot of the Baroque. Progression and elevation were the story of art, the unfolding of genius learning from genius, beginning with the perfection

of ancient Greek sculpture, such as the winged statue of Nike placed in the Louvre's main staircase in 1884, which could also have the effect of indicting modern art for falling away from the flawlessness of antiquity. Elevation is the literal experience of going through these museums, such as the Prado, opened to the public in 1819, gallery after wondrous gallery above ground, cafeterias and amenities below. The proudly neoclassical National Gallery of Art in Washington, DC, completed in 1940, is a fine replica of its numerous nineteenth-century European antecedents. It stands eloquently on the National Mall, there to elevate the citizenry.

Impurity was not invented in 1900, although the pursuit of impurity was galvanized by the formalities and the rigidities of nineteenth-century European and American culture. The Victorian age launched a thousand rebellions. Forbid something and people will hunger for it. By covering things up, the code overstimulated curiosity about what was being covered up: Karl Marx delighted in pulling aside the drapes and pointing to the capitalist mayhem beneath the surface of bourgeois respectability, and Sigmund Freud rent the veil of sexual respectability, having come to know and resent it as a young man in Central Europe, unmasking the maskers. As Marx and Freud (and their legions of artistic imitators) were both aware, the greater the pitch of respectability, the sharper the revolutionary instinct. The shielding of the nude statues in Union Station must have delighted Freud if he saw them on his trip to America in 1909. They were such an effortless metaphor for the conundrums that he devoted his life to studying. The pursuit of impurity, even if it emerged with intensifying force in the late nineteenth century and characterized large swaths of twentieth-century art, had always been there. Purity is forever condemned to living with its antithesis.

The Bad and The Beautiful

Three examples will illustrate the magnificence of an impure art. The first is *Ulysses*, published in 1922 and a gargantuan experiment in impure language and form, beginning with its convoluted homage to Homer's *Odyssey*, the classical text that gave Joyce's novel its title and Joyce his excuse to transform the grandiose Homeric hero into an unspectacular modern man. By inventing an impure novelistic idiom Joyce could explore layers of consciousness that a love of purity might deny — or forbid. The second example is *Moby-Dick*, a novel that appeared in 1852 and that stupendously exemplifies the artistic blessing of impure content. The most ominous book in the American canon, it is the grand anti-narrative of American politics, the book that takes the triumph of democracy, the necessity of solidarity, and the prospect of equality and shipwrecks them all, making the reader a party to the shipwreck. Melville tells his wildly impure story with near manic conviction. Third, there is Vermeer's masterpiece of impurity, *The Procuress* of 1656, which is anything but art as elevation. To view this painting is to experience a truly unexpected impurity, not in the composition or in the painter's abilities, but in oneself, the viewer — a shocking dissociation of beauty from virtue. In sum: if genius and evildoing do not combine, there are places where they meet and do business.

Joyce's *Ulysses* is a never-ending pastiche. Joyce was fantastically learned, and in digressions and in conversations in pubs and libraries *Ulysses* lays bare the mechanics of literature, whether it is the Irish epic waiting to be written or the Oedipal rhythms of Shakespeare's dramaturgy, all of which gets treated in depth. Perhaps *Ulysses* is itself the Irish epic that its characters were looking for. Perhaps it is a travesty of such epics, so

often does it slide into parody. Perhaps it is a picaresque novel condensed into a single day in June 1904. Perhaps it is a psychological novel: it is celebrated for taking streams-of-consciousness to new heights (and new depths). Perhaps it is a novel of ideas, a meditation on empire, on post-colonial striving, on mass society, on the grandeur and folly of novel-writing. Perhaps it is all of the above. Joyce elaborated a new form for the novel by putting all previous literary forms into the blender and mixing them up. The resulting form may be pure pastiche, pure modernism, but if so it is a peculiar purity, a virtuosic breaking down of anything resembling "classical" stability of form.

While exploding pre-existing notions of fictional form, Joyce reconstituted English as a written language. Grammar and syntax often dissolve into fragments and elisions in *Ulysses*, and these fragments intersect (seemingly randomly) with snatches of popular song, newspaper headlines, advertisements, quotations from Shakespeare and Aquinas, and the inchoate, sometimes unintelligible private language of the characters. The reigning impurity of language, the mongrelness of the diction, is not impurity for impurity's sake. Joyce was striving to make discoveries about life by defying and discomposing the conventions of language, to take the lid off the consciousness of his characters, to peer into their souls and to have the reader peer into their souls. The reader finds sublimity, the embers of love and artistic creation, and the reader finds prurience, prejudice, aggression, infidelity, obscenity, and loneliness. Joyce uses expletives as well as linguistic indirection to convey the irrepressible indecencies of existence, from defecation to masturbation to the unwanted prevalence of death.

Early on in the novel, Leopold Bloom, the Irish-Jewish Odysseus of *Ulysses*, attends the funeral of someone he knows.

257

The Bad and The Beautiful

His mind travels — through extremely foul language — away from and toward the subject of death:

> I daresay the soil would be quite fat with corpse manure, bones, flesh, nails, charnelhouses. Dreadful. Turning green and pink, decomposing. Rot quick in damp earth. The lean old ones tougher. Then a kind of tallowy kind of a cheesy. Then begin to get black, treacle oozing out of them. Then dried up. Deathmoths. Of course the cells or whatever they are go on living. Changing about. Life for ever practically. Nothing to feed on feed on themselves.

Each of the images here is revolting. Each turn of Bloom's mental and emotional process is inappropriate to a funeral. Bloom is not remembering the life of the man being buried. He is not honoring that life or reflecting on his own grief. He is distracting himself from elegy and ode, perhaps because ode and elegy instill sadness. Bloom's mind burrows instead into the decomposition of corpses. Joyce's rearrangement of "proper" English — kind of tallowy kind of a cheesy, nothing to feed on feed on themselves — augments the impurity of Bloom's thoughts. So, too, do neologisms like "deathmoths," which flitter into Bloom's psyche suddenly and then disappear; no verb in the sentence, no other words, just a strange noun followed suddenly by a period. The telegraphic psychological insight in this passage would be inaccessible without the impure language that mirrors the impure literary form of *Ulysses*.

As he states on the novel's final page, Joyce wrote *Ulysses* between 1914 and 1921 in Trieste, Zurich, and Paris. Joyce must have had an atmospheric motivation for advancing the cause of impurity in literature. He had to have been responding to World War I, which remains inexplicable but must have

been overwhelmingly inexplicable at the time, especially for a writer from Ireland, who was not one to wave the flag of the British Empire. Hemingway would answer World War I with impeccably pure prose, a clean and lucid style, an astringent minimalism that put words like "honor" and "sacrifice" in quotation marks. He countered the impurity of war with the purity of the unadorned English sentence. A pacifist, unlike Hemingway, Joyce would answer the ruptures of war with the ruptures of language. "History is the nightmare from which I am trying to awake," Stephen Dedalus, the aspiring writer in *Ulysses*, pronounces. More than Edgar Allen Poe, Joyce places us inside the nightmare, and he does so through a nightmare's emphasis on abrupt non sequiturs, half-formed images, and a nagging, elaborate incoherence. He does so by means of impure form.

Set some ten years before the outbreak of World War I, *Ulysses* is more ecstatic than it is despairing. Joyce's other motivation for advancing the cause of impurity in literature was to liberate. It was to affirm through impurity, which is the program that fires *Ulysses* and its volcano of language. Joyce famously concludes *Ulysses* in affirmation via impurity, channeling Molly Bloom, the vocalist wife of Leopold Bloom as she lies next to him in bed: "I asked him with my eyes to ask again yes and then he asked me would I yes to say yes my mountain flower and first I put my arms around him yes and drew him down to me so he could feel my breasts all perfume yes and his heart was going like mad and yes I said yes I will Yes." The impurity of form here is fully commensurate with the purity of the desire that it portrays. It is modest by the experimental standards of *Ulysses*. Easy to follow, it all makes sense and is neither repugnant nor outlandish. It is simple language taking unsimple flight by evading punctuation and grammar, another experiment in the rewards of formal transgression. If

259

good style dictates that there be only one "yes," then good style is joyless. From the cemetery to the marriage bed, Joyce winds his way through the plenitude of impurity to its versatility and abundance, and to the gifts it can give to those who are not too cautious, too squeamish, or too Victorian to receive and to cherish them.

In *Moby-Dick*, Melville anticipates the impure language and the impure form of Joyce's *Ulysses*. The narrative voice of *Moby-Dick*, which belongs to Ishmael, a character but far from a main character in the novel, is educated and colloquial, the voice of someone who went to sea at a young age without much formal education and who then read many, many books (and needs to tell the world about them). Ishmael's voice recedes at a certain point, as Ahab's fevered mind takes over the novel and the *Pequod's* journey alike. Along the way, the novel splits into Shakespeare-like dramatic sequences, into long passages on the scientific nature of whales and into minutely detailed excursions into the pros and cons of the whaling industry. Apart from the story of the voyage and the story of the hunt, which are as elemental as they come, *Moby-Dick* has no purity of form at all. It is a kind of grand miscellany. The novel is composed as much by its stubborn reluctance to go forward and its constant digressions as it is by its relentless drive toward the disastrous termination of Ahab's quest.

The more potent impurity in *Moby-Dick* is its impurity of content. Prophesy haunts this novel. In its opening chapters, set in New Bedford and Nantucket, portents of death and disaster are everywhere. In chapter nineteen, titled "The Prophet," a man named Elijah predicts catastrophe for the

Pequod — "what's to be, will be; and then again, perhaps it won't be," referring to the lives of those on the ship. (Ishmael dismisses him as "a humbug.") At the core of the novel, though, is not the fact of fatalism. It is a pattern of choice that leads step by step to the crew's enslavement to Ahab and ultimately to the lack of concern that Ahab has for the ship he captains, so concerned is Ahab to heal his wounded self by killing the white whale. On the ship, Ahab is only one person. The several dozen members of the crew do not have to follow him. They force themselves to follow. Their collective self-defeat is more terrifying than the white whale and the malice that it symbolizes.

The pivotal individual in the *Pequod*'s collective self-defeat is Starbuck, the ship's first mate. A study in contrast, he is a "staid, steadfast man, whose life for the most part was a telling pantomime of action, and not a tame chapter of words." Not given to literary dalliances, he is nevertheless not a man of action; he is merely an active man. He has "a deep natural reverence, [and] the wild watery loneliness of his life did therefore strangely incline him to superstition; but to that sort of superstition, which in some organizations seems rather to spring, somehow, from intelligence than from ignorance." His intelligent superstition is an aspect of his passivity, and "Starbuck was no crusader after perils; in him courage was not a sentiment; but a thing simply useful to him, and always at hand upon all mortally practical occasions." Faced with immediate physical danger, Starbuck has great courage. On the *Pequod*, his undoing is that he must deal with someone who does not put him in immediate physical danger until that danger is inescapable.

Across several chapters, Melville elucidates the twisted relationship between Ahab and Starbuck. If he can subdue Starbuck, Ahab can subdue the *Pequod*, of which Starbuck is

the day-to-day manager. Starbuck is rational enough to foresee the ship's demise and superstitious enough not to trust what reason tells him. He pleads with Ahab to steer the ship back to Nantucket, back home, though he should have known that Ahab is unreachable, and when Starbuck speaks "Ahab's gaze was averted; like a blighted fruit tree he shook, and cast his last, cindered apple to the soil." Starbuck, whose intelligence and courage do not coalesce in time, underestimates the blight in Ahab, who will not turn back. A bit later, Starbuck contemplates a loaded gun on the ship and considers taking it up to shoot Captain Ahab, but he cannot. His life is a pantomime of action. For this forgivable fault he goes to his death.

The impurity of *Moby-Dick* does not concern its anger and aggression, which permeate the novel. It does not concern Ahab's aggression of thought and deed or the ruthless profit motive of those who send the *Pequod* out on its doomed journey. That the aggression is met with tragedy is not an impure framing for a novel; it is a moral framing, a familiar framing. *Moby-Dick*'s impure content concerns the impotence of virtue, which exceeds Starbuck's personal weakness. The crew of the *Pequod* collaborates with Ahab, meaning — as with wartime collaborators — that they are not exactly free agents. They are under his command, but they are aware that he is dangerous, that his thirst for the white whale's blood is nihilistic, that they would be better off shaking themselves free of him. They are aware that Ahab, who at one point baptizes his crew (in Latin) in the name of the devil, is an agent of evil, and they carry out his will. They man his ship, and they lower for the final chase. The charismatic Ahab intuits their common virtue, which varies from character to character, inverting their virtue into his own desire for death. Had his crew had his degree of rage, they might have defied him, and

they might have lived to tell the tale.

An alternative ending to *Moby-Dick* might have taken Melville back to Nantucket. He could have described the community's acceptance, after years, that the *Pequod* would never return, showing us the grief of Ahab's and Starbuck's families. He could have ended his sad novel sadly. *Moby-Dick* is not an epic, because it is about a battle lost. Neither is it a tragedy, at least in the classical sense of the genre: a collision between noble intentions and implacable fate. Ahab's intentions are ignoble, and they are abetted by the short-sighted virtues of Starbuck and others. The novel's ending is not with the families of Nantucket. Rather than sadness, *Moby-Dick* climaxes in extraordinary images of indifference. The quest has been pointless because the white whale has outlived it. The destiny of the *Pequod's* crew is equally pointless:

> Now small fowls flew screaming over the yet yawning gulf; a sullen white surf beat against its [the *Pequod's*] steep sides; then all collapsed, and the great shroud of the sea rolled on as it rolled five thousand years ago.

This is the Book of Genesis in reverse. The sea generously lays itself, like a shroud, over the deceased *Pequod*, the ship having collapsed quickly into nothingness. In the blink of an eye, the *Pequod's* vital, vivid characters are uncreated, their lives a meaningless interlude in the sea's endless roll. Melville's thirty-eight-word sentence confronts the reader with the oceanic emptiness into which everything disappears. In the content of its story, *Moby-Dick* is a uniquely sullen tragedy. It is tragedy without catharsis.

263

The form of Vermeer's painting *The Procuress* is not in the least impure. Vermeer had astonishingly sharp vision, and he had the painterly technique to project this vision onto canvas. His rendering of even the smallest details in *The Procuress* — buttons, glass studs on a wine glass, a decorative motif on a carpet — has a precision that photography cannot match. In this painting, the people and the objects appear to the viewer in the clearest possible air, no smoke, not much shadow, just a limpid light, nothing to distort the clarity in which they exist. The painting's composition is careful, four figures quite close together, patches of darkness on one side of the painting and sharply delineated blocs of color on the other side, an interior setting that invites the viewer to see and understand exactly what is going on. On display is, as with many of Vermeer's paintings, a method of presentation that lies closer to scientific inquiry than to mystification or to mythmaking, a dignified economy of expression.

The content of *The Procuress*, starting with its title, is less than pure, and even sordid. The painting's procuress is dressed in black, and she wears a black headpiece. She is looking at two of the painting's figures, with anticipation and perhaps with a touch of amusement. One of them, a man, is dressed foppishly in a red coat and a wide-brimmed feathered hat. With his left hand he is touching the breast of a woman and with his right he is dropping a coin into her outstretched palm. She wears an attention-getting yellow shirt and a white bonnet, hinting at or making a mockery of respectable dress; her cheeks are rouged with youth. She is the one who has been procured. To the right of the procuress stands an elegant man holding a full wine glass, an onlooker and at the same time a part of the proceedings.

Many art historians believe him to be a self-portrait of Vermeer. Each of the painting's four figures are smiling — the procuress avariciously, the man in red lewdly, the man in black jocularly, and the young woman either resignedly or bashfully.

Paintings set in brothels were not uncommon in the seventeenth-century Netherlands. Vermeer was not inventing his subject. As might be the case with Vermeer's *The Procuress*, brothel scenes could be tied to the parable of the prodigal son. They could thus be approached as the first half of the story, as the moment just before the prodigal son's change of heart, before his atonement, before his return to his father's house. Scenes of prostitution might lend themselves to allegorical readings and possibly to allegories of moral purity, since they imply the progression from sin to salvation by portraying the motion of sin, the unchecked inebriation and lust, the willingness to purchase someone's body and for a moment's pleasure to leave the traces of sin in that person's soul. Vermeer may well have been painting in a religious mode, or he may have been exploring impurity secularly, without allegory. Or he may have wanted to leave the framing to his viewers. Let them figure out in what relation sin stands to redemption.

Whether it is imbued with Christian meaning or not, the picture draws on its austere purity of form to arrive at something more than an impure tableau. *The Procuress* is ravishingly, painfully beautiful. The composition has a taut natural drama to it, almost as if these are four characters on a pared-down modern stage, each unhidden and each relating to the other. The painting's many dark areas enhance its drama, forcing our attention on the young woman. Beauty emanates as well from the material world that Vermeer conjures — a rug that is a tapestry of folded patterns, impossibly lifelike; a blue-and-white wine pitcher, its lines and its proportion

converging into elegance and luxury; and the young woman's face, neither ethereally innocent nor crudely sensual, neither comfortable with the proceedings nor made overtly miserable by them. The painting's beauty is unarguable and arresting.

Owing to its subject, the painting's beauty unsettles its moral order outside of allegory. Not one of its brushstrokes is didactic. At the very center of the painting is the glistening edge of a coin, and surrounding it are the hands of the buyer and the bought. Beauty envelops a rank transaction, over which no tears are being shed: each of the four figures is smiling. The aesthetic and the moral dimensions of the painting challenge one another. They are at war with one another, which is the experience that Vermeer gives to his viewers, who cannot miss the depravity at work in this brothel and who cannot fail to find it beautiful. The painting has a compressed sensuality that, in the hands of a lesser artist, could become erotica, but there is far too much complexity in the young woman's face and far too much hardened appetite in the faces of the two men and the procuress for the painting to titillate. That the procuress gives the painting its title (which may or may not be Vermeer's) is telling. More than appeal or desire, this is a painting about the selling of sex, and it is exquisite.

If it is open to allegory, *The Procuress* may be an allegory about art. Living in a mercantile society that worshiped money and conspicuous consumption, seventeenth-century Dutch painters served a highly developed art market. These artists could not ignore the transaction on which their livelihoods depended — the selling of their art. Perhaps Vermeer's self-portraiture in the picture was not limited to the man on the side of the painting; perhaps the self-portraiture extended to the

painting as a whole, to the selling of self that is entailed in the selling of art. It is not at all obvious that Vermeer is decrying prostitution in *The Procuress* or that he is decrying the selling of art, if that is one of the painting's intended themes. Instead of recoiling from commerce, he very much wants his viewers to behold the sale of that which is beautiful and to see this sale for what it is, to stare at its transactional impurity. Art need not rise high to be great. It need not transcend. (And it need not debase itself.) It can vibrate gorgeously with a candor that is moral and immoral, civilized and barbarous, right and wrong. This is *us*, it can say, and to know us is to know our impurity as buyers *and* as sellers, to know this impurity directly, unfiltered, and not to externalize our reaction to it into pity or outrage or into the noisy condemnation of procuresses and the customers they find.

"I have written a wicked book," Herman Melville wrote in a letter to Nathaniel Hawthorne in 1851, "and feel spotless as the lamb." He was referring to *Moby-Dick*, which is dedicated to Hawthorne. Melville may have been exaggerating for effect, playing up the wickedness of *Moby-Dick* to the author of *The Scarlet Letter*, a book with its own purchase on wickedness and its own inquiry into the intimacy of virtue with evil. Melville was fond of verbal extremism. He was nevertheless right about *Moby-Dick*, right in noting that it is not so much a novel about wickedness, though it is that too, as it is a wicked book. Read at times as prophetic of fascism, *Moby-Dick* owes its gravitas precisely to its wickedness. The crew of the *Pequod* — the novel's "we" — marches behind Ahab. He gets their vote, and they elect for a lunatic quest. They extinguish democracy democratically,

267

and in favor of a charismatic leader, while in the richest possible language the novel exalts the brutality of nature. Ahab dominates the ship and the white whale dominates the seas. In the battle between these two ferocious animals, the stronger one wins, the only possible outcome in Melville's absolutely godless universe. For Melville, if not necessarily for its dreamy narrator Ishmael, *Moby-Dick* is a wicked book in part because it is so resolutely amoral, one of the many reasons why the book was a critical failure, not just for years but for decades.

To sting, the wickedness of a book or the wickedness of a work of art must be real. It cannot be mimed or counterfeited, a devil's costume that can be put on for a performance and then taken off. In the case of *Moby-Dick*, wickedness consisted in its contention that democracy may be weak and that it may undermine itself. And its sense of nature is so godless that it makes Charles Darwin's *On the Origin of Species*, published seven years after *Moby-Dick*, seem genteel and pious by comparison. Melville wrote an avant-garde novel so impure — by the standards of 1852 — that it wrecked his career, much as Ahab's hunt for the white whale wrecked his career as a ship captain. Prior to publishing *Moby-Dick*, Melville had been a literary celebrity. After *Moby-Dick*, he faded from view. The novel itself was largely forgotten until the twentieth century, when its insult to an assertive Protestant nationalism became less burdensome to its American readers and its godlessness more in tune with the times. Yet the sting is still there. It is there every time Americans sense instinctually that the ship of state could go down. *Moby-Dick* is wicked because it is so persuasive and so stark in its predictions. What it predicts is the suicide of American democracy.

A genuinely impure art provokes harsh reactions. *Ulysses* has a tangled publication history. Due to worries about

obscenity, it was not released in the United States until 1932. (By contrast, Vermeer's mother-in-law had a painting in her home titled *The Procuress*. Vermeer was not taking a risk in depicting a brothel.) Such resistance is natural and inevitable even in societies that think of themselves as free. It is par for the course in more authoritarian and repressive political orders, which invariably exalt some interlinked principle of cultural and political purity.

Yet the will to purge impurity demands particular consideration at the present moment. American culture is taking a neo-Victorian turn, though its propriety is very different from what propriety meant in the 1860s or the 1870s. In the artistic and intellectual worlds, contemporary propriety is rooted in progressive politics and in a shifting set of attitudes that conform to a particular conception of the political good. Conservatives have a similar catechism in the idea of the "common good," of "don't say gay" and anti-drag legislation and book-banning. To endorse these attitudes in art is to be pure. To impede them is to be impure. Books are getting forcibly liberated from their impurities, as was the case recently in the United Kingdom with several of Roald Dahl's children's books, which were rewritten and sanitized for contemporary publication. In the history of culture, periods without formal or informal censorship are exceedingly rare.

The defense of impurity is not that artists sometimes miss the mark or that they are fallible as people. It is not that impurity is a byproduct of changing mores, a skin that an artist might be taught to shed or that editors, critics, and publishers might assist artists in shedding. The defense of impurity is quite simply that it is integral to art. Troubling by definition, as art, too, should be, impurity is a kind of skepticism, a naturally adversarial stance, a form of friction that calls for

269

a separate and sequential resistance: the reader's response to Captain Ahab that does not make him out to be a counter-cultural hero, a glamorous madman with a death wish, but that pitches against Ahab's seductions; and the viewer's response to *The Procuress* that avoids cynicism, that does not confuse "this is us" with "this is all we are," that ponders relationships not stipulated by money, that envisions an exit from the comparison of life with a brothel. In the background of Vermeer's painting, one detects a faint window to the outside world. The brothel is not the only world there is. There are other worlds.

The defense of impurity in a culture, beyond any single work of art, is not less valuable. A culture that believes in its own innocence is dangerous. Cultures that can harbor an impure art, which they do at their own peril, lend stature to contradictions, which are an inalienable feature of human affairs, and by dignifying contradictions they may become more tolerant. But the opposite is also the case: contradictions make for political enemies, and for intolerance. State governments are removing Toni Morrison's novel *Beloved* from school libraries because they cannot tolerate the contradiction that it embodies, the affront that it gives to simplistic and self-serving historical narratives. The complications of history frighten them. Universities that protect their students from conservative speakers fear the contradiction that they intuit in non-progressive points of view, or more precisely, in the discomfiting fact that there *are* non-progressive points of view. On and on the merry-go-round of cultural purity goes — with a spin from the right, a spin from the left — in hopes that one day all the contradictions will be bled dry. But the contradictions will persevere, and a great deal of damage can be done in the name of eliminating them. Whereas cultural purity is a foolish ideal, a respect for impurities can teach a culture to

know and to live with its contradictions. This helps the polity behind the culture to stay sane.

The less conspicuous phrase in Melville's letter to Hawthorne wanders from wickedness. Having written a wicked book, Melville feels spotless as the lamb. Given his Christian wording, Melville seems to have undergone a communion ritual of authorship. He does not feel like a lamb. He feels like "the lamb," the lamb of God whose innocence is perennially sacrificed yet whose presence returns after the confession of wickedness. Melville's journey to spotlessness is instructive. Purity cannot be distilled from purity, goodness from goodness, virtue from virtue. Purity must be distilled from impurity, which is the alchemy of art. The best defense of impurity may not concern impurity at all. It may be that without impurity there can be no purity, that without the experience of impurity there could be no discovery of purity. Pushkin's Mozart was too categorical. Genius and evildoing are not antipodes. Genius, purity, and impurity are three points on an equilateral triangle. A proof of this geometry, in the second year of a war that has repurposed his reputation without diminishing his genius, would be Pushkin's own art. Like Mozart, his fictional alter ego, Pushkin was an impure genius.

ALICE GRIBBIN

Readymade

Be like the grasses, which are not waiting,
says the sun-whipped god.
Always with her partial information.
What grasses?
What must we go out there and learn about now?
The wild grasses—
here only of the wind's accord, happy survivors, rewarded for
their ignorance, their readiness, the seeds that took
 —are hardly enterprising,
and why should they be.
Living is a triumph.
See them, swaying to music we'll never hear.
Be lucky, they espouse, so helpfully.

So the planted, tended grasses, then?
Spoiled, carefree, utterly
incapable, presumably, of boredom—They are not waiting, god,
 because nothing ever happens to them.
Look at how easily they live,
forever in their element, positively made
for the elements.

To be cultivated
and have played no part in one's cultivation: How could we
 possibly admire that?
How! Remind us why we listen to this god.

Who even would cultivate us?

Wherever, Whenever

How long all this will go on,
the circulating blood—hauling, having
its way with us, around us, skin-deep
presence and us oblivious,
blood that stays where it should until
 it doesn't—
how long its warming,
halting, stock-taking, unremitting run
between some bloodlike-before and,
after, *what then, how*
 should we know,
being ourselves only minor players, a bit part—
where we are, when we are
in the story of blood—we've no idea.

The Shallows

Here we are.
The baby needs changing.
It's early in a midweek, late summer day.
The cool skepticism that blankets us all before the dew drops,
 before the dawn god rises reluctant from her bed,
is a memory now,
a feeling faded into thought.

Strange hours those, empty of opinion.
Strange feeling—so total then, now like pure accident.

Misty unknowingness, why should we ever believe you?
Any true feeling couldn't be discarded simply because the
 turning earth has met the morning's apple-green light.

We never even intend to be rid of you,
being free, in those hours,
of intention...

but here we are:
conscious, modern, self-conquering,
and the baby is clean, and the sun streaming in.

Portable Fire

In theory, anything can be depicted. And what
is? What, on the walls and floors and ceilings of theory, is
depicted and not? Not in the lover's light of retribution. Not
in the poets' utilitarian light.

In the fat-and-fire-in-a-cup light.

Artificial, if that's what that means:
light from other than
the foot-wide sun.
Stones dare the sun to burn itself through
because of this light.
Heraclitus,
with a mind like a forest,
pitched his mind at the sky and it rained and rained
down its fires.
Heraclitus ate this light.

Nature loves to hide, he said.
On the walls and ceilings
of a cave,
someone has made her hand
into a shape; another has traced a line and found an animal

 there, in the light that moves limbs, moves hooves,
in the light that muscles pull at skin to, light as music, fugue,
flicker, light of souls, in the light from a fire burning in a
sandstone cup.

Under Instinct

Let me explain to you mortals
what an instinct is:
the end of explanation.
Settlements are where your belongings are dropped.
Like gravity, there's nothing
under there.
None of you go around asking gravity
why it exists.
Life wants, like gravity wants.

*

"Unlike the rest of you, I refuse
to be governed
by the great expanse of blue,
that slanderer of life.
What have I missed?
What has anyone
said that's so convincing?
The beyond that wants
discovering has been fine this long without me."

*

Violently
the sun pulls water
from the flat sea

Chaotic shore,
water breaks there,
is untransformed

*

Many launched off, women among them.
Their arms and lungs and legs were strong enough to carry them
 or not strong enough.
And how many returned? What number
were lost? Could life be that difficult?
Could life be that appeasing, so satisfying
it throbs? So rich and paved and exhaustive and appeasing,
you dive in?

HELEN VENDLER

The Red Business: PTSD and The Poet

The representation of "real war" is more naturally expected in epics or novels than in a lyric poem or even a sequence of poems. But Walt Whitman is a rare hybrid, a lyric-narrative poet, and is necessarily aware that a war poem must visibly exhibit its primal archetype in realistic battle. His war poems can be read as a series urgently entering the war through different portals, each attempting to fill a different gap in the imagined panorama, each therefore reflecting the assumed partial inadequacy of the others, and the need for more. To read *Drum-Taps*, his collection of 1865, is to recognize how quickly Whitman realized the banality of his early jingoistic battle-cries

and flag-wavings, not to speak of the suppression, in those early war poems, of what he called, with deadly accuracy, "the red business." In 1861, when the Civil War began, Whitman was a man in his forties, a non-combatant who had never himself even been wounded. His most natural lyric genre was a poem spoken in the first person. Could he, should he, ethically assume the voice of an active soldier? Nor was he sure of the stance that he should take toward weapons and their wielders. Was he obliged to portray actual killing? He found comparably troubling questions everywhere in the composition of his war poetry.

In addition to such moral questions, formal questions came thronging, arising inevitably in the perplexities of representing battle. At what point should the poem enter the battle, and how much had the poem to accomplish before it could find an ending? What kind of battle should it present, in what large or small setting? Should it be seen in close-up or from a distance? Who will populate the battle, with what weapons, and in what choreography? How specific must the poem be: should the armies be named, should the cause of the war be articulated? What decorum should a war poem observe: should dead bodies be exposed to view? In a personal lyric such perplexities are more easily solved by ear, eye, and instinct, but when the topic arises from a contemporary war, known in its historical circumstances (from newspapers and military bulletins), how shall the poet enter his nation's current history? And how are his claims to be authenticated? Such questions would arise interiorly in anyone writing a group of war poems.

Whitman made the most active claim to the authenticity of his reportage in the first poem of *Leaves of Grass:* "I am the man, I suffer'd, I was there." Those words bring to a close an anecdote in which the poet learns of the actions of a heroic

sea-captain: how he risked following a sinking ship through three stormy days, and how, when the storm abated, the brave captain rescued the traumatized passengers from what would have been their sure death:

How he saved the drifting company at last,
How the lank loose-gown'd women look'd when boated from the side of their prepared graves,
How the silent old-faced infants and the lifted sick, and the sharp-lipp'd unshaved men;

— but at that very moment, within the very same sentence, the narrated story of the captain's acts begins to move, with almost biological caution, step by step, into first-person speech. The poet gradually feels himself mutating into one of the rescued passengers:

All this I swallow, it tastes good, I like it well, it becomes mine,
I am the man, I suffer'd, I was there.

His new identity, which at first appears (quite peculiarly) as a present-tense testing of sense-experience — of ingestion, of swallowing, of tasting — comes to life as a complete present-tense being ("I am the man"). The poet then recapitulates the process in the past tense: the poet insists that he is the same man as he was before the assumption of his added identity — that of one saved from death: "I am the man, I suffer'd, I was there." The three "I's", present and past, fuse into a new immaterial oneness.

Are you the man? Did you suffer? Were you there? How can the reader be persuaded of this extraordinary declaration?

And if this is the poet's suffering during a purely "natural" catastrophe — a storm — can he expect the reader to believe him when he takes on the hideous suffering — caused by arbitrary human evil — of "the hounded slave"?

> I am the hounded slave, I wince at the bite of the dogs,
> Hell and despair are upon me, crack and again crack the
> marksmen,
> I clutch the rails of the fence, my gore dribs, thinn'd with
> the ooze of my skin,
> I fall on the weeds and stones.

Whitman, often pondering the empathetic possibility of union, implicitly authenticated his claim by the accuracy of his vocabulary — his imagination alone was responsible for his convincing portrayal of the population awaiting rescue: the women of the shipwreck, their "lank" "loose-gown'd" selves, and the sad infants, surprisingly "silent" and "old-faced," the sick needing to be "lifted," the "unshaved" men with their three-days' beards. We can even see what the drifting doomed are thinking as they fear "their *prepared* graves."

In a postwar poem, "Sparkles from a Wheel," Whitman clarifies this imagined participatory process, naming it "effusion." As the poet-speaker casually notices a knife-grinder in the street, his impersonal first glance narrows to a directed focus. The focusing awakens in the eager eye an arterial imagination, recreating the material presence of the poet's physical body as an invisible immaterial one:

> Myself effusing and fluid, a phantom curiously floating,
> now here absorb'd and arrested.

Absorbing, he is absorbed; arrested by the scene, he is arrested into it. Only after his casual physical eyesight fixes on the individual detail of the organ-grinder does his spirit effuse itself (Latin: "pour itself out into a receptacle"). In "I am the hounded slave," the poet's self-doubling flushes nouns and verbs alike into physicality: *hounded, wince, despair, crack, clutch, gore, ooze, fall.* The poet's language also plays with the directional possibilities (right to left, left to right) of his fused identities: not only does the physical body arise to become the floating phantom, but the phantom's agonies (its immaterial woundings) can reverse into material furnishings (the garments he wears):

Agonies are one of my changes of garments;
I do not ask the wounded person how he feels, I myself become the wounded person,
My hurts turn livid upon me as I lean on a cane and observe.

In simultaneous actions, the wounded body bleeds as the phantom bleeds, immaterially, invisibly, while the immaterial body, livid with hidden hurts, issues from the apparently unharmed observer leaning on his cane. Standing in the street, the supposed "observer" absents himself into a "fluid" new state of feeling. Whitman's most eloquent and indubitable testimony to the mysterious process by which self-effusion generates an immaterial identity appears in a sublime moment of the prose Preface to *Leaves of Grass.* There effusion is described in almost biblical cadences, because even to the poet himself the invisible (but entirely real) psychological "effusing" seems an almost miraculous phenomenon:

From the eyesight proceeds another eyesight and from
the hearing proceeds another hearing and from the
voice proceeds another voice eternally curious of the
harmony of things with man.

Owing to his interest in others, and because he could "effuse"
himself into almost anyone, in "The Artilleryman's Vision"
Whitman invents, so far as I know, the first American poem
of PTSD. Gradually, in his involuntary effusion of linguis-
tic sympathy into the mind of the Artilleryman, Whitman
diagnoses the soldier's affliction as a form of mental illness
with a tragic prognosis: the soldier cannot (in the world of
the poem) awaken from his postwar "vision" and rejoin his
sleeping family. The poem is not the history of a single flash-
back (defined as "a reawakened memory"). On the contrary,
through its bizarre structures and disorganized suites of
perceptions, it becomes a surreal portrait of the grim alter-
ations of a disturbed mind.

It also incarnates Wordsworth's aphoristic but less familiar
definition of poetry in his note to "The Thorn" (in the 1800
addition of *Lyrical Ballads*): "Poetry is passion; it is the history
or science of feelings." The poem's irregular narrative "plot"
furnishes the *history* of the Artillery Man's heightened senses
and hypervigilant feelings, while the incoherent orientations
of his "vision" bring to light Whitman's *science* of the feelings
aroused by the distress of reliving — not merely remembering
— the trauma of witnessing or participating in death-threat-
ening events. I am not the first to see the poem as a description
of PTSD, but critics, in their abbreviated mention of the plot,

tend to treat the "vision" as a flashback to an actual memory of a single event, a literal transcription of real sights seen by day. But the Artilleryman calls the "sight" that shocks him awake not a memory or a nightmare, but a "vision" — a sacred word, denoting a transcendent and involuntary revelation.

Whitman must bring his readers to recognize the Artilleryman's "vision" not as a realistic transcript of the seen but rather as a record of the motions of a suffering mind — as a form of mental illness. How do we come to judge the Artilleryman's "vision" as a form of mental disease inducing distortion and distraction? The poem's disorder matches, I believe, one variety of the psychological disorders now medically defined (not least in the DSM) under the term "Post-Traumatic Stress Disorder" as a response to having experienced or witnessed actual or threatened death. Unafraid of diagnosing the Artilleryman's symptoms as indicators of a mental illness, Whitman establishes a tragic prognosis by violating the presumptive "happy ending" of such a poem. Normally an opening frame is matched by a closing frame, and since the soldier was asleep before being awakened by his "vision" we expect him to make a successful return from the vision-journey to his domestic bedroom. This he does not do. By amputating the expected exit-frame, Whitman traps his soldier in permanent trauma.

There are, I would say, three plots to "The Artilleryman's Vision." The first is the external, asymmetrical, and tragic plot of the frame-lacking-its-end-frame, which consigns the Artilleryman to everlasting torment. From his night-watches in hospital wards, Whitman would have known that post-traumatic stress could give rise to a recurrent disorder, warranting a hopeless closure of his poem. The second plot, the one of external narrative, tracks the battle's sights and sounds as the

Artilleryman's mind renders them, while silently, by various manipulations of language, it unveils the effects of trauma on his perceptions, exhibiting the full terror and zest of war before the "vision" arrives at its increasingly chaotic and dangerous close. And the third plot — initially invisible and most inventive — is that of the gradual dehumanization of the Artilleryman by the hellish elements of the "vision" pressing upon him.

In World War I, the link between unendurable battles and the nervous collapse of some soldiers seemed self-evident, requiring for healing only a period of sustained rest, after which the soldier was to be sent back to the front. (Success in "healing" was erratic.) Physicians attempting, at Craiglockart Hospital, to treat Wilfred Owen, Siegfried Sassoon, and other sufferers laid a groundwork for the scientific study of the disease. More recently, the internal and therefore invisible psychic injuries common in PTSD, such as "derealization" (in which the external world appears unreal) and "dissociation" (in which the sufferer watches himself from a numbed distance), have been added to the more evident behavioral symptoms (agitation, tremor, insomnia, self-isolation, hostility, and sudden flashbacks). "The Artilleryman's Vision" is Whitman's early — and astonishingly accurate — example of the variety of PTSD that, as an internal mental disease, is harbored invisibly by a physically uninjured veteran.

We notice immediately a disjunctive feature of "The Artilleryman's Vision": a hidden third-person "external" narrator gives the poem its title, thereby introducing his human subject not by a personal name but by a military title establishing the soldier's battle-function: he is the Artilleryman. (We soon discover that all the active soldiers in the poem are identified solely by their military functions.) The title-announcer does not call the poem "I, the Artilleryman";

rather, he is himself a military officer categorizing his men by their assigned mission. After the title, the Artilleryman immediately "takes over" the poem in his deceptively serene first-person opening lines, which serve to frame the central "vision" of battle. As the narrative proper arrives, the ex-soldier (at home) suddenly wakes explosively into a "vacant" midnight which is involuntarily and immediately "filled" by battle-scenes ("I see") and sounds ("I hear"). The poem then tracks the soldier's increasingly violent responses to his battle-vision. At first the Artilleryman strives to retain a frail residual sanity, recognizing his vision as a "fantasy unreal"; in a second phase (the battle) he strives to organize his perceptions by several means, for instance by connecting weapons and their wielders, but is defeated by the battle's overwhelming number of details pressing to be classified; in the third, noise and chaos mount as he undergoes a form of exhilarating madness, bearing out Whitman's most penetrating insight — that it is "the old mad joy" of killing that floods the heart of the now dehumanized soldier.

Whitman is of course not the first lyric poet brave enough to give a poetic journey an unhappy ending. George Herbert dared, in "The Pilgrimage," to thwart the devoted traveler's arrival at his sacred destination. When the pilgrim finds, as he ends his journey, not the promised "gladsome hill" but only "a lake of brackish waters," he cries out,

> Alas my King;
> Can both the way and end be tears?

It is a beautiful and resentful line, and as the deceived pilgrim journeys on, he observes that any rest, even that of death, would be preferable to this dangerous and unjust form of life:

After so foul a journey death is fair,
And but a chair.

Although Herbert's pilgrim is allowed at least that closing complaint, Whitman's Artilleryman at the end disappears completely unable to depart from the horrors by which he is still surrounded. Robbed of his personal functions, he is fixed forever in his military one.

Whitman was troubled as he sought for a truthful conclusion to "The Artilleryman's Vision." We know this because he left a draft of the poem from 1862 called "A Battle." There the Artilleryman addresses an anonymous comrade, narrating the events that he sees. In the immediate aftermath of mass-killing, however, he cannot continue his "objective" description of the battle, whereupon his recital falls apart in his hands. Mid-line, his second-person narration leaps into first-person testimony, sliding from fact into personal outcry:

> The chief gunner ranges and sights his piece,
> and selects a fuse of the right time,

> After a shot see how he leans aside and looks eagerly off,
> to see the effect!

> Then after the battle, what a scene! O my sick soul,
> how the dead lie.

The first-person draft-lament accelerates into an
 uncontrolled tautology of melodrama:

> O the hideous hell, the damned hell of war

Were the preachers preaching of hell?

O there is no hell more damned than this hell of war.

O what is here? O my beautiful young men!
 O the beautiful hair, clotted! The faces!

But almost immediately Whitman rejected the draft: apparently he could not feel at home in his own sedulously inserted but emotionally arid intrusions ("see how he leans aside and looks eagerly off!"), nor could he accept the unravelling of his lament into incoherent repetition. In 1865, when the abandoned draft was revised into first-person enunciation, the poet found a chillingly fitting form of closure, as we shall see.

Whitman had been asking himself whether he, as a non-combatant, has a right to speak in a soldier's voice. In the draft he had hoped that addressing a "you" would insert some second-person drama into the poem while wondering why he was unable to animate a third-person narrative. As the finished poem reveals, he solved the problem of voice by capitulating altogether to a first-person voice emanating from an active soldier. In this capitulation he is obeying the injunctions of poetic law in preference to personal fact. Speaking always, now, as the Artilleryman, Whitman will "become" a combatant, and his feelings (as well as his observations) will, as Wordsworth prescribed, govern his language.

Manifestations of feelings throughout the battle-scenes in the finished poem are multiple. The soldier uses gerunds (nouns made from verbs, and therefore more stable than verbs) in performing his inventory of weapons: he hears not bombs buzzing or muskets rattling, but rather abstractions: "the hum and buzz of the great shells... the rattle of musketry."

Such a conversion establishes the passage of time and gives distinct attention to each weapon. But finally the Artilleryman gives up on his inventory, despairing of precision and falling into vaguely generalized groups ("the sounds of the different missiles") such as haunt his "vision." Forsaking words, he valiantly attempts phonetic mimicry ("the short *s-s-t! s-s-t!* of the rifled ball"), falling back on such aural transcription once more in the penultimate line. Hoping to find a vein by which he may be able to "effuse" and empower himself, the Artilleryman internally undergoes the impact of his vision, unprepared for its outcome. At first a sliver of sanity remains, as the soldier characterizes his vision as a "fantasy unreal" and can adopt an "objective" view: "the skirmishers begin," "tumultuous now the battle rages." But such distanced perception disappears as the Artilleryman re-enters the battle, flaunting his imaginative power with hyperbole: "*all* the scenes at the batteries" return again.

But in what manner do all the scenes arise? The Artilleryman's view must now be a panoramic one (a form of divine omniscience) in sound as well as sight: the orchestral noise-level rises ominously. Whitman must conjure up — and represent — how the "vision" of a PTSD sufferer differs from the "same" events as seen in ordinary life or in transcriptive memory. He continues to imagine and to recreate the world as it lies inside the oppressed Artilleryman's brain — distorted, arbitrarily condensed, irrationally contracted or expanded in the fantasy of the "vision." To the startled Artilleryman, his "fantasy unreal" has become altogether real. The "vision" dictates even his cognition, what the soldier sees and where he directs his glance.

We perceive, as the soldier sketches his scenes, the flagrant reductiveness of war. The soldiers are nothing but their

functions: stripped of their personal names and their domestic roles, they become faceless individuals, unranked, without identifying uniforms, socially naked until they are given their guns and uniforms and their assignments or rank — "the chief-gunner", "the colonel." When the Artillery man sees a group of nameless "men" not yet engaged in battle, proudly exhibiting their guns, he offers no details of their position, rank, or duties; they participate in the facelessness of "the ranks." The new recruits remain nameless until they acquire, along with their uniforms and their guns, a military identity, an identifiable place in the army's implacable hierarchy. Thus does the Artilleryman's "vision" become "unreal," deleting from its soldiers all identifications but the external ones that they acquire when they join the army, becoming replaceable cogs in the military machine. If one artilleryman falls, another can be called to take his place.

I must mention, because it clarifies the unexpected closure of the revised "Artilleryman's Vision," another draft (immediately following the draft of "Battle"), which will evolve into "A March in the Woods Hard-Prest and the Road Unknown." In it, Whitman finds a plausible way to insert a first-person soliloquy into a third-person poem: one soldier, detaching himself from troops briefly resting from their "hard-prest" march fleeing their defeat, enters a field-hospital full of wounded and dying soldiers. Sharp-eyed, the soldier details all that he observes, arriving finally at the most desperate sight, a death-spasm. A reader may be baffled by the very strange end to the soldier's soliloquy: after he turns back to rejoin the ranks, the last sight that he records from his time in the field-hospital has

nothing expressly to do with the wounded and dying. Rather, he notes a purely eye-catching aesthetic detail, "the glisten of the little steel instruments catching the flash of the torches." In the finished poem "flash" was removed and the line was revised to emphasize by alliteration the reciprocity of light from scale to scale, from "glisten" to "glint." The alliteration further magnetizes the two halves of the moving light-gestalt, creating in effect a fascinating "reverberation" of light in chiaroscuro across differences in scale, from great flashing torches to little steel instruments. I mention this involuntary distraction from pain — enabled by a diversion of the eye to an impersonal aesthetic notation — because such a diversion becomes indispensable to the unexpected conclusion of "The Artilleryman's Vision."

An old, reminiscing "artillerist" had turned up in the first edition of *Leaves of Grass* in 1855, but at that time Whitman had never seen war. By 1862, he evidently understood, from his work in the Washington hospitals, the intense suffering of men who appear uninjured but who in fact bear invisible mental torments generated by what they and others had witnessed and done on the field. In Whitman's images of PTSD, the soldiers are not recovering "a" memory; rather, they are exposed to a kind of living film-mosaic of horrors accreted during their months or years of service. Their internal "film" has neither logic nor rational sequence, as Whitman is at pains to show in his "matching" of scenes to language.

When Whitman converts "The Artilleryman's Vision" into an autobiographical account, he makes sure, by its introductory peaceful domestic frame, that it is not a war poem but emphatically a postwar poem. It was first published under the title "The Veteran's Vision," but in 1871 the poet, realizing that it would be better understood as a poem about

the psychic trauma of lethal battle, made his protagonist not merely a "veteran" but rather a soldier tasked to operate a large front-line cannon, and therefore inevitably responsible for many enemy deaths. Though the Artilleryman's initial battle details may sound "natural," the poet's language, by separating the sounds from each other and distributing them among distinct weapons, ensures the ongoing passage of time during his compelled and exhausting inventory. And by framing the Artilleryman's experience of battle not as a remembered past moment of war but as the "now" of private midnight after-effects, Whitman has decided on a tragic prognosis for his wounded soldier.

The main verb of the Artilleryman's opening frame-narrative is in the present tense ("I wake"), and the apparently uninjured soldier alarmingly becomes a combatant again, filling the "vacant midnight" with his threatening "vision" as it unrolls through its "scenes" and "sounds", interspersed with early "objective" glimpses of the battle itself: "the skirmishers begin, they crawl cautiously ahead." These brief remarks reflect the soldier's attempt at the "objectivity" of a third-person observer. Soon enough, however, the aspiration to dispassionate reportage is crushed by the relentless vision that "presses upon" him, and he finds himself in the midst of a literally mimetic battle, where sounds substitute for words, and the soldier — still sane — comments parenthetically from the sidelines: "tumultuous now the contest rages." The first-person voice will not, however, submit itself further to the impartial voice of detached observation. As the Artilleryman re-enters the battle, he flaunts hyperbole as his banner of reprise: "all" the scenes at the batteries become present to him "again." "Again," is the familiar word normally introducing an imaginative reprise, except that here the alerted Artilleryman means

the word literally. It is as though a curtain rises on an immense and overwhelming panorama of the entirety of his wartime experience and the vision must choose at each scene the point to which he must direct his glance.

As Whitman begins to imagine and recreate the world as it exists inside the oppressed Artilleryman's brain, experienced reality becomes distorted, arbitrarily condensed, irrationally contracted or expanded in the madness of "vision." To the startled Artilleryman, his private and obsessive "fantasy unreal" becomes, as it overcomes his resistance, an experience entirely real and relived. The chaos and increasing uncontrollability of the scenes as the battle progresses warn us that we are following, now, not reality but the deformities of thinking that haunt the veteran of the war. Normally, a narrator would create a reasonable chronology of the battle, but Whitman's Artilleryman produces scenes arbitrarily and at random: here a close-up, there a distance-view; here a sound, there an action; here a limited capacity, there a panoramic display. These scenes are not produced by the soldier but rather are "pressed" upon him like an incubus, as he lies passive under its rising undermining of rationality.

The poem's ever-unstated underplot is, as I say, that of the dehumanization of soldiers. The process, begun when the soldier was dislocated from his family and civilian life and reduced from being a named person to being a named function, can end only when the recruit returns home — but the Artilleryman can never return to "a normal life." The dense battle in his "vision," is similarly reduced, since it is "populated" by only two groups: soldiers and weapons. The weapons-as-independent-agents, "shrieking" and "buzzing," dominate the Artilleryman's initial battle-scenes, and the killing power of those weapons excites their wielders. To the dehumanized

"chief-gunner," his success in killing is a matter of skill, part of an athletic contest and not part of the shedding of blood. At various points in the vision, soldiers become caught up in their own success, and are "cheering" as though war were a sport, giving a "shout of applause" as if the battlefield were a theater. Slowly their dehumanization becomes undeniable. As fantasy becomes reality, the soldiers numb themselves against the realization of what they are actually doing.

War has so dehumanized the Artilleryman, so effaced human distinctions, that he enumerates fallen comrades only as "gaps cut by the enemy's volleys." The "gaps" (boasts the Artilleryman) are visually "quickly fill'd up, no delay." At first the Artilleryman was relatively remote from the center of the battle, dependent on the senses that can operate at a distance, on sight and hearing, but as the battle closes in on him, a nearer sense is activated as his nostrils must admit "the suffocating smoke." After the respite of a deceptive "lull," the Artilleryman — earlier the active listener to what he was hearing but now an assaulted victim — quails before "the chaos louder than ever." The density of the population on the field increases: close by, he hears "eager calls and orders of officers," who are, we suppose, as "eager" as the chief-gunner to see the effect of their weapons. And all of these scenes have a soundtrack: "And ever the sound of the cannon far or near." Enemy cannon like his own now approach the Artilleryman; he cannot escape their menace.

At this desperate point Whitman's genius comes most fully into play: the last word we expect to hear from the Artilleryman is "joy." Yet here it is, as Whitman penetrates to the ultimate heart of war: it is a primitive tribal savagery, permitted nowhere else in "civilized" life. Not only is it a "joy," but it is also a madness — an "old" madness recognized from some previous undefined violence perpetrated by the

Artilleryman himself on some victim. Whitman's boldest insight is the frighteningly intimate response of "joy" to violence. In the depths of his soul the Artilleryman feels "a devilish exultation and all the old mad joy." The Artilleryman still has a conscience, he still knows his joy to be "devilish," but in the grip of his vision he is immune to shame and guilt. From the indifference of the soldier to the bodies that fill the gap in the line, from the dehumanization of the soldier until he is nothing but a weapon of war, feeling wild joy as his cannon leaps into action, Whitman depicts the Artilleryman's moral dissolution as he ignores his own companions, wounded unto death, as they flee the front. Indeed, self-numbed against the truth, he boasts of his own insensibility: "The falling, dying, I heed not, the wounded dripping and red I heed not, some to the rear are hobbling."

"And ever the sound of the cannon...And ever the hastening infantry shifting positions." "Ever" is the summary word of the vision; the Artilleryman is powerless to expel his incubus. How is it, then, that the Artilleryman turns his eyes skyward at the end? He is still in his "vision," but he is deflecting guilt and shame by two methods: he sophistically displays his "patriotism" by quoting from Francis Scott Key's poem "The Star-Spangled Banner" (later set to the music of an "English tavern-song" on its way to becoming our national anthem), and he resorts to an aesthetic language to support his evasion, resembling the soldier in "A March in the Ranks Hard-Prest" who could no longer bear to focus on comrades dying and focused instead on "glints" picked up by small steel instruments from the "glisten" of the great torches. Since the artist's eye seeks out from childhood what is beautiful, there is always the temptation (especially in youth) to obscure the unacceptable and to mask it by some version of the beautiful.

297

The Red Business: PTSD and The Poet

The most courageous artists, like Whitman in "The Artillery-man's Vision," hope to refuse the temptation to aestheticize, and therein to falsify, the truth.

The Artilleryman's vision never releases him: Whitman refuses to return him to the slumbering wife and the breathing infant of the opening frame. In the last moment of his vision, he is still trapped in the hell of war; there is no homecoming from derangement. The soldier attempts to sanitize his vision by abstracting it, in its last words, into a purely visual epiphenomenon: "And at night the vari-colored rockets." Yet he does not succeed, by these self-exculpations, in escaping his vision; it is still in power, still "pressing upon" its victim, enabling the Artilleryman to excuse his violent joy in war by concluding on an "innocent" and unrepentant note, pleased by the distance from himself in Key's poetic bombs and colored rockets in the sky. It is a self-defensive conclusion that should shock every reader, the Artilleryman's flight, by means of an appeal to isolated beauty, from the deaths inflicted on others by his cannon.

To confine a battle to a short lyric is to court trouble. It is natural in a war poem to cite a *casus belli,* but in the published poem Whitman does not. The implications are evident. What are the two sides fighting about? Who knows, who cares; war is a constant in every culture; men, weapons, deaths. What permits war? The dehumanization of the soldiers on both sides. And what motivates war, generation after generation? Exhilaration: men find it exhilarating, a unique, irresponsible thrill, and can forget, in its spell, the humanity not only of their opponents but of their fellow-soldiers, even of themselves.

Only after rereading "The Artilleryman's Vision" do we recognize its analytic ambition: to diagnose, silently, by the apparently incoherent reportage of the postwar mentality of a flailing soldier, a disordered mind helpless against the midnight assaults of its alternately frightful and (secretly) zestful vision. And it is only after seeing the poem as a case history that we recognize the implicit prognosis in its abrupt end. Within his own stricken account, the Artilleryman cannot diagnose his case nor admit its prognosis. Every conclusion drawn by the reader must be hinted at by Whitman's pen — whether by a structural feature (the absence of a closing "frame"); a fall into mimetic sound to suggest the impossibility of intelligible renditions of battle; an unnerving descent into a suddenly religious vocabulary — "the depths of my soul." — when the Artilleryman is appalled by his own appetite for killing, his "devilish exultation and all the old mad joy." And the more frenzied revelation — "I heed them not" — allows us to see him indeed as a damned soul, further damned by his affected distance as he contemplates not death nor dehumanization nor self-numbing but instead the pleasing liveliness of the skyward spectacle. And by the time he fuses, at the end, an illogical list of unregulated entities — "grime, heat, aide-de camps galloping by" — we perceive that his mind has broken down into a distorting chaos from which he will never recover, a recurrent mental illness not yet given a name.

CELESTE MARCUS

Reason, Treason, and Palestine

The Palestinian refugee camp Dheisheh is buckling beneath poverty and inherited hopelessness. The despair is palpable even in the pictures that my friend and co-worker Ali sends me from inside the camp. I have never been there — even before October 7 it was not simple or prudent for a Jewish woman to visit Palestinian refugee camps, but now passage has become impossible. Since I began working with Ali to restart the after-school program for children which he used to run in his camp, my view into Dheisheh has been dependent on Ali's glitchy WiFi. Ali grew up in Dheisheh, which has no parks, no playgrounds, no art museums, no movie theaters. The streets

are marked by potholes and littered with the detritus of a population which lives on memories. There is nothing beautiful there. A life without beauty binds the mind as ropes bind hands and feet.

"Return" is the echo that haunts places like Dheisheh. There, tomorrow is an unfriendly specter, and the embers of a past worth remembering require much effort to keep from flickering to ash. The camp is located south of Bethlehem, the ancient town between Hebron and Jerusalem on the west bank of the Jordan River. It was built in 1949 as a temporary shelter for Palestinian refugees from both those cities. They had fled their homes during the war that would become known to Palestinians as the Nakba and to Israelis as the War of Independence. That war ended in an armistice on July 22, 1949. For the past seventy-six years, the Palestinians of Dheisheh have remained stalled in its aftermath.

Dheisheh was built to be provisional. The displaced Palestinians are bound together by the siren call of their former homes. Many of them carry keys to the buildings from which their grandparents or great-grandparents were evicted. Yet even if the people of Dheisheh could leave the camp and find somewhere else to live, starting a new life is considered a dereliction of duty, a treason toward their past. They are, in this sense (and more largely in their politics), complicit in their own misery — to leave Dheisheh, to eschew the refugee status in search of a fresh start, would be tantamount to conceding Israeli ownership of the homes from which their families were forced. They are bound to, and by, the past. To be Palestinian is in some essential way to live in longing for those lost homes. In this regard they are not unlike the Jews who for two thousand years prayed for a return to Zion. President Biden enjoys recounting the moment, just before

301

the Yom Kippur war in 1973, when he and then-Israeli premier Golda Meir were standing shoulder to shoulder for a photo op. The two of them knew that Israel was about to be invaded by Egypt and Syria, and neither were confident the still-young, puny country could repel those forces. "Why do you look so worried, Senator Biden?" Meir whispered. "We Israelis have a secret weapon: we have nowhere else to go."

It's true. In all the centuries Jews wandered in the diaspora they were never permitted a sense of belonging or a sense of true safety. The vast majority of the Jewish tradition was written in exile. The entirety of it is tinctured with nationalist yearnings. Just as Palestinian identity been shaped by displacement, for most of the time that Jews have existed they have existed in exile. A marrow-deep sense of vulnerability is another trait that Jews and Palestinians have in common. Jews as good as kept their keys when the Romans forced us from Jerusalem and destroyed the Second Temple in 70 CE. In prayers three times a day for the subsequent millennia, we vowed that we would come back, that we would be restored to the territory that was taken from us and that is rightfully ours. If Israel fell today, there would be nowhere for the seven million Jews who now live there to flee, nowhere that such a population could find rights and safety.

And nowhere is precisely where Palestinians are now. Today, to be Palestinian is to be suspended in the same inhospitable dimension between the past and the present that the Jews know so well. For Palestinians, any aspiration towards permanence is impossible, legally and culturally, when permanence – by which I mean stability and self-determination – is what they most need. The Israelis will not allow it, and neither will the Palestinian ghosts, who are just as present as the living. Perhaps even more so, since they seem to determine

the unfortunate behavior of the Palestinian leadership. Nothing can be permanent until a will to live triumphs over the weight of all our dead. Palestinians must renounce their right to their grandparents's olive trees if their children are to have parks and playgrounds. The price of progress is compromise, which fools confuse with treason.

Ali was born in Dheisheh in 1991. His father and mother were born there, too. His father's father was raised in Hebron, and his father's mother in Zakariyah, or Zechariah, an Israeli moshav west of Jerusalem where, according to legend, the body of the prophet Zechariah was found in 415 CE and buried there in what became a Christian shrine. (Zechariah was supposed to have been inside the Palestinian state that the United Nations established in its partition plan in 1947, which the Arabs rejected. In 1950 its last Arab residents were expelled by Israel.) Ali's mother's family was from Bethlehem originally. In 1949, after the armistice was signed, three thousand and two hundred refugees came to Dheisheh. They lived in caves or in tin-sheeted shacks, where they stayed for one year before moving into tents. In all the intervening time every step towards more habitable dwellings was made grudgingly, because these camps were not supposed to last. There is a terrible irony in this, because they have lasted. They have become permanent sites of impermanence. There was supposed to be some ending after which life begins, some political release from transient misery. It never came, at least not yet. Meanwhile, in an expression of ritualized loyalty which does not remotely resemble hope, Palestinians demand a return to the homes that were destroyed in and after 1948. Time travel is not a policy.

303

Ali's grandparents were among those who lived in tents until 1956. In that year UNRWA, the United Nations Relief Work Agency which was founded in 1948 by the United Nations for the purpose of aiding Palestinian refugees, built housing units in Dheisheh, with one to two rooms for each family depending on the family's size. Basic amenities such as running water, electricity, and telephone lines were provided in fits and starts over decades, siphoned from the Bethlehem municipality, which belonged to Jordan until Israel gained control of it in 1967. Until 1988 sewage flowed in open gutters. A working sewage system is among the few things that have gotten better in Dheisheh. With every instance of Palestinian terror, starting with the frenzy of suicide bombings which started in 2000, Israel tightens the security noose, restricting Palestinian movement, commerce, and the passage of goods. There are no sidewalks in the camp. Homes open out onto narrow alleys. The highway between Jerusalem and Hebron runs alongside Dheisheh and serves as its main street. Ali learned early that a culture which lives on memories is not designed for children. Children want to live, which is not the kind of activity that Dheisheh was built to sustain.

The place teaches them to die. In January of last year, a fourteen-year-old boy named Amr Khamour was shot by Israeli soldiers after throwing stones at a military jeep in Dheisheh. After his death, his parents found a goodbye message that he had written for them on his phone: "If I come to you a martyr, God willing, don't cry. And forgive me for every mistake I made. Don't be sad, father, I wished for martyrdom and I received it." Amr was killed less than two weeks after his friend Adam Ayyad was shot dead by Israeli soldiers. Before his death, his mother had found a farewell note that he had written, torn it up, and begged him not to write another one. He disobeyed her. In the

back pocket of his corpse's pants she found a slip of paper: "I wanted to do many things, but we live in a place where achieving your dreams is impossible. Martyrdom is victory. It's true that your life ends but at least it ends in happiness." Before his death Amr told his friends he wanted to be buried next to Adam.

Other teenage boys from Dheisheh who draft farewell messages in anticipation of an early death quote Uday al-Tamim in their letters. Tamimi was a twenty-year-old Palestinian who wrote a suicide note while on the run after killing an Israeli soldier at a checkpoint at the entrance of the Shuafat refugee camp: "I know that I will be martyred sooner or later, and I know that I did not liberate Palestine through this operation, but I carried it out with a goal in mind; for the operation to mobilize hundreds of young men to carry arms after me." Amr and Adam are both buried in the Martyr's Cemetery on the outskirts of Dheisheh. Their friends have chosen plots for themselves in a nearby row of empty graves.

Teaching children to value their own lives is antithetical to life in Dheisheh, but that is what Ali is trying to do. His method is an after-school program for children, which he created in 2018. When there is no hope, when there is no future for your children, the question "Do you believe in a two state solution?" means nothing more than "Do you wish to prettify your own debasement?" When a people's horizons are as high and as wide as the border fence which restricts their movement beyond their small camp, when tomorrow is only a series of yesterdays, brutality is an appealing shield against crushing despair. Ali's little institution was established to fight this temptation. If diplomacy has failed and terrorism has failed and protests have failed and cries for aid have not lifted the misery, the only heroes left are the ones who recognize their duty in the face of each child. I believe that Ali is a hero — that

is why I have seized on his program like a life raft also for a Zionist Jew who is always on the verge, and sometimes past the verge, of despair about peace. He and I found one another in the small community of Jews and Palestinians which understands our two people's fateful bond. I confess that I need Ali, and he needs me to know that I need him.

Ali is not interested in martyrdom, but nor is he a politician or a journalist or an activist. Politics is not his concern: people are. The children in Dheisheh are not statistics for Ali. They are people who deserve more than any adult has the power to give them. Ali is not trying to solve the Middle East crisis. He is trying to run an after-school program for two dozen Palestinian adolescents. If he succeeds — and it is not at all likely that he will — his success will not secure his people a future worth living for. But it may teach these children not to die.

Palestinians may be the only people who pass their refugee condition from one generation to the next. Ali was born in the same camp as his parents, but it is not his home. He told me this in exasperation, as if the word "refugee" was itself a whip at his back depriving him forever of the nourishment of belonging. How do eternal refugees raise their children? How do they school them, when the purpose of an education is to give a child the chance to excel? Excellence is neither possible nor culturally valued. The collective tyrannizes over the self. Yet accepting the conditions of life and trying to make the best of what little possibility there is – such stoicism is a sort of capitulation. It colors also the syllabi and the teaching methods in most of the schools that are available to Palestinian children in the refugee camps in the West Bank.

"Each of us refugees are like tiny human-sized versions of the whole conflict," Ali explained to me. He was alluding to the many different sorts of Palestinians in the region, and how each type interacts differently with their inheritance. Palestinian Israeli citizens who live within the 1949 borders — that is, in Israel — are accorded the most rights of any of the Palestinians in the region. It is difficult to place the rest on a continuum, since all Palestinians suffer from different varieties of discrimination. Palestinian residents of East Jerusalem, for example, are in some sense Israeli citizens, since Israel annexed East Jerusalem after the 1967 war, but they do not enjoy the rights of Jewish Israelis, or Palestinian Israelis living outside East Jerusalem. They cannot, to name just one example of the illiberalism of their status, vote in national elections. Palestinians who live in the West Bank suffer from all kinds of degradations that their Palestinian-Israeli counterparts only ever experience if they cross the checkpoints to visit them. But the West Bank is divided, by Israeli-Palestinian agreement reached in previous rounds of the peace process, into areas A, B, and C, and each poses a different set of threats for Palestinians. Each of these areas is its own political and moral territory. Area C represents sixty percent of the West Bank and is governed entirely by Israel. In area A, the Palestinian Authority controls both civil and security concerns. In area B, the Palestinian Authority oversees only civil concerns. Areas A and B are non-continuous. Google will furnish you with maps which reveal exactly how inconvenient the configuration is. Inconvenience is a feature, not a bug, for Palestinian life in the West Bank. (The hell that is life in Gaza is its own saga of misery.)

Within areas A and B, those who live closer to Jerusalem and those who are inside cities such as Bethlehem are safer than the farmers and the shepherds in the Jordan Valley or in

the hills south of Hebron. You may recall sporadic coverage in American media of the attacks on Palestinians in those areas at the hands of settlers whom Israeli Security Minister Itamar Ben Gvir has been arming to the teeth. These thugs roam from village to village brandishing M16s, butcher knives, and pistols, always intoning the same threat: "You have twenty-four hours to leave. If you don't, we'll be back to kill all of you." Between October and January, vigilante Jewish settlers succeeded in forcing almost a thousand Palestinians out of fifteen villages that were wholly or partly emptied.

But inside Bethlehem there is comparative stability. The "refugee" status somehow makes their condition official. It rubber-stamps their generational paralysis. Ali wants to shake his students free of this historical complacence. One of his strategies is to teach them English. The necessity of this instruction is itself revealing: his students, all of whom are enrolled at UNWRA schools within the camp, have been studying English for years but none of them have learned it, just as Ali – whose English is fluent – did not learn the language in school. That is because Ali and his students are poor, and because they live inside the camp. All residents of the camp whose families cannot afford to send them to the expensive private schools outside Dheisheh — Palestinian society in the West Bank is stratified and the class differences begin right outside the camp — must attend the UNRWA schools through the ninth grade, after which they are bussed to public schools in Bethlehem.

In both private and UNRWA schools, English language study is mandatory beginning in first grade. But the difference between the two systems in teaching methods and curricula is astonishing. In private schools, which are largely Christian and run by churches, the teachers are native English speakers.

Cultural proficiency is part of the curriculum, so students are simultaneously learning about ways of life that are different from their own while they learn the language. Not so in the UNRWA schools. There the Palestinian Authority imposes a specific curriculum which focuses primarily on grammar. Students sit in chairs at their desk reciting grammatical charts in repetitive hums. They could pass all the way through the school system without once reading more than a few English sentences. In class they hardly converse in English at all. This, unsurprisingly, seeds students with a hatred for the language. They loathe English class. This is among the minor malignancies of Palestinian life which Ali is endeavoring to excise. "One of my favorite things to do with the students was play them music," Ali recalls. "Once, while playing them a song, I suddenly realized that I had not even heard a song in English until I was in twelfth grade. No one in my English classes even spoke English except the teacher. And even the teacher doesn't really speak it, he just reads it! And we all just repeated it, we never even wrote the charts down. Who could learn like this? Who would like it?" He shook his head.

Ali was born with a rare and priceless resource: a love for the English language. "I just loved speaking it — I don't know why. And it was this love that really freed me. I had a job working at a restaurant in Bethlehem and I looked forward to work because there was so much opportunity for me to practice my English with the tourists who came to the city. I remember realizing for the first time in the restaurant that speaking English with native English speakers allowed me to change the way I think. The thoughts inside my head, the tone of them, changed. I was able, for the first time, to enter a different world, a world that doesn't feel the way the camp does, that isn't cramped and hopeless. There is no hope

Reason, Treason, and Palestine

inside the Arabic I was raised in. The Arabic language itself that Palestinians are taught carries this hopelessness, and this colors our thoughts and our hearts. We can't escape it, it's part of every thought we have." Every bilingual person knows the feeling that Ali was describing, the strange alteration in thought patterns that has the power to change even a person's sense of possibility.

"We have YouTube, we have Instagram, Ali said, but because we don't have English our world is so limited. When you get to communicate with people outside your bubble and you see that there is a world outside the one you know, that's when it's possible for a voice in your head to question all you've been told about how the world is, and how the future must be. Contradiction gives you the opportunity to start thinking for yourself." He gave me a concrete example: at the restaurant Ali was able to talk with English speakers about the idea of a refugee. These conversations were the first time he understood that refugee status is not an unalterable fate, that refugee crises can be resolved. Absorption, integration, self-reliance, collective dignity: all this could be included in his imagination of his people's prospects. "I had never heard before about what happened in India and Pakistan. I didn't know that any refugee crises had ever been solved. The idea of solving it had seemed impossible to me before these conversations. I couldn't imagine myself without that identity. Learning English let me think of myself as something other than a refugee."

After learning English, Ali came to his own conclusions about the political extremism and heaviness that dominated his home. In our long sessions strategizing about how to raise money to get his program started again, he and I don't talk about politics much. When we do, it quickly becomes clear that his resentment for the Palestinian Authority rivals

310

his distaste for the Israeli government. But neither of those antipathies are included in his syllabi. (The same cannot be said of the curricula at other educational institutions, where ideology and prejudice are taught.) It would defeat his purpose if they were: his goal is to provide his students with the tools to think independently. "My goal is not to be another dictator demanding that my students think the way I do, about peace or about anything else. I want to provide them with the tools to change just like I did, and if they come through it differently than me it will be because they thought themselves to a different place. English lets me see different perspectives. In the refugee camp there is only one perspective: the Palestinian Authority's. I never once had the experience of reading two different analyses of the same political event and then having to work out in my own head which is right and which is wrong. The word 'dictator' is considered a political term mostly, but that's not how I mean it. Sisi is a dictator, and Assad, and Abbas. But the truth is that the dictatorial mindset starts in the home. My father was a dictator. This sounds harsh, but it's true. After my own transformation I could see how he ran our family like a dictator. We couldn't have our own thoughts. We weren't even given the ability to disagree with him inside our own heads, let alone contradict him out loud. He didn't just tell us that we couldn't argue with him, he did worse than that: he made any argument impossible. I will not do this to anyone. I don't want to dictate to my students. My hope is that with the tools I give them they will learn how to think. Not *what* to think, but *how*."

Ali went on to remark that the study of English is essential for the capacity for independent thought and that independent thought is essential for self-respect. That is another course on the curriculum in his program. It, too, is a rare

311

commodity in the refugee camp. The vast majority of Palestinians in the West bank work in Israel. Seventeen thousand Palestinians worked in Israel on a daily basis before the war in Gaza, most of them on construction sites. "Construction is important and it pays good money." Ali said, heavily. "But it makes me sad that I know there are lots of people who spent twelve years in school, four years getting a BA, two or three years getting an MA, and then five or six years getting a PhD, and the best they can hope for for themselves and their families is to work in construction. I still work in a restaurant, but working as a teacher in the program for the kids, that job is dignified. When I was doing that, I felt proud." When the funding for his program ran out, his chance at more dignified labor disappeared with it.

"Every week, I and the two other teachers — both of whom went to Bethlehem University, which is one of the most prestigious in the West Bank — we used to meet on the weekend and come up with lesson plans for the whole week. Usually, we run the program every weekday for four to six hours a day. Every session begins the same way: we give the children a meal. We prepare the food and the students serve it to one another. They love this, they are not used to this kind of thing because in school there is nothing like a free lunch program like you have. Some of the kids loved this so much that they would come to the program twenty minutes early to help us make the food. After meals we always do some physical activity. Then, for an hour or an hour and a half, we help them with their homework, or if they have to study for tests we help them study. Then the rest of the program differs from day to day. Sometimes we would listen to music in English and then practice singing the words. Sometimes we would paint and draw. In the public and UNRWA schools, they are no art and

music classes. This is part of the reason that the kids don't think about school as a place where they are being nourished and taken care of. School is about studying, of course, but for most students around the world school is also a place where young people are introduced to things that can inspire them, that they can be passionate about and look forward to every day."

He continued recounting the day at his program: "The last activity of the day is also always the same: a sharing circle. We stand in a circle and pass around a ball. Whoever is holding the ball is allowed to share. Initially we set aside a half hour for this activity, but everyone wanted a chance to talk for longer, so now it takes an hour and even an hour and a half. And it's such a useful activity because they learn so many things: how to respect others when they are speaking, what it feels like to be given the respect of having careful listeners, how to express themselves, how to feel comfortable sharing their ideas with an audience. Students often start the program shy, but after a short time doing the sharing circle they open up and they learn how to communicate proudly and sweetly."

Ali set tuition at twenty shekels, which is just under six dollars. It was only a symbolic amount. He wanted the parents to feel that they were contributing, that it wasn't free. "If you're given something for free, it's easy not to take it seriously," he explained. In addition to the payment, Ali demanded that the parents all commit to enforcing regular attendance. He needed them to know that the group was building something significant together, that they were forming a community, and that the community needed to be accorded respect in order for the students to be enriched by it. No girl ever missed a single day. The boys were a little tougher – it took a bit of time for them to develop the discipline to come regularly and on time. Eventually, though, they learned that investing in the program

313

Reason, Treason, and Palestine

was a way of investing in themselves. And then something remarkable happened: students would arrive a half hour early every day because they loved the program so much. "Here in the Middle East we are always late," Ali laughed, "but these young kids arrived so early that sometimes I would find them lined up outside the door before I had even managed to get there from work."

Ali has shared many stories about his students with me, often with pride, sometimes with a terrible sorrow. But there is one student, Muheb, a very sweet, kind boy, who has challenged Ali more than any other. He is the sort of remarkable young person who naturally inspires intimacy and confidence. "If he were from somewhere else, he would be capable of greatness one day," Ali muttered. Early in the program, right after they had started the sessions, Ali asked the students to take turns presenting special talents. Muheb chose to sing a song — he has a beautiful voice. To everyone's shock, Muheb began to intone an ISIS terror ballad. Ali asked where he had heard the song, and the young boy replied that his father liked to sing it in the house, and that he also played videos of ISIS terrorists butchering people with the same song blaring in the background. Ali told him never to sing it again. It was difficult to explain to Muheb why a song that his father liked was inappropriate for class.

Sometime later, two Finnish nuns who were on a yearlong mission at a church in Bethlehem began to volunteer with the students three days a week. They were an enormous help to the small staff of overworked teachers. Two days after their arrival, Muheb told Ali that he needed to talk to him privately "about something crucial, something very, very important."

314

Ali agreed and the two of them went into an empty classroom. When they were alone, Muheb whispered: "You must choose between me and those two Finnish ladies. If they keep coming back, then I will leave the program." Startled, Ali asked,:"Did they harm you in any way?" Muheb shook his head. "No, but my father told me that Europeans are against Muslims and they hate Islam and those Christian ladies are the enemy of Islam." His father had shown Muheb a video of Finnish police officers violently arresting a man whom Muheb's father said was being attacked simply because he was a Muslim and because he was black. Muheb continued: "Those women are my enemies, I refuse to even be near them. They may try and kill me!"

Ali posed a question to Muheb: "Those two women, did they make you feel that they dislike you because you are a Muslim? Did they even ask if you were a Muslim? They don't consider you as a representative of any people, they just see you as a human being and they want to help you. These women left their home to come here to Bethlehem and help us. They know there are Muslims here!" Muheb admitted that he had not witnessed them behave badly himself, but repeated that this is what his father had told him. Ali asked if Muheb would show him the clip that his father had found. Muheb took out his old smartphone and pulled up the video which had a title in English beneath it. Ali suggested that, as an exercise, Muheb write out the English title on Google Translate so he could see for himself what the words mean. Muheb did so, and then read aloud in Arabic that the police were forcefully arresting immigrants. "It says immigrants," Ali pointed out, "not Muslims or black people." And then Ali explained to Muheb what an immigrant is, and told him that whereas they are discriminated against in some places, these women were in no way implicated in that discrimination.

315

"What if for now you continue to come to the program," Ali said, "but if those women — or anyone else! — makes you even slightly uncomfortable, you come tell me?" Muheb accepted Ali's terms, and after about a week he went from being slightly suspicious of these women to being the first of the students to wrap his arms around them when they arrived each day. This was precisely the kind of change that Ali had hoped the program would elicit in his students. For the first time in his young life, Muteb had encountered something foreign, something potentially dangerous, and had come to the conclusion independently that it was not a threat to him. He had learned to love something alien, something different.

One day sometime later, Muheb came to class very late. Ali was concerned — unlike the other boys in the program, Muheb had always been early or exactly on time. "Where were you?" Ali asked him. Muheb explained that the Palestinian Authority had called for a day of rage to protest against the decision of the Trump administration to move the American embassy from Tel Aviv to Jerusalem. Ali asked why Muheb would put himself in danger by going to one of these clashes, and Muheb confessed that his father only ever told him that he was proud of him when he went to clashes or threw stones at the Israeli soldiers who regularly raid the camp. "Why does your father pressure you to do these dangerous things?" Ali asked. "Doesn't he know you could be killed? Isn't your life precious to him?" Muheb replied: "Yes, of course, but he wants something special for me, he wants me to be a martyr. Martyrs have the power to save seventy family members from hell and bring them to paradise." Later Muheb stopped coming to the program. His father would not allow it any longer. As far as Ali knows, Muheb is still alive.

Bethlehem was ground zero for covid in the West Bank. The city shut down in the middle of March, 2020. That was the beginning of the end of Ali's program. It took the parents two months before they would agree to let the students come back, and then only under strict conditions. Mahmoud Abbas, president (for life, it seems) of the Palestinian Authority, had announced that Palestinian schools would continue running from home, using Zoom like the rest of the world. In this he evinced the cynicism for which his own people despise him. Abbas knew full well that the poverty of the Palestinian population rendered online-learning impossible for the vast majority of his citizens. The wealthy families in Ramallah and elsewhere would get by just fine. They had laptops and internet connections; and when the Israelis let the vaccine in, they had it, too. Ali recalls visiting the local hospital in the camp in the early days of the pandemic and seeing nurses without masks. His students' families barely had WiFi, let alone a laptop for every child. And so the months dragged on and the young people in Dheisheh had no schooling, no interaction with other children, and nowhere to play ball or have picnics. Abbas maintained this policy for an entire year. Every student who did not have the requisite technology missed a grade's worth of learning.

When the parents finally allowed their children to return to his program, Ali and his partners developed safety protocols. They staggered attendance from day to day and instituted social distancing. Masks and hand sanitizers were difficult to acquire. For one terrifying stretch of time there was no running water in all of Bethlehem, let alone pocket-sized Purell. The teachers tried valiantly to secure the necessary materials, but funds were dwindling fast. At about the time

317

the money ran out, the landowner with whom Ali had signed a five-year lease found a buyer who was willing to purchase the premises outright. He insisted that the program clear out a year early. Ali had spent hundreds of hours and much of his own money to transform the apartment into a beautiful learning space. The doors shut for the last time two years ago.

When politicians abandon their people, the solution is not to reject politics but to reform politics. Community leaders are not politicians and after school-programs are not school systems and no amount of paper flowers can simulate the smell of fresh rosemary, which perfumes the parks in Israel just a few hundred feet away from the restaurant where Ali works. A program such as Ali's is no substitute for political reform. It cannot be. Ali is a hero, but he cannot bring the revolution that Muheb needs. A young, promising child whose father prays that he will one day martyr himself needs a political force that can protect him and a political culture that cherishes different dreams and ideals. In making change there is no substitute for the power of a government, especially a decent and enlightened government.

The Palestinian people have been abandoned by every political authority whose duty it has been to protect them. The boot of Israel's occupation is on their necks, and their own leaders conspire to keep it there. The only ally more precious to Israeli extremists than Mahmoud Abbas is Yahya Sinwar. Sinwar, the leader of Hamas, gave the xenophobic radicals in Netanyahu's government the bloody gift of hardening Israeli society. We will see how long this new hardening lasts, though the atrocities of October 7 will never be forgotten. That cursed day birthed a hideous world. As Ali said to me, Hamas targeted exactly the Israelis who could have given his people hope. (The vicissitudes of Israeli political life are watched closely

by Palestinians.) In the kibbutzim and moshavim just outside Gaza, Hamas butchered a community of peace activists. Benjamin Netanyahu had been busy for more than a year attempting to crush the liberal character of Israel, which had been gaining strength every Saturday evening for the entirety of 2023, when Israelis had taken to the streets to agitate for liberalism — but on the night of October 7 the streets were silent. The largest and longest protests in the history of the state had been protests against the most right-wing and openly racist government since Israel's founding, and Hamas put an end to them. What dazzling and disgusting symbolism! The thugs who govern both peoples can be counted on to collaborate in extinguishing of every glimmer of hope.

Politics is the realm in which this hopelessness is perpetuated, and politics must be the realm in which it is obliterated. Regimes of despair cannot be contended with, they must be deposed. I look often at the pictures that Ali shared with me of the children in his program. Muheb was twelve years old when he first started attending. If he is still alive, he is sixteen now. Soon it will be his responsibility to do more for his children than was done for him. Perhaps he or someone like him, or many promising young people, will realize that hopelessness is a malignancy that must be dispelled internally – indeed, that it is not a historical inevitability but a human choice, the consequences of particular actions by particular leaders and populations.

Among the shackles which bind children like Muheb are the shackles of loyalty. These shackles, which present themselves as eternal verities, are in fact politically fabricated and manipulated. In order to envision a future worth living for, Ali and Muheb and every other Palestinian refugee must free themselves from the fatalistic grip of the past. They must

319

believe that they owe their people more than a life lived in pained service to a time gone forever. They have been taught that such emancipation is treasonous; but there can be honor in "betraying" one's tribe, especially if one "betrays" the tribe in order to heal and protect it. Is the perpetuation of Palestinian misery by a Palestinian culture of dogmatism and implacability and hatred not also a betrayal of the Palestinian people?

In 1878, a Zionist and bohemian Jewish poet from Poland named Nafatali Herz Imber wrote a nine-stanza Hebrew poem called *Tikvatenu*, or "Our Hope", which included these words: "as long as a heart beats within a Jewish breast, and Jewish eyes gaze towards Zion, our hope is not lost — a hope which is two thousand years old: to be a free people in our own land, the land of Zion and Jerusalem." Not long afterwards the words were adapted, by a Zionist pioneer in Palestine named Samuel Cohen, to a Moldavian folk melody (made famous by Smetana in *The Moldau*), and the resulting song, under the title *Hatikvah* or "The Hope," became a Zionist hymn and then the national anthem of the State of Israel, which actualized the yearning that the lyrics expressed. In a truly novel experience for the Jews, hope and history rhymed.

But there are some among the Jewish people who remain unsatisfied. They want still more. There are some who believe, as Benjamin Netanyahu recently insisted, that the land must be under Jewish sovereignty from the river to the sea (a doubly cursed locution — Zionists rightly shudder when pro-Palestinian activists chant the same slogan and it is no less ugly when one of our own makes this irredentist threat). Some Jewish chauvinists hector that any compromise

on any element — or acre — of our national birthright is a betrayal of the hope that sustained us in all the centuries when we wandered homeless. But it was this very "betrayal" that brought the Jewish state into existence, when David Ben Gurion and the Labor movement nobly and rationally decided that safety and sovereignty and self-determination and political dignity in a world of nation-states were more important than the worship of soil and scriptural promises, and agreed to accept less than the ancient dreams and maps, and brought Jewish refugees home to a state.

Not all compromises deserve to be denounced as betrayals. Compromise, too, can be a moral and even a spiritual achievement. The Jews spent two millennia in exile longing for Jewish sovereignty in the Jewish land. The Palestinians have nurtured the same longing for sovereignty in the same land for the better part of the last century. Their identity is no less real and their claim is no less justified. Palestinian eyes gaze towards Zion with no less love or loyalty than our own. In the name of prudence as well as decency, the holy land must carry two flags in two countries for two peoples. This is our, and their, only hope.

LEON WIESELTIER

Giving and Forgiving

Look who thinks he's nothing.

All these blacks and whites make existence grey. The certainties, the rectitudes, the stridencies, are like a cloud cover interdicting the light, halting it in its natural course to us, and trapping the world in a dense foggy dread. It sometimes seems as if the more people make a claim to clarity, the more unclear things become. The unsure people begin to look perversely attractive, insofar as they represent minds not yet closed. But hold on. How can anyone not be sure about the evils that we face? Are they blind or are they stupid or are they bought? It is a fair question, except for its naivete about the actual processes of opinion formation, which leave us all not only in disagreement, which is one of the sweetest features of life with

other people, but also in the tragi-comic position of building an absolute view out of a partial perspective. I do not mean to hold myself above the ferocity of our absolutist mood. I, too, know that I am right. For this reason, I have been trying to lower my own temperature as history is demanding only fevers. In this new era of atrocities, some of them close to home, I strain not to become the slave of my feelings. I find myself grateful to people who maintain their composure and even hide their thoughts. I believe that interstices must be created between the emergencies, so that a man's soul does not shrivel. Not escapism; just some escapes. Something a little tender, a little alien, a little private, a little serene; stimulation without pain; a rupture in the ambient anxiety and a break into a less bruising variety of seriousness — a kind of spiritual furlough, in the knowledge that the crises and the controversies will still be there when we return with renovated selves. People cannot serve well who are spent.

When a new life of Diogenes the Cynic arrived in the mail a few weeks ago, I saw my opportunity. Here was a swift transit to another planet, a flight from breaking news to the unbreaking stuff, a promise of mental diversification and refreshment. It was also a reason for taking Diogenes Laertius off the shelf: *Lives of the Eminent Philosophers* is the most mentally diversifying book I know. It is a vast compendium of biographical anecdotes about seventy-three ancient Greek seekers of wisdom; Plato gets an entire chapter, Monimus gets half a page. ("Monimus was so grave that he disdained mere opinion and sought only the truth." Go, Monimus!) The tales are delightful, vexing, colorful, and hilarious, and somehow the panoply of the doctrines pokes through them. Diogenes Laertius, who appears to have lived in the first half of the third century CE, included among his subjects Diogenes the Cynic,

who was born in Sinope on the Black Sea at the end of the fifth century BCE and died in Corinth in the second decade of the fourth century BCE, though he is best known for the years he spent in Athens. I turned to those pages.

Exiled from Sinope for a financial crime, Diogenes the Cynic lived on the streets of Athens in a ceramic jar or tub. He begged for his sustenance. In his itinerant life he carried a staff and a knapsack and a lamp lit even in daylight to guide him in his famous search "for a man." He kept a dog. ("Cynic" means "dog-like", and Diogenes was flattered by the epithet, because many of his ethical values were derived from his admiring observations of the behavior of dogs.) He wore only a cloak, which he folded doubly in a way that became the fashion for his disciples. He was the first to call himself a *cosmopolite*, a citizen of the world. He was a defiant outsider, a devastatingly candid non-conformist, a great master of impudence. He especially enjoyed tangling with Plato. When someone pointed out that the Sinopeans had sentenced him to exile, Diogenes replied: "And I sentenced them to stay at home." When pirates captured him and put him up for sale in Crete, he was asked to describe his greatest skill. "Ruling over men," he said, and pointing to a buyer he added: "Sell me to him; he needs a master." He declined to leave his jar when Alexander the Great came to Corinth, so the conqueror came to the jar and asked if there was anything he could do for its indigent inhabitant. "Yes," Diogenes replied. "You could stand a little out of my sun."

In his teachings — his contempt for material things, his radical austerity, his tolerance for hardship, his aspiration to a virtuous life lived in harmony with nature — Diogenes was the early ancestor of the Stoics, though he was innocent of the hypocrisy that tarred many of them. He was a pioneer in

the notion of philosophy as a way of life, and he fanatically practiced his conception of it. I have always treasured this particular remark: "even if I do pretend to wisdom, that in itself is philosophy." I take this to mean that the hunger for wisdom is itself wise and the thirst for philosophy is itself philosophical. Why would one aspire to these dispensations if one were not already touched by the spiritual refinement that they promise? Aiming high is already a way of reaching high. The spiritual climate in which one chooses to toil will determine the success or the failure of one's exertions — but if one has chosen a spiritual climate that pressures one's powers and situates one's struggles at a significant elevation, then total failure is no longer a possibility. Spiritual fulfillment is infrequent, and not the only kind of spiritual success. The ambition can be its own reward. The real spiritual defeat is shallowness.

What struck me in my recent reading about Diogenes was his conception of charity. Diogenes Laertius records that "when some people were praising a man who had given him alms, Diogenes said, 'Yet you don't praise me, who deserved to receive them." It sounds ungrateful and impertinent. But the mendicant philosopher was speaking precisely: he had a theoretical foundation for his apparent obnoxiousness. It was not Diogenes' custom to make his points with arguments — when he wished to refute the suggestion that motion is an illusion, he got up and walked around -- but in this instance he posited a kind of syllogism. "He declared that all things belong to the wise", Diogenes Laertius relates, "and advanced this argument: all things belong to the gods; the gods are friends of the wise; the possessions of friends are held in common; and therefore all things belong to the wise." Diogenes' donors were merely returning to him what was already his. Never mind

325

the flaws in all his premises, except to note the culture-bound character of what often purports to be logical reasoning. What strikes me about Diogenes' posture is not only the stoutness of his self-respect, so that he did not experience extreme need as humiliation; but also his further claim that charity was not his good fortune but his just deserts.

The pride of a poor man is exhilarating, because it is a proof that outer circumstances may be impotent against inner resources, that the material world is not invincible. I do not mean to be sentimental about poverty, of course. Neither do I mean to be sentimental about Diogenes' poverty. For there is no universal compassion in his theory, no natural sympathy with all the other men and women who share his adversity. Quite the contrary: he is an outcast who believes that he is the member of an elite — of the supreme elite of those who enjoy the friendship and the admiration of the gods. His jar is his palace. There is no provision in his interpretation of charity for beggars who are not philosophers. Moreover, he has voluntarily chosen a life in which he has exempted himself from common human bonds, so that he himself cannot be expected to act charitably, to give as he receives. It is not an altogether edifying picture. Plato once scolded him: "How much vanity you expose, Diogenes, by not appearing to be vain."

Still, a few important features of the relationship between the benefactor and the beggar may be coaxed out of Diogenes' vanity. The first is that teachers and thinkers have a claim on the support of their society. Whether or not they are friends of the gods, and whether or not they are an elite or "culture workers", those who devote their lives to the exploration and

the clarification of what we believe about our universe and our society and ourselves, who have consecrated themselves to the education of their era – they have a claim on material support. They *deserve* it: not charity, but recognition in the form of resources that will enable their work, because their work is at least as essential to society as the work of engineers, who these days have the temerity to regard themselves as philosophers. They should never be regarded as beggars, though there are writers and painters and composers in our society who may be forgiven for living each day with insecurity about the next. The quality of their work — they cannot all be right and beautiful and profound — matters less than their existence in our midst. We have an obligation and an interest to help pay for the jar.

And there is something else, a more startling idea, that recommends Diogenes' insolence: it is a ringing statement of the primacy of the receiver over the giver. This is especially tonic in our wealth-addled country, in which the cult of the donor deforms many institutions. Why do so many Americans believe that wealth confers knowledge? Why is the acknowledged "sage" of present-day America a stock-picker? How can a hedge-fund thug presume to judge the qualifications of a university scholar? Philanthropy was supposed to be a humble activity. Maimonides, who pondered the matter deeply, judged anonymous charity to be the most perfect charity of all. (I oppose the building of the Third Temple for many reasons, not least among them the naming opportunities. At the most numinous moment of the year, who wants the Lauder Family High Priest to enter the Miriam and Sheldon Adelson Holy of Holies?) Philanthropists deserve to be honored, by their beneficiaries and by their society, but the bowing and the scraping must stop: between the givers and the receivers, they really are not the most interesting figures in the relationship. I have

always studied losers more than winners, because they know more about the world. (Which is not to say that everything that victims believe is true.) There is something so parochial about a billionaire. The insulation brings a cognitive disadvantage. The poor and the weak and the scorned, by contrast, are taxed to the core of their being every day of their lives. They live on the edge and somehow make a human life there. They have nothing, but still they have children. The resilience that they discover — when their strength does not fail them — cannot be bought. I know what I would do if I had a lot of money, but I have no idea what I would do if I had none.

The satisfactions of generosity are justifiably great for the giver, and I envy the "high net-worth individuals" for their ability to transform people's lives. I wish that I, too, had the power of rescue. But too many of them put me in mind of an ancient problem, which is the vanity of virtue. Our "donor class" likes homage and they agree to an awful lot of tributes. They are always available to the media which is always available to them. They give in a spirit of self-congratulation and even self-love. For people who claim to lose sleep over the sufferings of others, they smile too much. (Is there a more perfect emblem of complacence, a more definitive image of perpetual fabulousness, than Darren Walker's face?) They swan around like aristocrats, but this is a democratic society. I could go on, but what I want to emphasize here is the sagacity of Diogenes' shift of focus from the giver to the receiver. He wishes to make charity seem not just charitable, but also the acknowledgment of what we call, millennia later, a right. Or if not a right, then some intrinsic and inalienable feature of his person that makes a valid claim upon the will and the wherewithal of others. I guess we call this dignity, which defies all distinctions of class; all distinctions, period. The history of class wars and

class struggles and political fights against extreme economic inequality shows that they have always referred at some point, in religious or secular terms, to the irreducibility of dignity in reduced circumstances. A broke man is not a broken man. He is a man who needs help. The moral condition of a society may be measured by its attitude toward help. Diogenes in his squalor based his concept of his own dignity on a theological belief about his closeness to the gods, and in their way monotheistic believers think similarly when they speak of being created in the image of God, so that the privilege, the claim upon others, is universal. A universal privilege, an elite of everyone: the apotheosis of inclusion.

The transfer of emphasis from the giver to the receiver is itself an ethical condition of generosity, and a reminder that the primary goals of a society do not include the self-fulfillment of the rich. They are as entitled to the pursuit of happiness as the rest of us, but their failure to find it is not a social failure in the way that the unhappiness of the poor is. I have known some hugely generous benefactors whose motives plainly had nothing to do with their own aggrandizement, and their satisfaction at having given help, and ameliorated the disadvantage and the pain of others, is genuinely affecting; but it is not the essential point. The self-fulfillment of any benefactor, rich or unrich, the ratification of his or her own self-esteem by means of a good deed, the warm sensation of his or her "flourishing", must take a back seat to the real accomplishment of their charitable acts: the overwhelming recognition of the immensity of another person, of other people, before which our presence to ourselves mysteriously gives way.

The giver is indebted to the receiver, who is the giver's guide to the full range of human actualities. The receiver

offers the giver a correction of vision, an expanded sense of reality, a new moral plane, a door. So, then, thank-yous all around! But even to say what I have just said seems to restore the sticky first-person standpoint that was put into doubt. The ego relentlessly regenerates; it is the original hydra; it survives every circumscription. The trip out of our ourselves is always a round trip. Is it too condescending, too self-regarding, for the giver to thank the receiver? (After a speech that she delivered about surviving the Holocaust, my mother was approached by a woman in the audience. "Mrs. Wieseltier," she solemnly said, "thank you for surviving." "You're welcome," Mrs. Wieseltier replied.) Surely we must not, for the sake of our own personal development, be grateful to the poor, the weak, and the scorned for being poor, weak, and scorned – and yet we need to learn.

In 1991 a German-born Australian philosopher named Raimond Gaita published a profoundly humanist book called *Good and Evil: An Absolute Conception*. It includes an illuminating discussion of remorse, of proper and improper ways to think about a person whom one has wronged. Gaita wishes to arrive at what he calls "lucid remorse." He gives examples, which are also a delicious satire of contemporary moral philosophy, of how people might remorsefully describe the wrong that they have perpetrated.

330

> 'My God, what have I done? I have violated the social compact, agreed behind a veil of ignorance.' 'My God, what have I done? I have ruined my best chances of flourishing.' 'My God, what have I done? I have violated rational nature in another.' 'My God, what have I done? I have diminished the stock of happiness.' 'My God, what have I done? I have violated my freely chosen principles.'

Gaita then glosses his bit of polemical frivolity: "Even if one thinks the parodies to be to some degree unjust, they point unmistakably to the fact that the individual who has been wronged and who haunts the wrongdoer in his remorse has disappeared from sight."

Neither the receiver or the giver must ever disappear from sight. All doctrines of disappearance must be rejected. Even in Diogenes' revision, the receiver does not usurp the giver on the moral ground, but the giver agrees to share the moral ground with the receiver, because (as Diogenes insisted) having nothing is not being nothing. The act of begging misrepresents the moral standing of the beggar. Generosity is finally not a wish for charity, but for justice; the gift is in fact an obligation; and justice is never achieved without the detachment of the powerful from themselves, so that the authority of others, their incontrovertible and binding humanity, at last commands their deference.

Diogenes' transfer of emphasis puts me in mind of another sphere in which the same shift is sorely needed. I refer to the sphere of forgiveness. Or more precisely, of unforgivingness. We have become a disgracefully unforgiving society. There are no mistakes in our time, and certainly no innocent mistakes; there are only crimes and sins. Nothing transpires between the allegation and the punishment. The objective of the exercise is disqualification. We are a pariah-producing culture. Our collective memory is increasingly becoming a dossier of indictments and inuendoes, all of them more or less inexpiable. The moving finger writes, and having writ, moves on. Nothing is forgotten, or submitted to the test of fairness and proportionality,

or allowed to fall into oblivion, in the name of ambiguity or decency or social peace. Instead imperfect people regard the guilt of other imperfect people as final, often without bothering to inquire into the grounds of their alleged guilt, which anyway becomes folklore long before a responsible inquiry can be conducted. Your vice, after all, establishes my virtue. And if, by some miracle, the guilty status is overcome, it is an event of such rarity and drama that we call it "redemption."

The political regimentation of moral discourse leaves us incapable of honesty about contradictions and complications. When things do not add up, we resort to rhetorical violence, to slander. We must learn to accept that a man who rightly believes in free speech may at the same time be a miscreant, and that a woman who rightly denounces the tyrannies of wokism may at the same time be a racist. Even in an environment in which false allegations flourish, true allegations may be made; and our responsibility is not, as the Marxists used to say, to work them into the analysis so that our side remains unshaken. Our responsibility is to recognize human pain and human culpability wherever we find it. I remember my shock many decades ago when a friend said to me about Ariel Sharon, "he may be a fascist, but he's *our* fascist." (This was in the years when the appellation still applied to Sharon.) Now imagine this sentence about someone: "He may be a rapist, but he's *our* rapist." Thinking like a group is hardly the most assured way of arriving at fairness and sympathy. The veracity of an allegation has nothing to with the lack of veracity of many allegations that preceded it. Even if we have grown skeptical about our culture of umbrage and trauma, and despite all that we have discovered about the mechanisms of suggestibility in our society, about cascades and contagions, all accusations are

not mischievous or phony or ideologically inspired. We must secure some of our credulity against our sophistication. And whatever one's views about forgiveness, a rush to forgive may reveal a lack of seriousness about the accusation and a lack of respect for the accuser.

In my reading, and in my reflection on my own experience, I have encountered a certain notion of forgiveness, a grandiose notion, even a mystical one, that I have come to loathe. It is best captured by this sentence by Jacques Derrida: "One only ever asks forgiveness for what is unforgivable." He made this statement in a two-year seminar on "Perjury and Pardon" that he gave in Paris in 1997–1999. It suffers from a strange premise, which is that anything that can be forgiven can, or will be, forgiven, so that the forgivable need not detain us. This ignores the fraught psychological vicissitudes of apology; and it suffers, too, from Derrida's tiresome love of paradox. It would have been less startling but more plausible to say that one only ever asks forgiveness for what is not easily forgivable, but such a formulation would obscure the radical and epiphanous conception of forgiveness that Derrida wants to develop.

Like almost all post-war thinking about the subject, especially in Europe and England, Derrida's discussion begins with the war, with the barbarities that seem to have exploded any possibility of absolution. He begins, quite properly, with Jankelevitch. In 1965, amid a debate about statutory limitations on Nazi war crimes, a French-Jewish philosopher named Vladimir Jankelevitch, who had fought in the French Resistance, published a scorching essay called *"Pardonner?"*, which was translated into English thirty years later under the title "Should We Pardon Them?" The essay is a masterpiece of ethical fury. It begins: "Is it time to pardon, or at least to forget?" After all, he notes witheringly, it had been twenty

years. Jankelevitch's answer to his question was a sonorous no. In one of the most haunting lines in all of Holocaust writing, he declares: "Forgiveness died in the death camps." As for reparations, "there are no reparations for the irreparable." There is only the everlasting horror, "because this agony will endure until the end of the world."

Jankelevitch was not alone in the absoluteness of his refusal. Jean Amery, Andre Neher, and Elie Wiesel similarly insisted that honor — personal honor, human honor, Jewish honor — demanded unforgivingness. Especially in the decades after the extermination, this is not hard to understand, though it certainly does not settle the question. Derrida did not concur, though he made no explicit plea for pardoning Nazis and other war criminals. Instead he writes with appropriate disgust at the ease with which historical atrocities against whole peoples, modern and medieval, have become the subject of glib ceremonies of public contrition and expedient theaters of apology. Who has not been similarly disgusted? Every time a pope apologizes for the Church's conduct during the Holocaust or for the millennia of anti-Semitic doctrine and violence that preceded it, I always think the same thought: fuhgeddaboudit! And I have always been a bit embarrassed by my reaction to the sight of Willy Brandt falling to his knees at the memorial in the Warsaw Ghetto: I was moved, but not beyond words. It was an admirable gesture by an admirable man — during the war he was active as an anti-fascist outside of Germany — but my gratitude for his decency was overrun by my blinding awareness of what occurred in that place, and I was strangely content with the myopia. And we have come a long way, fifty years later, from Brandt's stricken sincerity to the parade of penitent politicians doing what polls tell them to do, as the stagecraft of conspicuous repentance kicks everywhere into

action. Derrida called this "the globalization of forgiveness." What is an apology for a deed that you yourself have not done, or for a crime that was committed many centuries before you were born? Can peoples apologize to peoples? (I wish they could.) It is churlish to turn away an apology, any apology, but there are apologies that make matters worse by their assumption that the injury can be this efficiently healed. Silence, shame, and solidarity would be more respectful.

In his discussion of forgiveness, Derrida formulates a concept of forgiveness that raises it to the status of a miracle. "Forgiveness is not, it should not be, normal, normative, normalizing. It should remain exceptional and extraordinary, in the face of the impossible: as if it interrupted the ordinary course of historical temporality." And elsewhere: "forgiveness must therefore do the impossible; it must undergo the test and ordeal of its own impossibility in forgiving the unforgivable." While it is true that real forgiveness is rare, and that its rarity is owed in part to the comfort that many people feel with unforgivingess (anger is so much less demanding than fellow-feeling), Derrida's idea of forgiveness, by making it seem almost saintly, has the unwitting effect of sufficing with our world of sovereign grievances.

In his insistence upon something stupendous, he slides too smoothly from the exceptionality of forgiveness to its impossibility. This is in part the consequence of taking historical forgiveness as the model for all forgiveness. For the sake of the possibility of personal forgiveness, however, it must be said against Derrida that the unforgivable is also rare. Most sins are forgivable, if only the injured party is prepared to see why and to enlarge themselves to the proportions of the ideal. And even if forgivable sins are hard to forgive, as they often are, to call them unforgivable is to exaggerate their magnitude, to lie

335

about them, in a kind of reverse cruelty. The presumption of enormity, which is what underlies the discussion of historical forgiveness, has no place in the discussion of personal forgiveness. Even the wronged must be held to standards of accuracy about what happened, and expected to calibrate in their understanding of the gravity of what has been done to them.

In sum, the ethical and emotional challenges of everyday existence render Derrida's extremism useless. Genocide is not the archetypal misdeed. In this context, its enormity makes it less instructive. (The overheatedness of existentialism was owed partly to its transposition of the crucibles of war and resistance to the entirety of existence.) There is life to live, and we live it prosaically, at lesser levels of vice and virtue, always in its unglamorous details. These lesser levels are no less interesting for ethical analysis and no less important for spiritual progress; and even if they are small and unapocalyptic, they can be excruciating. They are replete with actions that are very wrong but forgivable, or forgivable but very wrong. In 1971, Jankelevitch published a book called *Forgiveness* in which he complicated his account of the subject. The infamous nay-sayer wrote this:

> There is an inexcusable but there is not an unforgivable. Forgiveness is there to forgive precisely what no excuse would know how to excuse: for there is no misdeed that is so grave that we cannot in the last recourse forgive it. Nothing is impossible for all-powerful remission! Forgiveness can in this sense do everything. Where sins flows, Saint Paul said, forgiveness flows.

It cannot be that forgiveness died in the death camps, even if forgiveness for the death camps died in the death camps.

We must be wary of praising forgiveness too extravagantly, so that we do not expel it from the realm of common human intercourse and make it too daunting. The rarity of true forgiveness is owed more to the hard-heartedness of people than to the preternatural scale of the task. In our relations with people, forgiveness should be — I am directly reversing Derrida here — normal, normative, and normalizing. If it is exceptional and extraordinary, that is because of the difficulty of the inner path to a forgiving will, not because it interrupts the ordinary course of historical temporality. It is indeed a historical interruption, on the plane of personal history, because it undoes the finality of the trespass, and out of a temporally irreversible event it makes a morally reversible event; but it is in no way eschatological, at least as regards wrongs committed by one individual against another. (I am borrowing a fundamental element of Judaism's theory of forgiveness, which is the distinction between sins between man and God and sins between man and man, and not even God has power to remit the latter.) Forgiveness, if it is to become a regular feature of living together, is an instance of what might be called the banality of good. The moral life is not the same as the heroic life. There are moral heroes, but they are made by their circumstances. Of what benefit is an ethical code that is beyond the capabilities of the flawed and fragile creatures for whom it was promulgated?

A system of reward and punishment, religious or secular, can be, well, unforgiving. It is a machinery of judgment whose rigors can be oppressive and result in rebellion or despair, in the ancient feeling that if justice were done the world would perish. For this reason, every system of reward or punishment has been accompanied by a fallback, a work-around,

a loophole of mercy with which to soften or even transcend justice. As far as I can understand it, and I have been wrestling with it for many years, the primary instrument of this relief has been the idea of grace. Given our sinfulness, or, in less religious language, given our capacity to do wrong, it is not hard to grasp the attraction of the idea of grace, its psychological ingenuity, because it abrogates a system that will find us wanting and it releases us from the culpability to which our weakness inevitably carries us. It is a promise of immunity from doom, and thereby rescues the wrongdoer from hopelessness. In the Christian writings on the subject that I have read, grace saves us from the consequences of our actions in two ways: before the action is done, when it preemptively inclines our will (even when it is free, as in the Augustinian tradition) to choose the good, and after the action is done, when it annuls the case in a demonstration of divine love. In both instances, it is a metaphysically based form of moral hazard — a get-out-of-hell-free card. Or as Jankelevich put it, "forgiveness of sin is a defiance of penal logic."

And that is its beauty. Who has not dreamed of such cosmic clemency? Where is the individual who is confident that he or she can dispense with grace, or with any similar appellant rescue? Grace is the signature fantasy of the finite. It is no wonder that forgiveness would be described as a form of grace, as a gift. But there is something troubling, at least to me, in the account of forgiveness as grace, and it is the picture that it presents of the individual who stands, or kneels, in need of it. This individual is utterly without merit. Indeed, it is his complete lack of merit that makes him eligible for this exonerating intervention. In the manner of Tertullian, who espoused his faith precisely because it was absurd, the forgiven man is granted his release precisely because he is odious.

This condition that the sinner, to be worthy of salvation, must be worthless appears often in the literature of Christian forgiveness. Late in life, in the *Retractations*, Augustine described "the new heretics", the Pelagians, as those "who make such claims for the free choice of the will that they leave no place for God's grace, because they say that grace is given according to our merits...And if this divine assistance, whereby the will is freed, were granted for its merits, it would not be a 'grace', a gratuitous gift." A few years earlier, in the *Enchridion,* he explained that

> this part of the human race to which God has promised pardon, and a share in His eternal kingdom, can they be restored through the merit of their own works? God forbid! For what good work can a lost man perform, except so far as he has been delivered from perdition? Can they do anything by the free determination of their own will? Again I say, God forbid! For it was by the evil use of his free will that man destroyed both it and himself.

Augustine held that the free will that chooses evil forfeits its freedom and cannot therefore correct itself. A mistake — which is usually what a transgression is: most offenders are not rebels or heretics — immediately plunges the individual into a dire crisis, a state of emergency. To be sure, Augustine was hardly insensitive to the infirmities of the flesh and the will, and he wrote eloquently and with compassion, and autobiographically, about the psychology of sin, observing that sins "happen so often by ignorance, by human weakness; many are committed by men weeping and groaning in their distress." (In his view it was the Pelagians who were the perfectionists

and the purists.) And yet his description of the aftermath of sin depicts the errant individual with a savage disrespect, as nothing but his sin, and therefore as nothing. The sin obliterates the sinner, leaving only a beggar for redemption.

Nobody was ever improved by being erased, but this annihilation of the wayward person, whose misdeed costs him the entirety of his worth, lives on. It figures in Christian theology also in modernity, from Jonathan Edwards ("They must be sensible that they *are not worthy* that God should have mercy on them. They who truly come to God for mercy, come as beggars, and not as creditors: they come for mere mercy, for sovereign grace, and not for anything that is due.") to Simone Weil, who in her late journals defined grace, not surprisingly, as the nullification of the self, as its "decreation." It is distinctly odd for such an apostle of goodness to erase one of its conditions, which is selfhood. Utter selflessness, if it is at all possible, is not compatible with moral agency, with commitments to causes, with the energy required to repair the breach.

I do not mean to lay this sentence of abjection exclusively at the feet of the churches. Early in every morning's prayers the Jew plaintively declares his own worthlessness: "what are we, what are our lives, what is our righteousness, what is our salvation, what is our strength...for man's advantage over the beast is naught, because all is vanity." And in the Jewish religion, so renowned for the alleged severity of its law, its emphasis upon reward and punishment, there are also theological work-arounds to mitigate the desperation of the guilty: doctrines of God's mercy and its likelihood, constant appeals to the merits of the forefathers, regular citations of the Scriptural promises of individual and collective salvation, certain constructions of the idea of chosenness. And yet — I

don't mean to engage in apologetics, I really don't — there is not quite the sense of sin as an ontological catastrophe. The Hebrew word for "sin" is the same word for "missing a target", as in Biblical scenes of archery. A misfire is not the final word. When you miss a target, you reach into your quiver — your undepleted quiver — for another arrow.

Such an attitude toward a misdeed does not make of it anything casual or trivial, but it is not attended by a sea of fire, a threat of damnation. It is humbling but not self-abnegating. Moreover, the will that led you freely into sin is the will that is expected to lead you freely out of it. The misuse of freedom does not vitiate it or cancel it: a deal is a deal. The responsibilities of freedom notably include the duty of repentance, which implies the efficacy of repentance; and even though Maimonides famously defines the mark of repentance as "the brokenness of the heart", the guilty individual is not so broken that only a miracle will restore him. (There is a doctrine of "the negation of the I" in Kabbalah that became a central idea in Habad Hasidism, but it pertains not to the consequences of human conduct but to the conditions of mystical contemplation.)

Dissolve to the jar. "When some people were praising a man who had given him alms, Diogenes said, 'Yet you don't praise me, who deserved to receive them.'" The idea behind the philosopher's impudence, I suggest, pertains also to the practice of forgiveness. A person in need of forgiveness is still a person, and not a worm. The process of exculpation — the pain and fear and regret and sorrow that (hopefully) culminates in a pardon — should mend the wrongdoer, not abolish him. There is something haughty and arbitrary about the conception of a

pardon as a gift. A pardon would be better construed as what all mortals who have made a mistake deserve. Even in their guilt, they deserve it. Precisely in their guilt, they deserve it. Why forgive the innocent? (Who are the innocent?) Forgiveness is not supererogatory to justice; it is just. And justice requires a clarification of guilt, not a morbid obsession with it. (I have the good fortune of not having to struggle with the notion of original sin. My idea of original sin is a sin that nobody has yet committed.) If the essential characteristic of grace is its gratuitousness, then forgiveness should not be compared to grace. It need not be anything so wondrous and epiphanous. It should be familiar, vernacular, completely terrestrial. It should occur not in the ruins of the quotidian system of reward and punishment, but as an element of it. It should leave an impression not of power but of love.

When Augustine exclaims "God forbid!" about the intactness of the sinful self, I whisper *Deo volente!* The guilty, too, must be spiritually strong. After all, a decimated person, a person frightened to pieces by the hysterical conception of the sinner, is incapable of introspection, and the sinner has a lot of work to do. It is internal work that the rest of us do not see. We must look for its outward signs. Forgiveness should not, as they say, come cheap: it should come after the epic effort of repentance. The candidate for forgiveness must present himself with the tracks of his tears. As is commonly said, forgiveness must be earned. Obviously we must be careful not to be played for fools. Counterfeits of repentance, facsimiles of regret, are everywhere, especially in our public life; and toughness, too, and strictness, have their justifications. Yet we must not flatter ourselves that we are always accurate and impartial in our judgements of people, or erroneously believe that stringency has a more natural relationship to truth than

leniency. We must be a little suspicious of suspicion, which can serve as a mask for many indefensible and unattractive reasons to withhold forgiveness. Everyday experience abundantly shows that contrition is not always followed by absolution.

Since none of us are in a position to base our interpretation of the predicaments of others upon our own investigations, what will most likely determine the award of forgiveness is a prior inclination to forgive. If only as a response to our cognitive limitations, this is more supportable than a prior disinclination. Generosity is not only an action, it is also a disposition, a previous philosophical decision about the spirit in which one wishes to go through the world. Erring in the right direction may be the best that we can do. I was not always this way, but I would rather mistakenly forgive than mistakenly condemn. I have learned never to think about forgiveness as if I will never be in need of it.

Liberties

345

CONTRIBUTORS

CYNTHIA OZICK is the author most recently of *Antiquities and Other Stories*.

LINDA KINSTLER is the author of *Come to This Court and Cry: How The Holocaust Ends*. She was recently elected to the Society of Fellows at Harvard University.

MICHAEL IGNATIEFF is, the author, among many books, of *On Consolation: Finding Solace in Dark Times*.

TIMOTHY NOAH writes a column for *The New Republic* and is the author of *The Great Divergence: America's Growing Inequality Criss and What We Can Do About It*.

SOHRAB AHMARI is a founding editor of *Compact* and the author most recently of *Tyranny, Inc: How Private Power Crushed American Liberty — and What to do About It*.

CAMILLE RALPHS is the poetry editor of the *Times Literary Supplement*.

YAROSLAV HRYTSAK is a professor of history at Ukrainian Catholic University and the author of *Ukraine: The Forging of a Nation*.

DAVID RIEFF's *Desire and Fate*, a collection of his essays, will appear this year.

LEN GUTKIN is an editor at the *Chronicle of Higher Education*.

ELLIOT ACKERMAN is the author of *Halcyon*, a novel, and *2054*, written with Admiral James Stavridis, which will be published this year.

ALFRED BRENDEL, the pianist, is the author most recently of *The Lady from Arezzo: My Musical Life and Other Matters*.

ARASH AZIZI's book *What Iranians Want: Women, Life, Freedom* has recently appeared.

MICHAEL KIMMAGE's new book, *Collision: The Origins of the War in Ukraine and The New Global Instability*, has just been published.

ALICE GRIBBIN is completing her first book of poems.

HELEN VENDLER is the A. Kingsley Porter University Professor Emerita at Harvard University.

CELESTE MARCUS is the managing editor of *Liberties*.

LEON WIESELTIER is the editor of *Liberties*.

Liberties — A Journal of Culture and Politics is available by annual subscription and by individual purchase from bookstores and online booksellers.

Annual subscriptions provide a discount from the individual cover price and include complete digital access to current and previous issues along with the printed version. Subscriptions can be ordered from libertiesjournal.com. Professional discounts for active military; faculty, students, and education administrators; government employees; those working in the not-for-profit sector. Gift subscriptions are also available at libertiesjournal.com.

———————

Liberties

As a matter of principle, *Liberties Journal* does
not accept advertising or other funding sources
that might influence our independence.

We look to our readers and those individuals
and institutions that believe in our mission for
contributions — large and small — to support
this not-for-profit publication.

If you are interested in making a donation
to *Liberties*, please contact Bill Reichblum,
publisher, by email at bill@libertiesjournal.com
or by phone: 202-891-7159.

Liberties — A Journal of Culture and Politics is distributed to booksellers in the United States by Publishers Group West; in Canada by Publishers Group Canada; and internationally by Ingram Publisher Services International.

LIBERTIES, LIBERTIES: A JOURNAL OF CULTURE AND POLITICS, is published quarterly in Fall, Winter, Spring, and Summer by Liberties Journal Foundation.

ISBN ISBN 979-8-9854302-4-0
ISSN 2692-3904

Printed in Canada.

The insignia that appears throughout *Liberties* is derived from details in Botticelli's drawings for Dante's *Divine Comedy*, which were executed between 1480 and 1495.